S

2-07

Francisco de Goya

Author: Sarah Carr-Gomm
Design: Baseline Co Ltd.
19-25 Nguyen Hue
Bitexco Building, Floor 11
District 1, Ho Chi Minh City
Vietnam

© 2005 Sirrocco, London, UK (English version)
© 2005 Confidential Concepts, worldwide, USA

Published in 2005 by Grange Books
an imprint of Grange Books Plc
The Grange, Kingsnorth Industrial Estate
Hoo, nr Rochester
Kent ME3 9ND
www.Grangebooks.co.uk

ISBN 1-84013-778-9

Printed in Singapore

Francisco de Goya

(1746-1828)

Grange
BOOKS

Contents

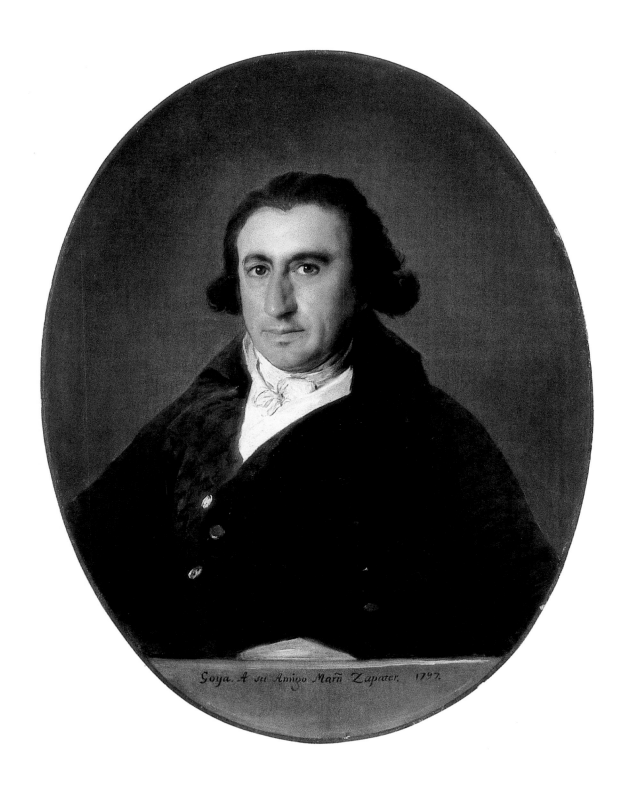

Goya. A su Amigo Marñ Zapater. 1797.

Introduction

There are no rules in painting, Goya told the Royal Academy of San Fernando in Madrid during an address he gave in 1792. He suggested that students should be allowed to develop their artistic talents freely and find inspiration from their own choice of masters rather than adhere to the doctrines of the neo-classical school. Goya himself was known to have claimed that Velázquez, Rembrandt and Nature were his masters, but his work defies neat categorization and the diversity of his style is remarkable.

Francisco Goya lived for eighty-two years (1746-1828), during which time he produced an enormous body of work — about 500 oil paintings and murals, nearly 300 etchings and lithographs, and several hundred drawings. He was proficient both as a painter and a graphic artist, and experimented with a variety of techniques; even at the end of his life he was a pioneer of the new printing method of lithography.

Essentially a figurative painter, Goya treated an enormous variety of subjects. He became the leading portrait painter in Spain, decorated the churches of Saragossa and Madrid with altarpieces and murals, and designed tapestries illustrating life in Madrid. Numerous personal sketch books contain his private observations, recording a glance, a movement or an attitude that caught his eye.

Two catastrophic events dramatically affected Goya's life and his vision of the world. The first came in 1792 when, at the age of forty-six, he was struck by an illness, probably an infection of the inner ear, which left him totally deaf. As a result, he became increasingly introspective; it was as if his deafness forced him to retreat into solitude, and to understand more clearly that every man is alone with himself. The second cataclysmic event was the Napoleonic invasion of Spain in 1808 which was followed by six years of fighting for Spanish independence. During the war, hideous atrocities were perpetrated by both sides and Goya recorded many of them in a series of etchings which are testaments to the cruelty of mankind. Towards the end of his life, Goya painted a series of murals in his own home which seems to echo the dark cloud hanging over Europe in the first decades of the nineteenth century.

Portrait of Martin Zapater,
1797, 83 x 64 cm,
Museum of Fine Arts, Bilbao.

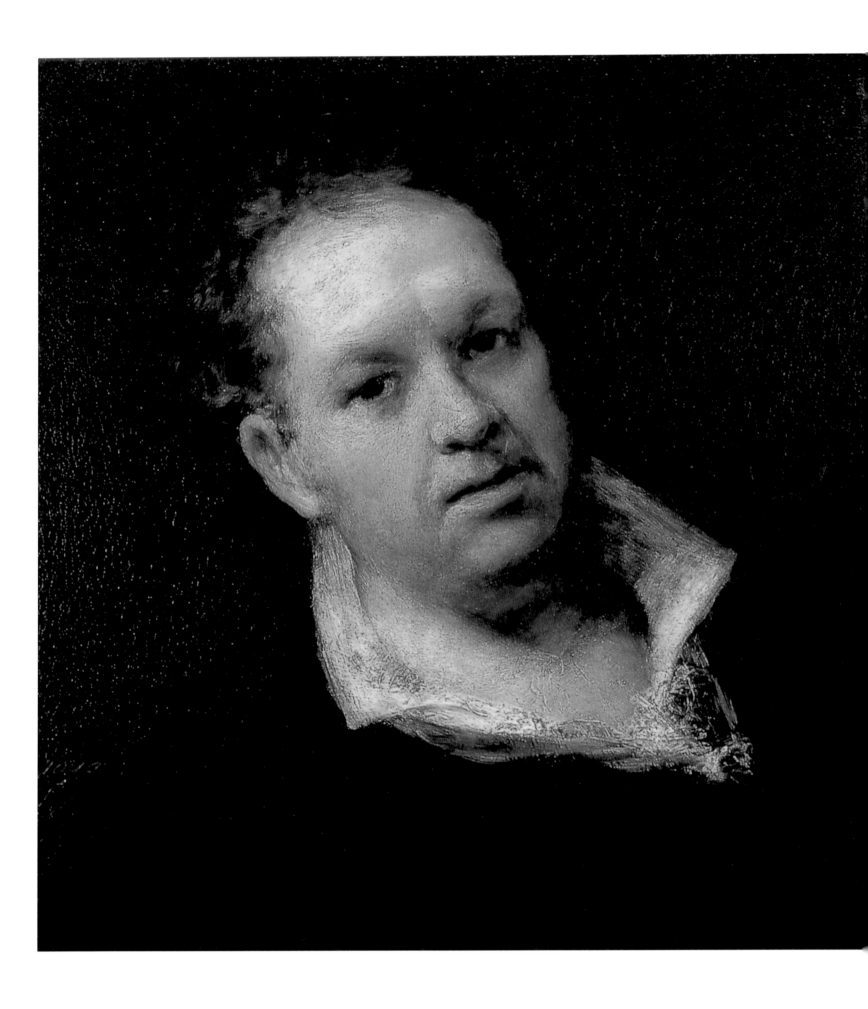

Self-Portrait, 1815, oil on panel,
51 x 46 cm, Royal Academy
of San Fernando, Madrid.

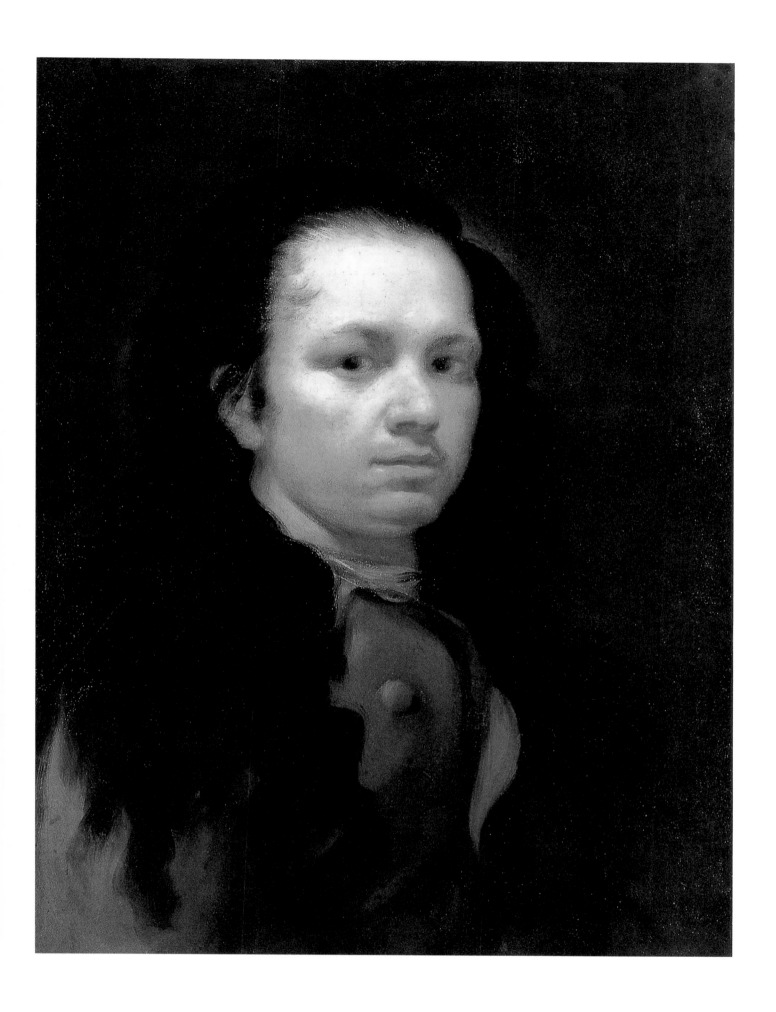

Self-Portrait, 1773-1774,
oil on canvas, 58 x 44 cm,
Ibercaja Collection, Saragossa.

Goya's early life

Francisco Goya, the son of a master gilder, was born on 30 March 1746 in Fuendetodos, a small village in the barren Spanish province of Aragón. When Goya was a boy, his father was appointed to oversee the gilding of the altarpieces in the Basilica of El Pilar, the great cathedral in Saragossa, the capital of Aragón. The family moved to the busy commercial centre and Goya went to school at a religious foundation, the Escuelas Pias de San Antón. There he met *Martin Zapater* (p.6), who became a faithful friend with whom he corresponded for more than twenty-five years. Goya's letters reveal his humour and impulsiveness, and tell of his delight in hunting, his love of chocolate and his constant concern for his personal financial affairs. Sadly, they say little of his political ideas and it is possible that they were later censored by Zapater's nephew, who thought them too liberal.

Aged fourteen, Goya took lessons in drawing and painting from José Luzán y Martinez, a local religious painter, who introduced his pupils to the works of the Old Masters through engravings which he made them copy. Among Luzán's other pupils were three gifted brothers, Francisco, Manuel and Ramon Bayeu, who were to become his brothers-in-law. In 1763, aged seventeen, Goya submitted a drawing to the Royal Academy of San Fernando in Madrid in the hope of gaining a place, but his entry gained not a single vote from the academic judges. Three years later, he tried — and failed — again, and it was not until July 1780 that he was finally elected to the Academy.

Goya's movements between 1766 and 1770 are unknown. In later years, in letters to Zapater, he was to refer to his misspent youth, and it is possible that he may have been working in Madrid with Francisco Bayeu. It is known that in 1770 Goya went to Italy, probably travelling to Rome and Naples, and in April 1771 he received special mention for a painting he submitted to the Accademia di Belle Arti in Parma. By June of the same year, he had returned to Saragossa where he received his first important commission, the decoration of the ceiling of the coreto, or choir, of the Basilica of El Pilar, the city's great cathedral.

Goya's marriage and the move to Madrid

Goya's career started slowly and, not content to stay in provincial Saragossa, he was determined to make his name in the Spanish capital. In July 1773, he married *Josefa Bayeu* (p.12), the sister of his three fellow pupils. Francisco Bayeu was, by this time, employed in decorating the new Royal Palace in Madrid under Anton Mengs, a leading exponent of the neo-classical style, and Goya hoped, no doubt, to further his career by marrying the sister of a prominent painter. The marriage was to last for thirty-nine years until her death in 1812, and the couple had seven children, although only one son, Mariano, survived to adulthood (p.11). Curiously, however, there appears to be no record of a single word said by or of Josefa; she does not seem to have taken any interest in either her husband's work or his social life and he is thought to have represented her only once.

In the winter of 1774, Goya and Josefa settled in Madrid. With a bustling population of some 150,000 inhabitants, the capital city had been transformed during the eighteenth century by the Spanish Bourbon kings who widened streets, opened piazzas and constructed numerous religious and civic buildings.

Portrait of Mariano Goya,
ca. 1815, oil on panel, 59 x 47 cm,
Duke of Albuquerque Collection,
Madrid.

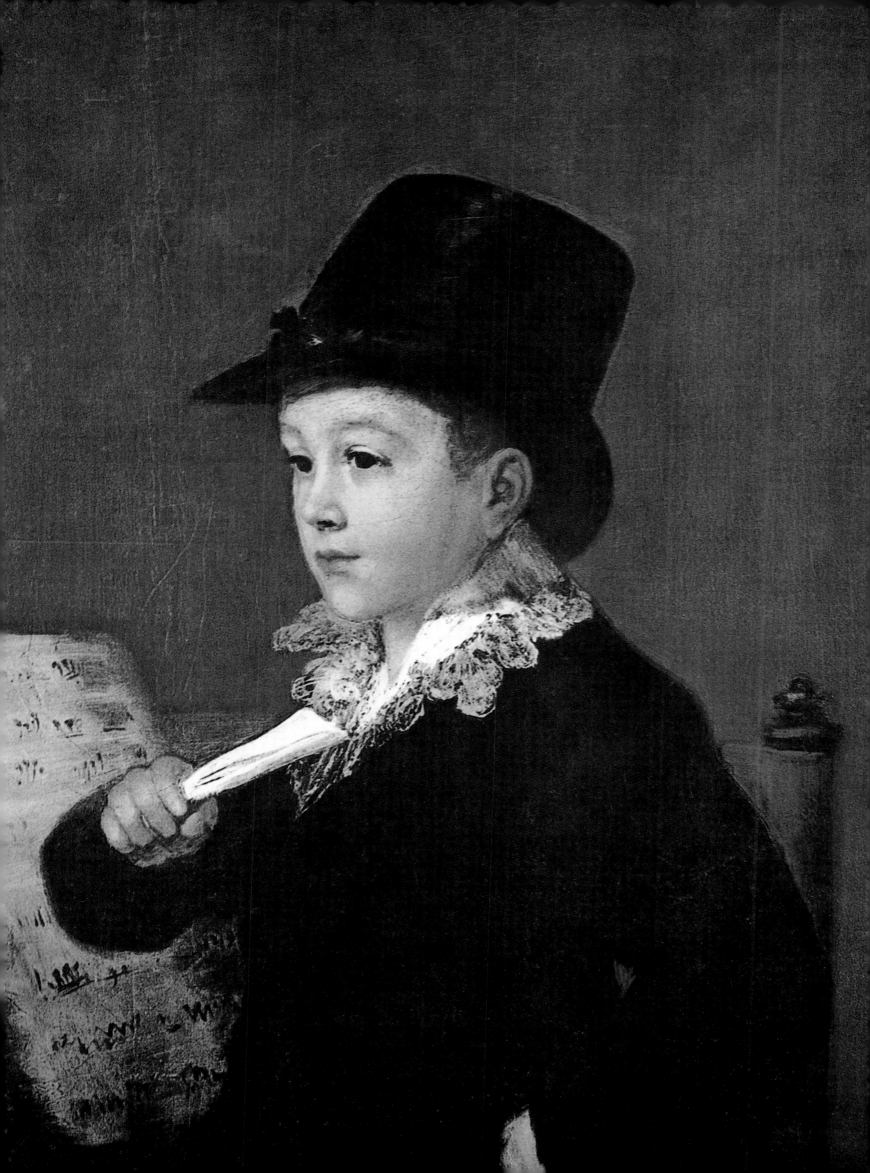

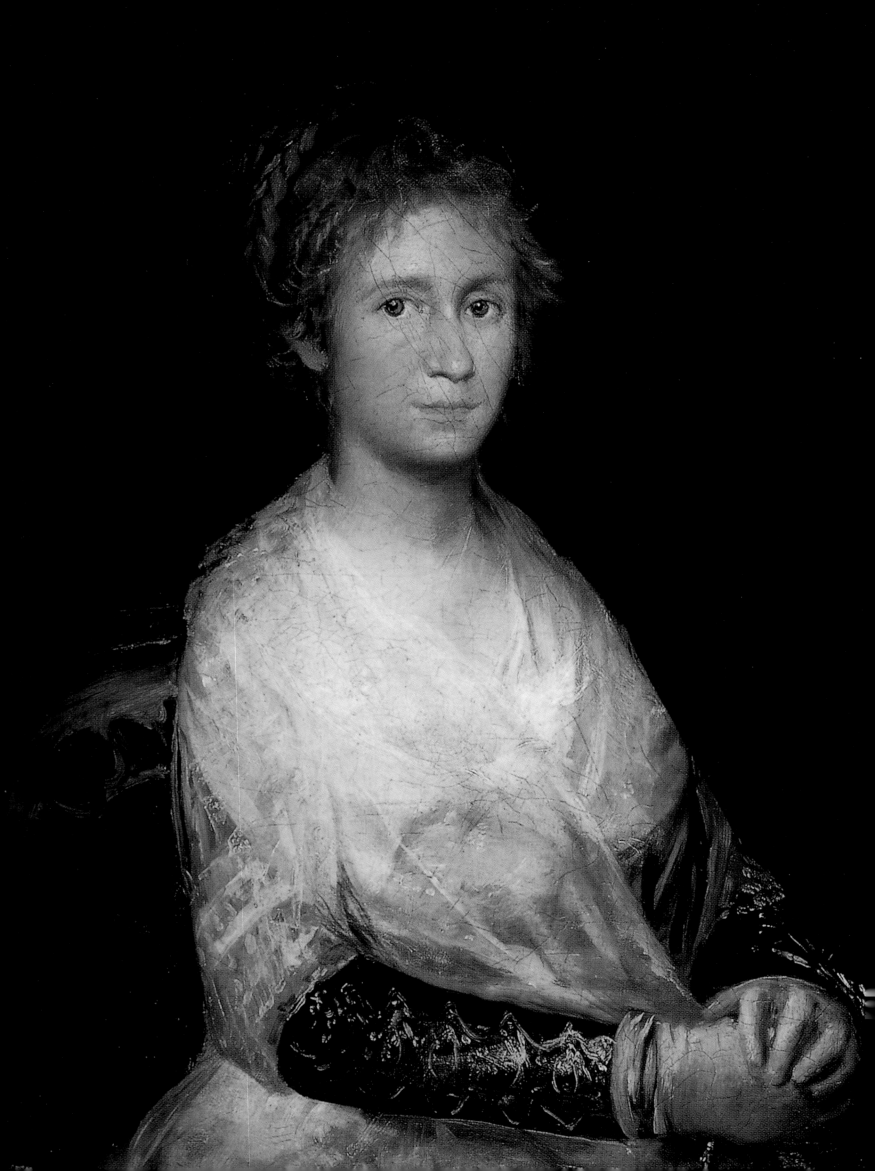

They also expanded the five Habsburg palaces and created three new royal residences, requiring a team of designers to decorate their interiors.

Unlike their predecessors who had imported tapestries from Flanders in 1721, the Bourbons founded the Royal Tapestry Factory at Santa Barbara in order to promote the industry in Spain. In 1775, Anton Mengs (1728-79), first court painter to Charles III, returned to Madrid and was given the responsibility of overseeing the execution of numerous tapestry cartoons. He employed Francisco Bayeu and other Spanish painters to cope with the demand. The Goya's move came in response to his first royal commission to design a series of cartoons for tapestries to hang in the personal dining room of the future King Charles IV, in the Escorial Palace. Goya was given the commission at the suggestion of Mengs who had earlier commissioned Francisco Bayeu to work on the new royal palaces. For several years, Goya was gainfully employed painting further series of cartoons for the Royal Tapestry Factory.

During the 1780s, Goya's career prospered. Finally elected to the Royal Academy of San Fernando in 1780, he became its Assistant Director of Painting in 1785. In June 1786, he was appointed official court painter with an annual salary of 15,000 reales (equivalent to about £150 at that time) and in 1789, was promoted Court Painter as a result of which he began to mix with a glittering array of royalty, aristocracy and statesmen, and became a celebrated portrait painter (p.15).

However, the son of humble parents and born far from the splendours of the court, Goya never became a courtier in spite of his official position; he painted not only members of the fashionable elite but also artisans, labourers and the victims of poverty. He sympathized with the Spanish Enlightenment whose members disagreed in principle with all that the court stood for. Disturbed by the social inequalities of the day, the Enlightenment felt that the monarchy, through blindness and neglect, had done little to bring Spain out of the Middle Ages, and its members sought to redress the uneven distribution of wealth through constitutional reform.

Goya became a proficient etcher and in this medium, recorded his personal observations. In these, and in the numerous drawings he made in private sketchbooks, he ridiculed the vulgarity and follies of humanity. His critical vision appears to have been intensified by the deafness with which he was inflicted after an infection in 1792, which left him suffering from dizzy spells and roaring noises in his head.

The French invasion of Spain

The early years of the nineteenth century were disastrous for Spain. On 21 October 1805, the Spanish fleet was destroyed by the British at Trafalgar and for ten years, Britain controlled the Atlantic cutting off Spain from its colonies. In 1806, Spain agreed to help Napoleon, then Emperor of France, in the conquest of Portugal. Thousands of French troops poured into Spain and it soon became evident that Napoleon had no intention of their ever leaving. In 1808, King Charles IV abdicated in favour of his dim-witted son, Ferdinand VII, and the old king fled to Bayonne, in France, with Queen Maria Luisa and Manuel Godoy, his Prime Minister. Napoleon invited Ferdinand to Bayonne and persuaded him to return the crown to his father, upon which Ferdinand was imprisoned. Charles then abdicated in favour of Napoleon and went to live in exile in Rome, leaving Napoleon free to place his brother, Joseph Bonaparte, on the Spanish throne in June 1808.

Portrait of Josefa Bayeu,
ca. 1798, oil on canvas,
82 x 58 cm, Prado Museum,
Madrid.

Napoleon had not expected resistance and was surprised when large numbers of Spanish patriots began to wage a merciless guerrilla war against the invader. For six years, Spain became a battlefield: six years of bloodshed, terror and suffering. In 1808, Goya was sixty-two. He was well respected and financially secure. He had created lively tapestry designs, incisive portraits and successful religious murals, but many of his most important works were yet to come, which they did in response to the terrible events that racked the peninsular.

The restoration of the monarchy

Napoleonic power began to decline in 1812. The British army, under the command of the then Viscount Wellington, advanced on Spain. It won victory after victory until finally entering Madrid in August 1812 and ousting Joseph Bonaparte and the French army. The liberal Cortes of Cadiz, the Spanish parliament, sought the restoration of the monarchy, but in constitutional form and answerable to the government. Ferdinand VII returned to Spain to popular acclaim but, in defiance of the Cortes, immediately instituted an autocratic regime and brought an end to the Enlightenment in Spain. He re-established the Inquisition, dissolved the Cortes and imprisoned many of its members as well as many of those who had supported the French government. Goya, who had accepted the post of painter to Joseph Bonaparte during the French occupation, was brought before the Inquisition and accused of collaboration. However, he was acquitted on the grounds of his claim that he had never worn his French medal and had painted Joseph from an engraving and not from life.

Ferdinand had no great interest in art, but was happy to have a celebrated artist in his employ; Goya continued to receive an annual salary of 50,000 reales and somehow managed successfully to avoid having to fulfil his duties as court painter. He became increasingly withdrawn and the imagery evident in his work became more and more imaginative. He had long been fascinated by insanity and superstition, and in his old age, on the walls of his own house, the Quinto del Sordo, he painted powerful, dark images, known collectively as the Black Paintings (see 'Visionary').

In 1812, Josefa Goya died. The following year, Goya's housekeeper, Leocadia Weiss, a recently divorced mother of two, gave birth to a daughter, Maria del Rosario Weiss, who is generally assumed to be Goya's child.

A liberal coup in Cadiz in 1820 forced Ferdinand to accept a constitutional monarchy and, for three years, the king was under the domination of a liberal government. In 1823, the French king, Louis XVIII, sent troops to Spain and restored Ferdinand to absolute power. The king immediately took punitive action and once again brought a reign of terror which saw liberals imprisoned or shot.

Goya flees to France

Thoroughly disillusioned with Spain, Goya pleaded ill health and requested a leave to take a cure at Plombières in France. Permission was granted and he made for Paris where he saw the famous Salon. He then settled in Bordeaux where some members of the Spanish Enlightenment were living in exile. In 1824, he was joined by Leocadia Weiss and her children. The King granted the artist several extensions of his French vacation and in May 1826, Goya, aged eighty, returned to Madrid in order to request that the king allow him to retire while continuing to pay his pension. Ferdinand agreed and Goya returned to Bordeaux where he died two years later, on 16 April 1828.

Self-Portrait with Easel,
1790-1795, oil on canvas,
42 x 28 cm, Museo de la Real
Academia de Bellas Artes, Madrid.

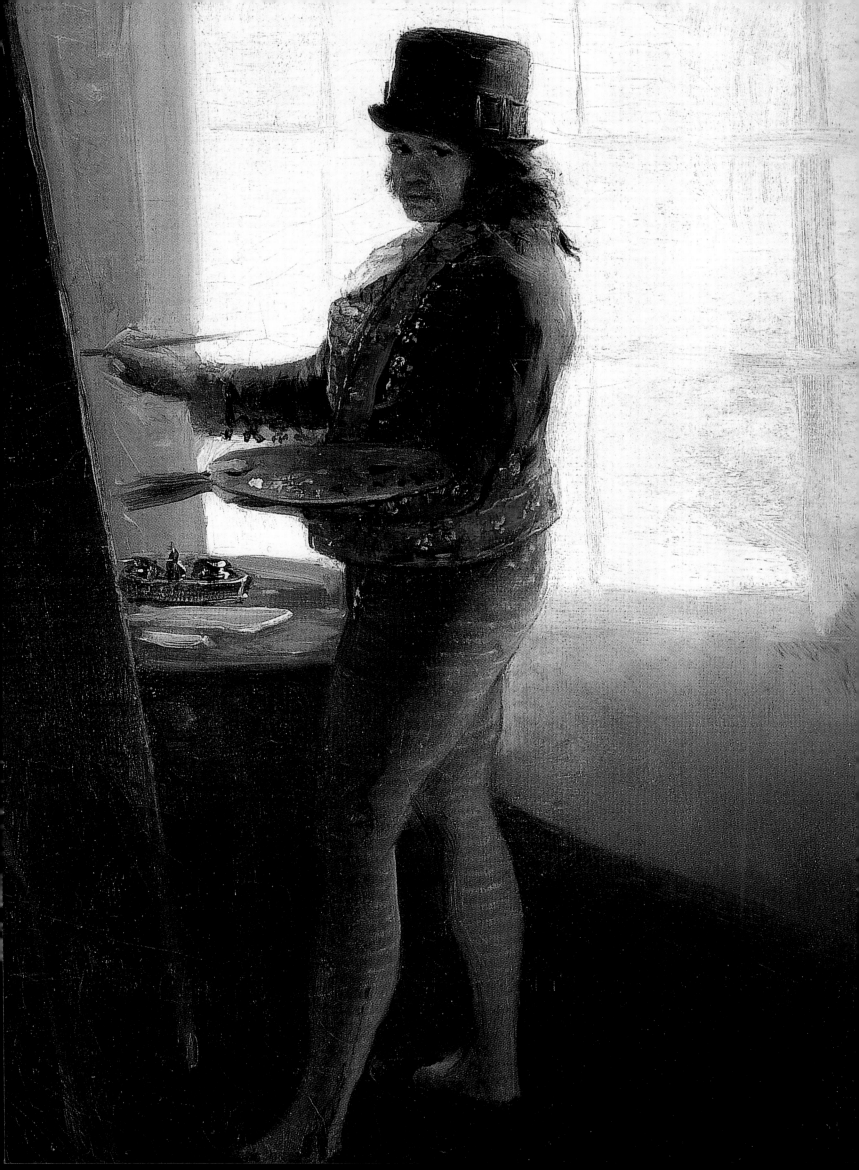

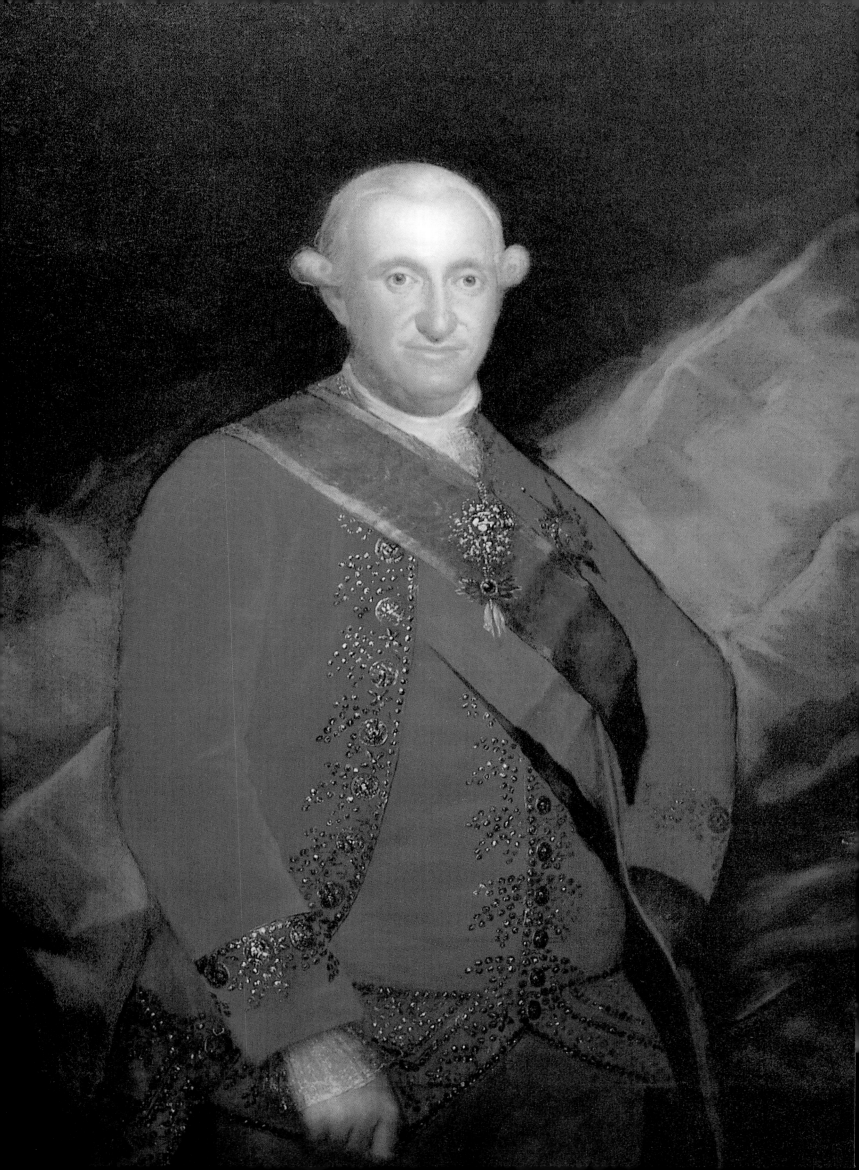

<div style="text-align: right">

II

Portraits

</div>

Goya's skill as a portrait painter lay in his ability to capture something of the personality of the sitter, more than simply to record an accurate likeness. He became celebrated as a portraitist relatively early in his career, and royal patronage ensured a steady stream of commissions. More than 200 of his portraits are extant, an extensive output even in the great age of portraiture, and they offer a panorama of Spanish society at the time. Goya recorded for posterity three successive kings and their families, their courtiers and many Spanish aristocrats. He also painted political potentates — among them statesmen, liberal thinkers and army officers who helped to mould Spanish history — and he painted his friends and associates.

The influence of Velázquez

Goya greatly admired the paintings of Diego Velázquez (1599-1660), the eminent Spanish portraitist of the seventeenth century. In 1774, he was asked to design tapestry cartoons for the future King Charles IV, giving him the opportunity of studying Velázquez's masterpieces in the royal collections. Four years later, Goya printed eleven engravings after Velázquez, the first copies of Velázquez's works to be made. These include *Prince Balthasar Carlos* (p.19) and *Las Meniñas*. In *Las Meniñas* (or "The Maids of Honour"), painted by Velázquez in 1656 (p.20), the little figure of the Infanta Dona Margarita is placed in the centre of the composition. However, Velázquez has ingeniously reversed the emphasis of the painting, making the viewer focus on the painting rather than on the Infanta. On the left, the artist steps back from a large canvas in order to study his sitters, the king and queen, who are reflected in the mirror on the wall at the back of the room and in whose place we now stand. The Infanta, with her ladies-in-waiting and a court dwarf, has come to distract her parents. In an unusually informal scene, Velázquez has shown himself at work painting his royal patrons and their daughter. Including himself as artist in the picture was a device that Goya was to adopt and to use often.

Royal and aristocratic patronage

More than a century after Velázquez's death, Goya stepped into the master's shoes as the leading portrait painter to the court of Spain. When he was first appointed official court painter in 1786, Charles III was on the throne. Charles, a hard-working and enlightened monarch, devoted himself to reforming a country that had scarcely moved out of the Middle Ages. His lifestyle was extremely austere, and his only diversion was hunting, at which he spent several hours each day.

Charles IV, 1789,
oil on canvas, 137 x 110 cm,
Tabacalera, Madrid.

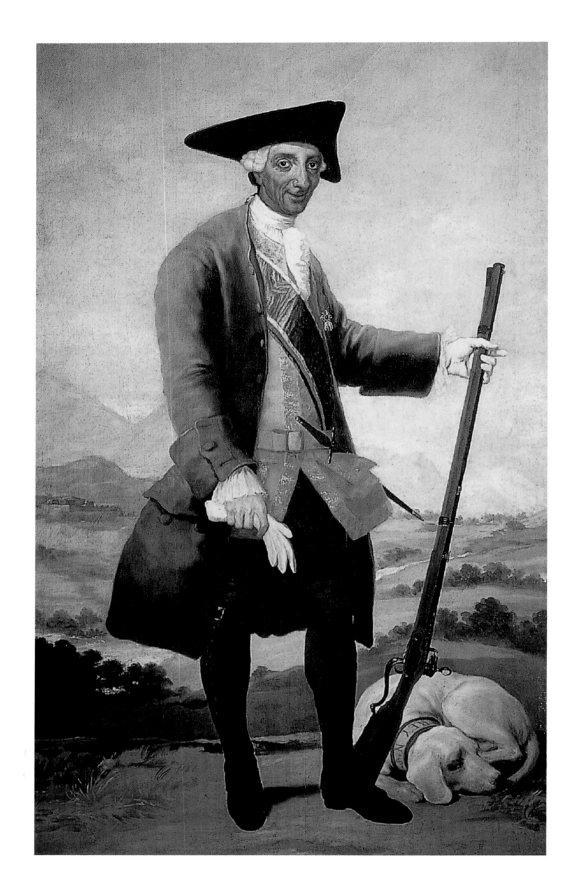

*Portrait of Charles III in Hunting
Costume*, 1787,
oil on canvas, 207 x 126 cm,
Prado Museum, Madrid.

Prince Balthasar Carlos, 1778,
etching after Velázquez,
32 x 23 cm,
Prado Museum, Madrid.

19

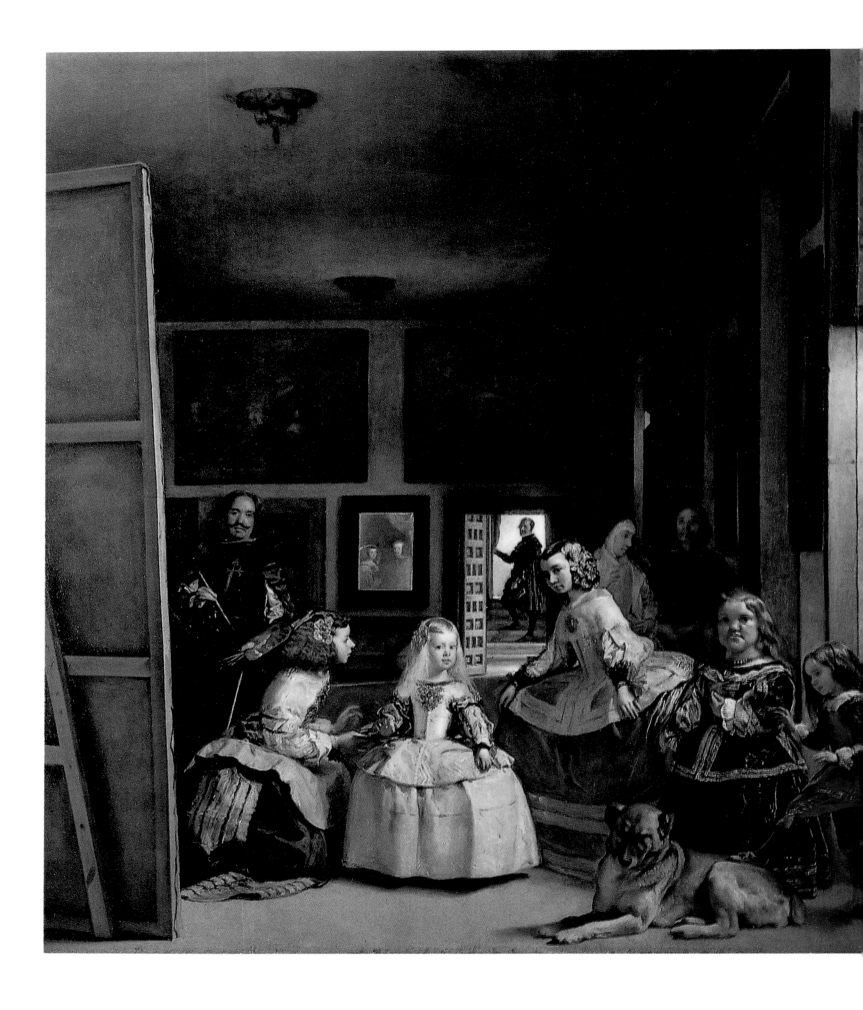

Diego Velázquez, *Las Meniñas*,
1656, oil on canvas,
318 x 276 cm, Prado Museum,
Madrid.

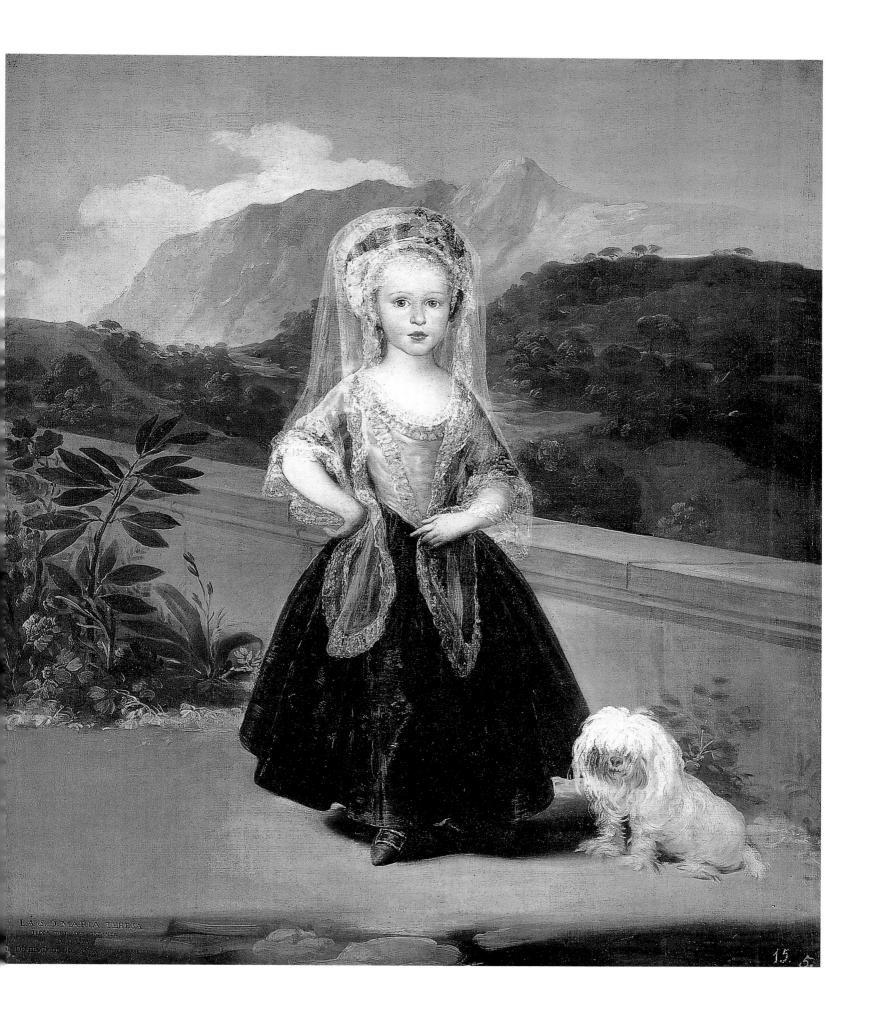

Maria Teresa de Borbón y
Vallabriga, 1783, oil on canvas,
132.3 x 116.7 cm, Mrs Mellon
Bruce Collection, Washington.

Charles had no defined taste in the arts; in 1761, Anton Mengs had painted him in a formal neo-classical style in armour and regalia of kingship. Goya's less flattering *Portrait of Charles III in Hunting Costume* of 1787 (p.18) is of the man, renowned for his ugliness, who was described by a British diplomat as having "a very odd appearance in person and dress. He is of diminutive stature, with a complexion the colour of mahogany. He has not been measured for a coat these thirty years, so that it sits on him like a sack."

Charles III respected tradition but at the same time encouraged the cult of liberty, welcoming the ideas of the French Enlightenment as they filtered into Spain. He shrewdly chose capable ministers with clear visions of Spain's needs and a desire to implement economic and social reform. In 1777, Charles III appointed the Count of Floridablanca, a former magistrate, to the position of Prime Minister. Floridablanca was involved in scores of projects to transform many aspects of Spanish life; in particular, he was concerned with the development of industry and with solving problems relating to agriculture and irrigation.

The *Portrait of the Count of Floridablanca* of 1783 (p.23) was Goya's first important portrait commission and one from which he hoped to secure an introduction to Madrid's official circles. In a traditionally commanding pose, the Count is placed in the centre of the composition and is surrounded by references to his office. An oval portrait of the king presides over the scene and a clock, placed conspicuously on the table to the right of the subject, reflects the regulation and order with which he serves his monarch. The maps on the table and a plan on the floor refer to an important undertaking of his ministry, the building of a canal in Aragón. On the left, is Goya himself, a somewhat bold inclusion even though he is in a position subservient to his patron. As if preoccupied with matters of state, the Count ignores the artist and the canvas held out to him; however, by including himself, Goya alludes to the minister's support of the arts.

It seems that Goya's introduction to Floridablanca did not provide him with the opportunities he had hoped for. However, he was lucky enough to be introduced to the small domestic court of the Infante Don Luis de Borbón, the youngest brother of Charles III, through one of his relations. In the Infante, Goya found his first sympathetic patron. Don Luis had been destined for the church — he was made a cardinal aged six and by ten, he was Archbishop of Seville — but his temperament was unsuitable to his calling. In 1754, he renounced his cardinal's hat, and to the displeasure of the king, embarked on an impious life.

In 1776, aged forty-nine, Don Luis married the beautiful seventeen-year-old Maria Teresa Vallabriga. The king disapproved of the match because she was not of royal blood and Don Luis was forced to remove himself from the court. In the summer of 1783, Goya stayed at their residence at Arenas de San Pedro where he painted several portraits of Don Luis and his family.

The *Family of the Infante Don Luis* (pp.26-7) is a domestic scene of the Infante's immediate circle and is unusually intimate. Placed in the centre of the painting is Doña Teresa de Vallabriga; she is having her hair arranged and to the left, two ladies-in-waiting carry a tray of ornaments for its decoration. Doña Teresa's white gown is strongly illuminated by the single candle placed on the table and her prominence suggests that Goya wished to pay homage to a woman shunned by the court. Don Luis, dressed in his house coat, sits at a table playing cards. Behind him, wearing blue, is his eldest son and his daughter, Maria Teresa, whom Goya was to paint several years later as the Countess of Chinchón (p.24). She leans eagerly forward towards Goya who sits in the shadows studying the group before working on his canvas. On the right of the composition, a nursemaid holds the Don's little daughter, Maria Josefa. The unidentified men are perhaps the Don's secretary and assistants.

Portrait of the Count of Floridablanca and Goya, 1784, oil on canvas, 262 x 166 cm, Banco de España, Madrid.

The Countess of Chinchón, 1800, oil on canvas, 216 x 144 cm, Duke of Seneca Collection, Madrid.

Queen Maria Luisa, 1789, oil on canvas, 137 x 110 cm, Tabacalera, Madrid.

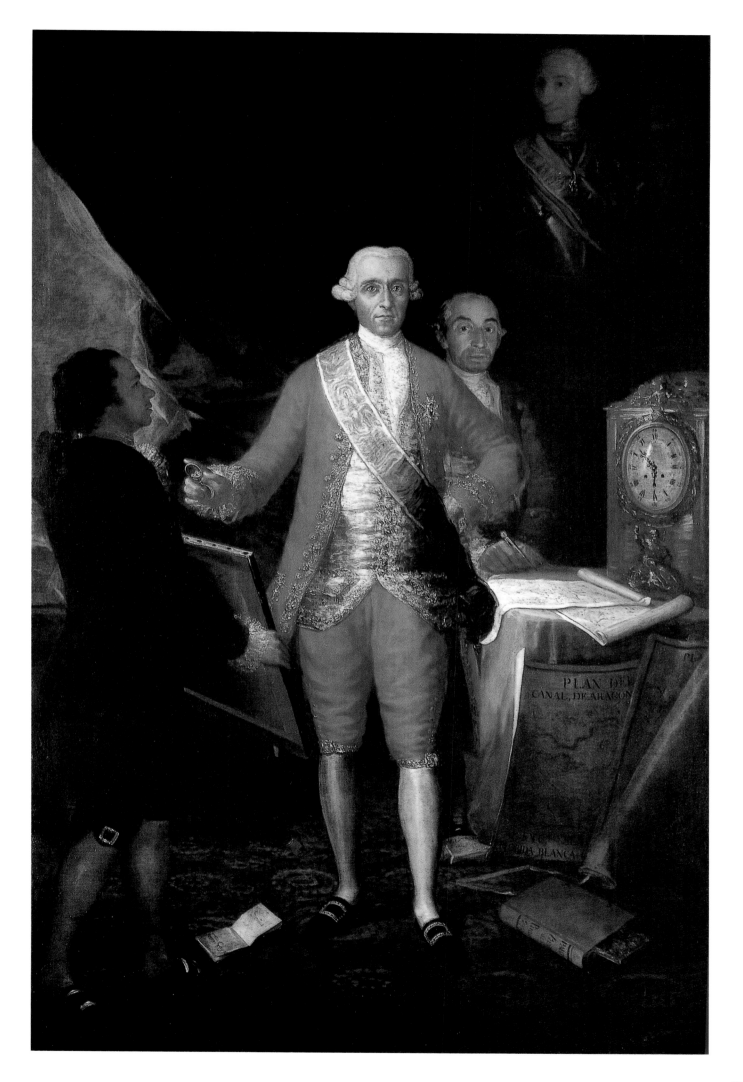

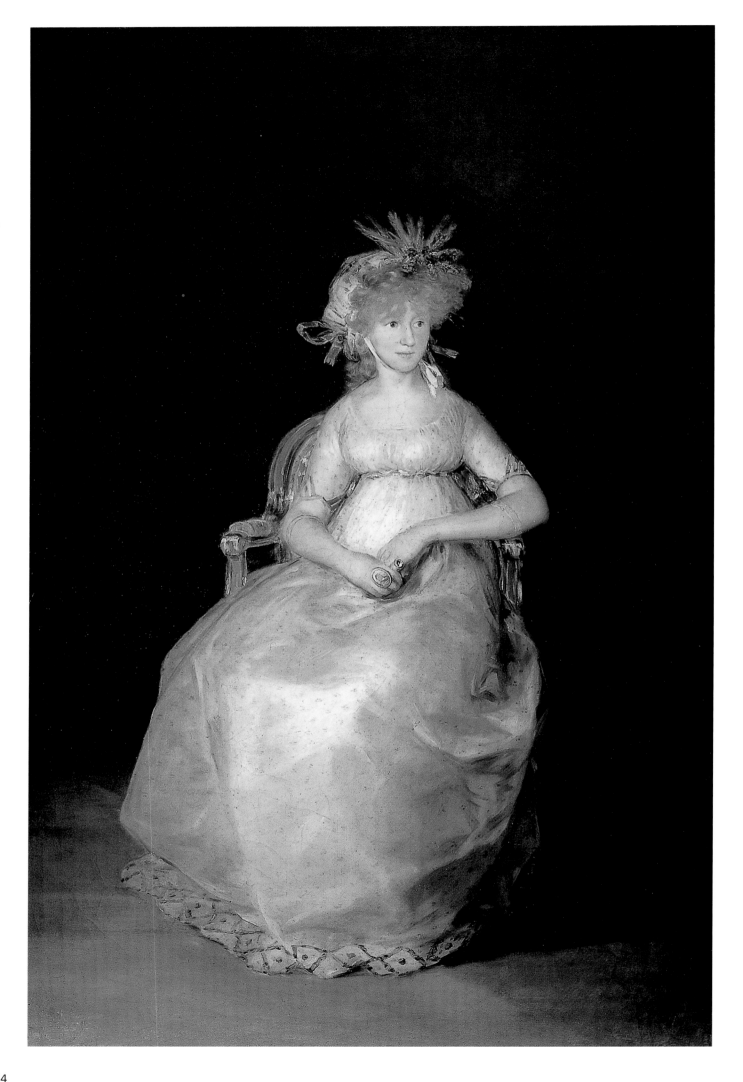

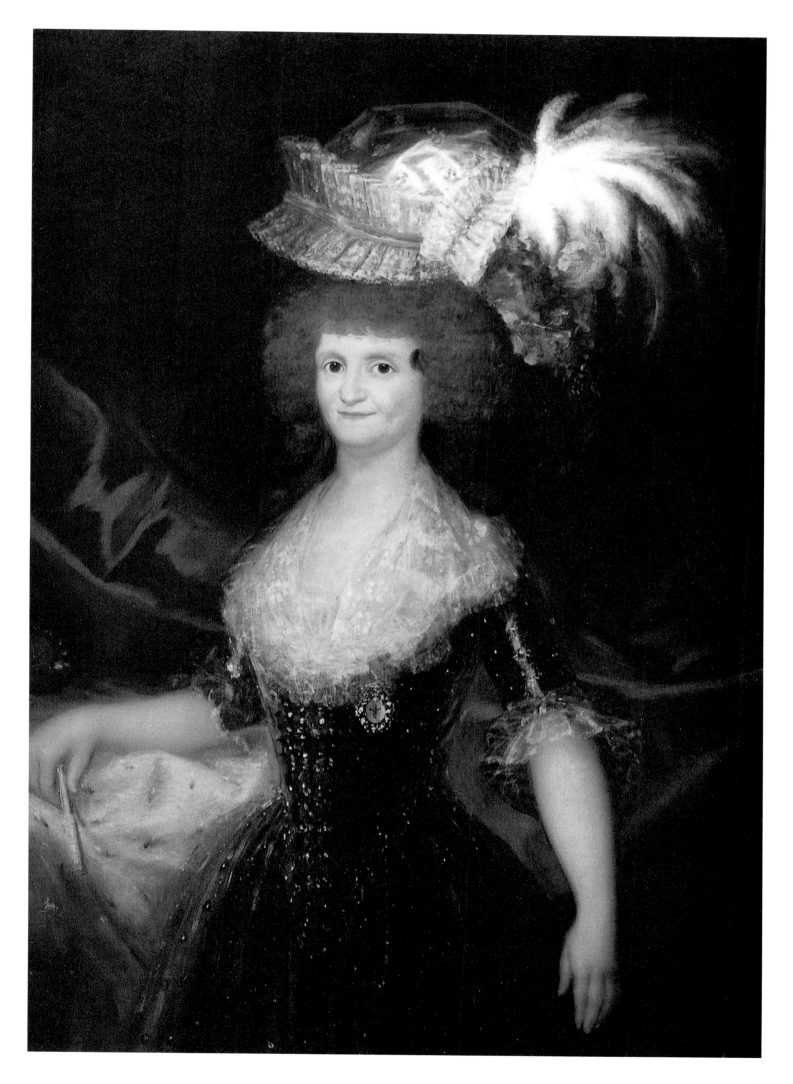

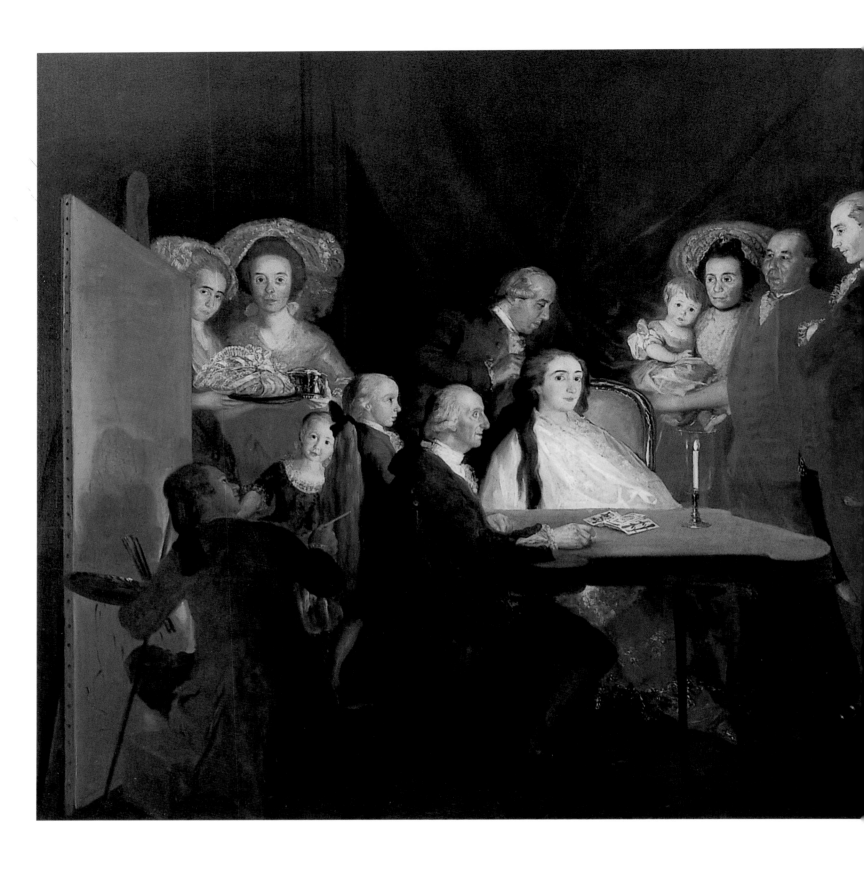

The Family of the Infante Don Luis,
1784, oil on canvas, 248 x 330 cm,
Corte di Mamiano, Foundation
Magnani Rocca, Parma.

The portrait, Goya's first major group portrait, is remarkably complex. The composition relies on European models, in particular Hogarth and the English school, which Goya would have known through prints. The painting also recalls Velázquez's *Las Meniñas* (p.20). Goya not only includes himself at work within the painting but also gives the impression of an activity momentarily interrupted during an informal, rather than ceremonial, occasion. This relaxed domestic scene, real or invented, suggests Goya's sense of ease within the Infante's household.

In June 1786, along with his brother-in-law Francisco Bayeu, Goya was appointed official court painter with a fixed annual salary of 15,000 reales. In keeping with his new status, Goya introduced the gentlemanly 'de' into his name and bought for 7,000 reales a birlocho, a little English two-wheeled carriage, which was "all gilded and varnished, which people stopped to look at." Despite the death of Charles III in December 1788, Goya's career continued to flourish. A few months after Charles IV's ascension to the throne, Goya was promoted Court Painter. In 1799, he was awarded the highest artistic post of First Court Painter with an annual salary of 50,000 reales and 500 ducats for carriage maintenance. He boasted to his friend Zapater, "The royals are mad about me."

Charles IV was apathetic about affairs of state and showed little inclination to govern. He later told Napoleon, "Every day without fail, in winter and in summer, I went hunting until noon, I ate, and immediately returned to the hunting ground until evening. Manuel [Godoy, his Prime Minister] informed me about affairs, and I went to bed only to begin anew the same routine on the following day, unless some important ceremony disrupted it." Charles IV was married to Maria Luisa of Parma, a woman of immense vanity and a compulsive desire for luxury (p.25).

As principal painter to Charles IV, Goya's main task was to provide numerous portraits of the king and his family. Goya's large painting of *The Family of Charles IV* of 1800 (pp. 28-9), places life-sized members of the royal family in an ostentatious display of costume and jewellery. Queen Maria Luisa is centre stage with her two youngest children. She wears a sleeveless dress to show off her arms, of which she was so proud that she forbade the use of gloves in court. Although the costumes sparkle, the king's and queen's expressions are so dull that they provoked the French novelist, Théophile Gautier, to compare them to "the corner baker and his wife after they have won the lottery."

On the left of the painting, in blue, stands the heir to the throne, the future despot Ferdinand VII. Beside him are his brother, the Infante Don Carlos Maria Isidro, and a woman who turns towards the queen and may be Ferdinand's future wife. It is thought that her features were not included because, at the time of the painting, the engagement was not official. Peeking between the couple is Doña Maria Josefa, the king's sister, who died shortly after the completion of the painting. To the right of the king are other close relatives: his brother, the Infante Antonio Pascal; his eldest daughter, the Infanta Doña Carlota Joaquina; and, holding a child, another daughter, the Infanta Doña Maria Luisa Josefina and her husband, Don Luis de Borbón. Once again, Goya includes himself in the painting, in the shadows on the left, at work on a canvas. Without expression, he stares out of the painting as if looking at the group in a mirror. The royal family is depicted without any attempt at flattering their features and with their decadence and pretensions clearly exposed, and it is somewhat surprising that they did not object.

Queen Mara Luisa was an unpopular consort and her indiscreet private life threw even the paternity of her children into question. A favourite was Manuel Godoy, who first came to her notice in 1784 as a young cavalry officer. A controversial figure, Godoy's success with the queen ensured a meteoric rise to power.

The Family of Charles IV,
1800-1801,
oil on canvas, 280 x 336 cm,
Prado Museum, Madrid.

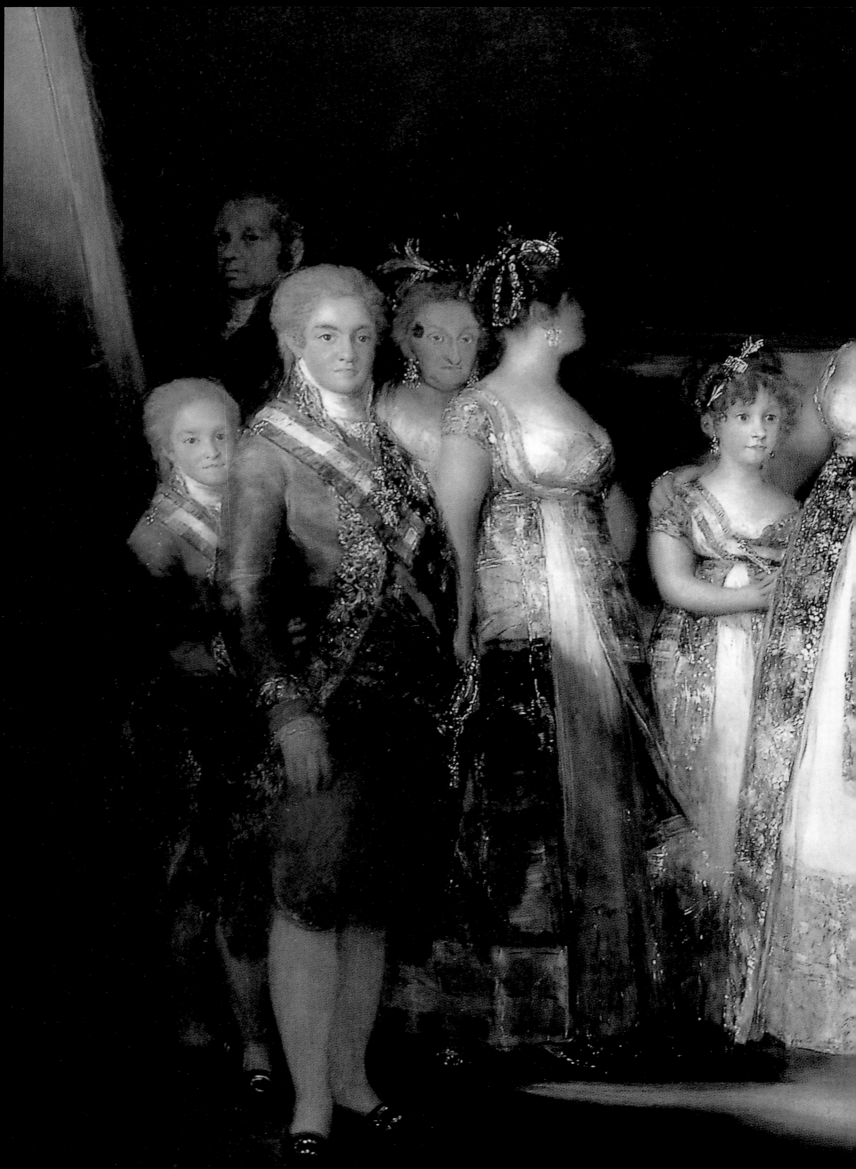

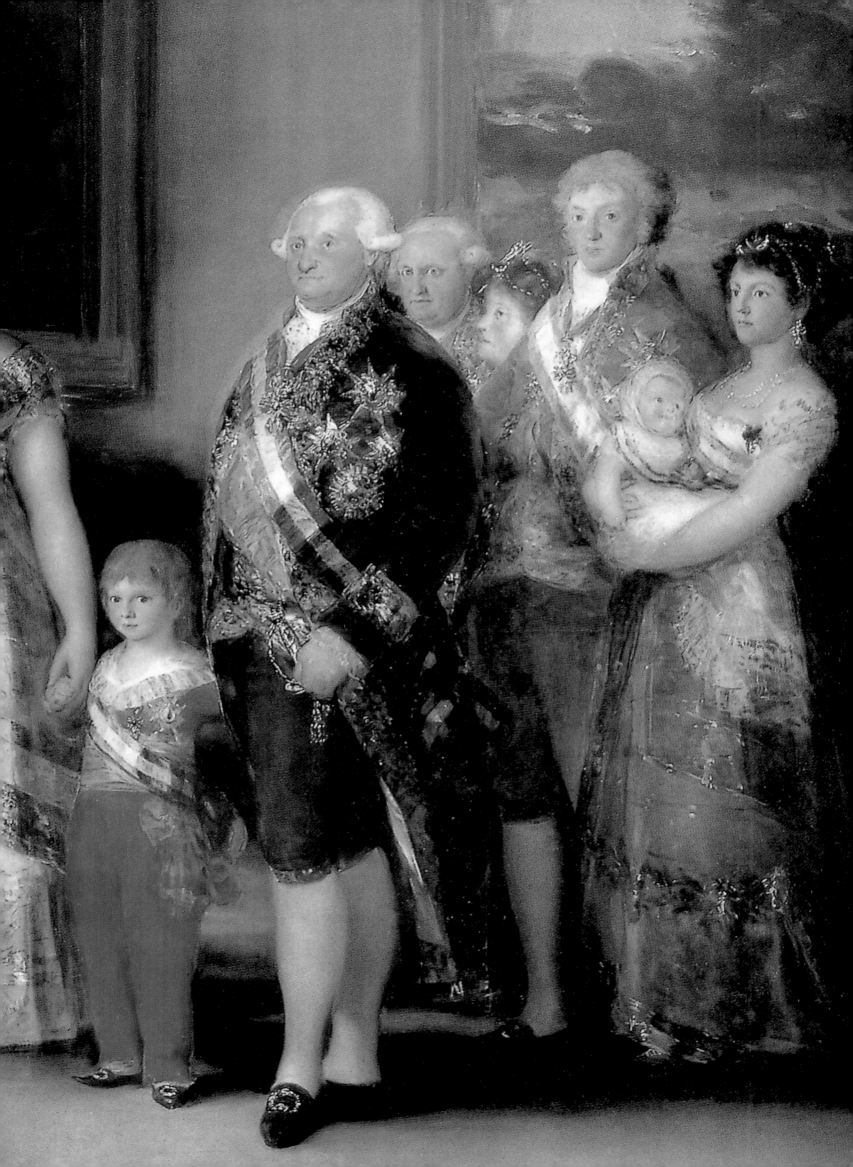

In 1792, aged twenty-five, he was nominated first secretary of state, the first of a host of official positions and titles he was to hold, including Prime Minister and captain-general of the army.

Goya's portrait of Don Manuel Godoy of 1801 (pp.36-7) shows the subject at the height of his power. It was probably commissioned to commemorate a victory in the wars with Portugal, known as the "War of the Oranges", because the Portuguese flag rests prominently on the left of the painting. Goya depicts Godoy's easy self confidence; as a battle is fought in the background, the victorious general reclines on a commander's chair in a nonchalant attitude while an aide waits for his response to the information conveyed on the piece of paper he holds in his right hand. The most influential man in Spain had a personable air. Godoy was not only able to take command but also able to relax among his men.

The year before, Goya had painted Godoy's wife, *The Countess of Chinchón* (p.24). The daughter of Don Luis, she had appeared sixteen years earlier as the inquisitive child in Goya's *Family of the Infante Don Luis* (pp.26-7) and in the portrait entitled *Maria Teresa de Borbón* (p.21) he had also painted her as a little girl, standing like a grown-up on a balcony with her tiny dog. Brought up in a convent from the age of five, Maria Teresa was at the age of eighteen forced to marry Manuel Godoy in an attempt to quash his passion for one Pepita Tudó, an unsuitable liaison which complicated his relations with the queen. Painted five months before their first child was born, the Countess sits demurely in an empty room, her silvery white dress accentuating her naïvety. Her blond hair is decorated with wheat, a symbol of fertility and a reference to her impending motherhood for which she looks barely prepared. The Countess seems unsure of herself, and was likely unable to compete with her husband's mistress, the probable model of Goya's *Nude Maja* (pp.92-3). Maria Teresa finally abandoned her libidinous husband but a telling account of the strain caused by her husband's infidelity was given by Jovellanos, a guest at one of their dinner parties, who sat with Godoy's wife on his right and Godoy's lover on his left. "It was more than my heart could bear. I could neither speak nor eat nor think straight; I fled the scene."

Godoy was an indefatigable worker and ardent reformer, and he selected several liberal men to run his government. Jovellanos was Godoy's friend and one of the greatest intellectuals of the Spanish Enlightenment. When Goya painted *Gaspar Melchor de Jovellanos* (p.34) in 1798, the subject had just been appointed minister of religion and justice. He probably met Goya when the artist arrived in Madrid in 1778, at one of the parties where the city's cultural *élite* used to gather. Jovellanos is shown at work, sitting elegantly in a sumptuously furnished room, leaning on an elaborate table while contemplating some matter. On the table are his pens and papers and a statue of Minerva, the goddess of wisdom, stretching a hand towards him. He has the melancholic air of one who realizes the burden of his responsibilities; he held the post for just nine months.

During the War of Independence (1808-14), Spain was split between those loyal to the monarch and the *afrancesados*, those who supported the French in the belief that they would bring about a more enlightened regime. Goya did not align himself definitively with either side but, concerned with his profession and his purse rather than politics, he accepted the official post of painter to the French king. As such he was entrusted with the selection of fifty Spanish works of art to send to France. He was also employed in painting portraits of French officers, for example that of *General Nicolas Guye* (p.31), who had been appointed Commander of the Order of the Two Sicilies and to the Royal Order of Spain as well as being made a member of the Légion d'Honneur. Goya pays great attention to Guye's uniform and medals, which are in sharper focus than his facial features and hands, as if to avoid any description of Guye's character.

General Nicolas Guye, 1810, oil on canvas, 106 x 84.7 cm, Mrs Marshall Field Collection, New York.

Ferdinand VII, 1814, oil on canvas, 225.5 x 124.5 cm, Museum of Fine Arts, Santander.

The Marquesa de la Solana, 1794-1795, oil on canvas, 183 x 124 cm, The Louvre Museum, Paris.

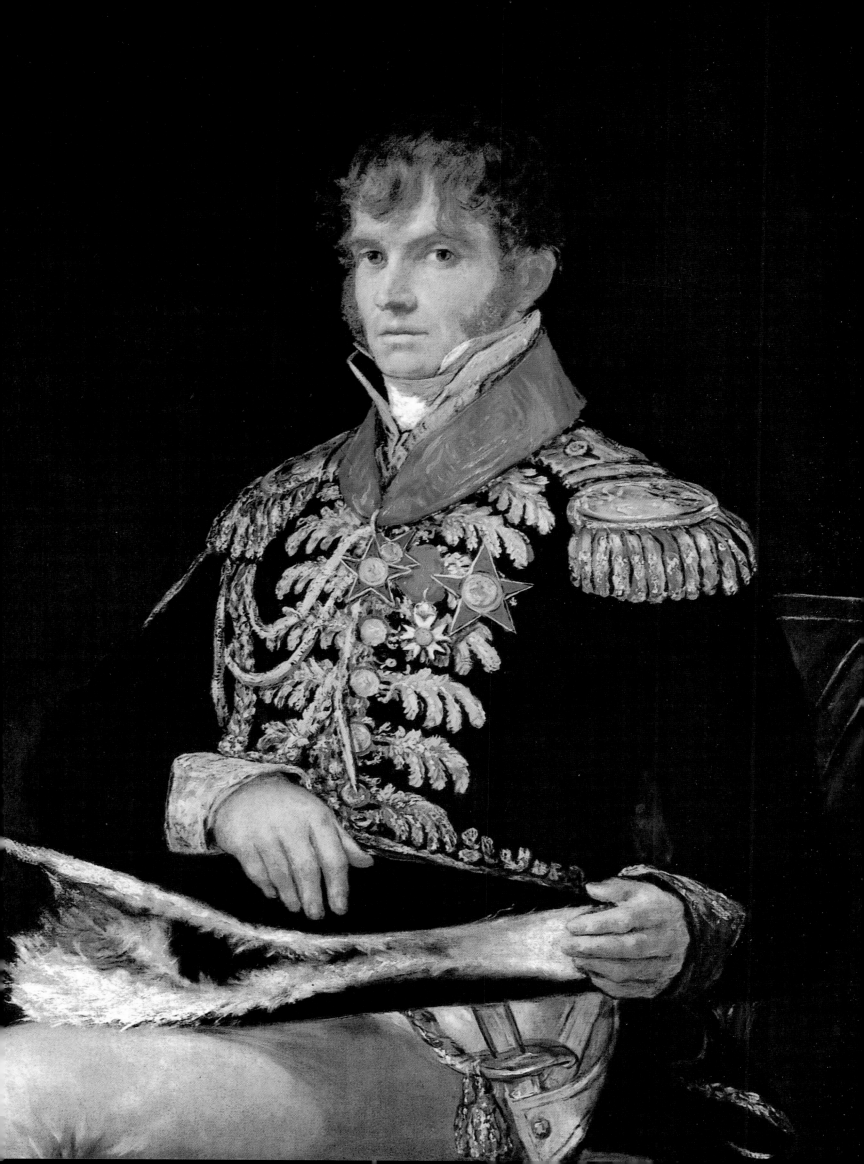

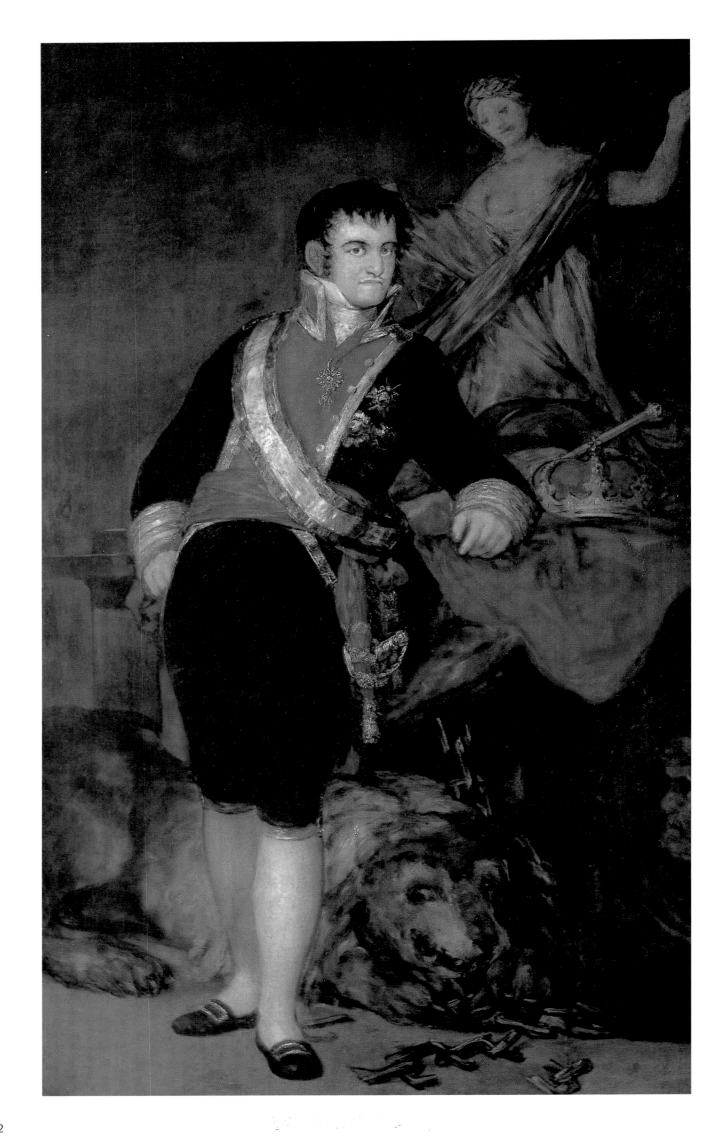

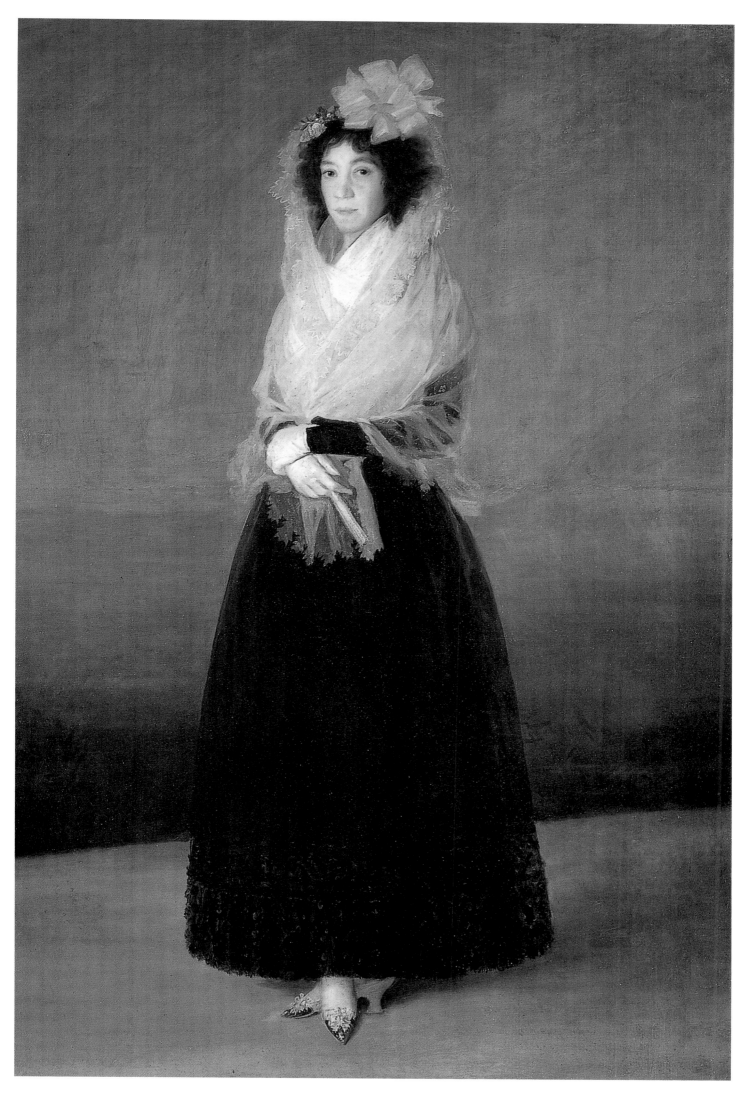

33

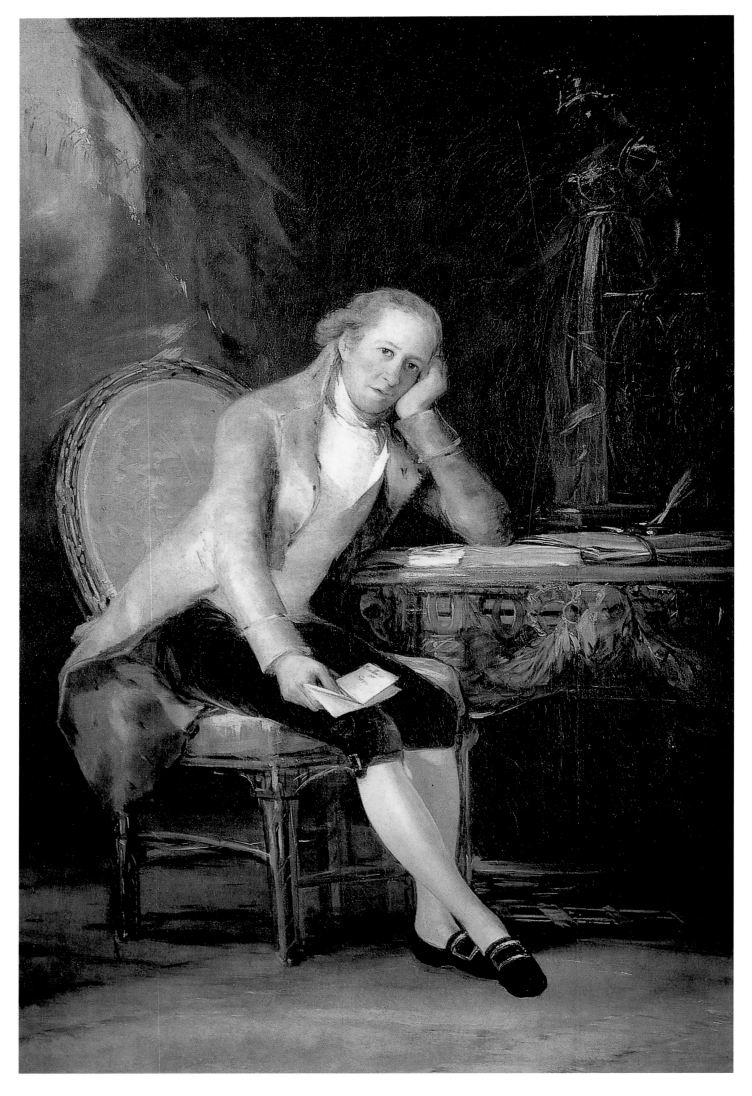

The only time that Ferdinand VII actually sat for Goya was immediately after his succession in 1808, just before the Napoleonic invasion. However, following the king's return to Madrid after the abdication of Napoleon in 1814, Goya painted several portraits of him based on the earlier one. *Ferdinand VII* (p.32) was commissioned by the city council of Santander for their town hall. The council asked for a close likeness and stipulated that "the portrait should be full face and full length, with the king dressed as colonel of the guards, wearing the royal initials. His hand should be resting on a statue of Spain crowned with laurel and on this pedestal will be the sceptre, the crown, and the mantle; at his feet will lie a lion with broken chains between his paws." Goya agreed to execute the painting in fifteen days and it was carried out according to the contract, except for the position of the king's hand. A very life-like statue, representing Spain, looks down upon the king with an expression of remorse, indicating Goya's dislike of Ferdinand.

As court painter, Goya was obliged to produce portraits of the royal household, but he also had time to paint members of the aristocracy, and his own acquaintances and friends. In 1785, he painted *The Countess-Duchess of Benavente* (p.39), wife of the ninth Duke of Osuna and one of the most distinguished woman in Madrid, admired for her elegance and sophisticated taste. As foremost members of the Spanish Enlightenment, the Osunas were involved in the improvement of education and industry, and in charitable works. The Countess-Duchess was extremely well-read in both French and Spanish and had a fine singing voice; she kept an orchestra on the payroll of her country house, La Alameda. She used her position and wealth to patronize artists, scientists and writers, and was Goya's faithful patron for thirty years. Goya's portrait conveys her lively and intelligent personality; an aura of light surrounds her figure, which is set against a plain background so that attention is drawn to the elaborate details of her fashionable dress.

The portrait of *Mariana, Marquesa of Pontejos* (p.38) was probably painted in 1786 when, aged twenty-four, she married Francisco Antonio Monino y Redondo, Spanish ambassador to Portugal and brother of the Count of Floridablanca. The portrait displays Goya's knowledge of French and English painting; the Marquesa is placed in an idealized landscape that frames her beauty, her hat set on the back of her head like a halo. The bows of her dress, her lace and rose-trimmed collar and the wilting flower that she holds are all suggestive of her feminine nature. A slightly comic pug dog stands at her feet.

Compared to the delicate handling of the portrait of the *Marquesa de Pontejos*, Goya's image of the *Marquesa of Solana* (p.33) of 1794-95, is more sober. A woman of great intelligence, the Marquesa was devoted to literature, especially poetry, and performed many charitable works. Against a plain dark background, this generous spirit stands above a low horizon, her black embroidered dress contrasting with her white gauze shawl, gloves and the bows of her shoes. The pink bow in her hair gives a youthful air to a woman who was already frail; she died the year after her portrait was completed.

The portrait of *Doña Isabel de Porcel* (p.40), of 1805, depicts the wife of one of Goya's greatest friends. Her husband was Antonio Porcel, a government official, protégé of Godoy and associate of Jovellanos. According to her grandchildren, it was painted along with one of her husband during a visit Goya paid to their home in Granada, in gratitude for the Porcels' hospitality. As was fashionable among Spain's social *élite*, Doña Isabel wears the costume of a maja, a woman of the artisan classes of Spain. Goya has caught the air of a woman who enjoys dressing up. The black mantilla hangs from her head over her shoulders, showing the blond highlights in her hair. In common with the portrait of *Francisca Sabasa y García* (p.41), painted around 1805, Goya creates a contrast of black and gold colouring. Francisca's sensuous, full-lipped smile and hair falling loosely from the mantilla clearly show how the artist warmed to this attractive woman.

Gaspar Melchor de Jovellanos, 1798, oil on canvas, 205 x 133 cm, Prado Museum, Madrid.

Don Manuel Godoy as Commander in the "War of Oranges", ca. 1801, oil on canvas, 180 x 267 cm, Royal Academy of San Fernando, Madrid.

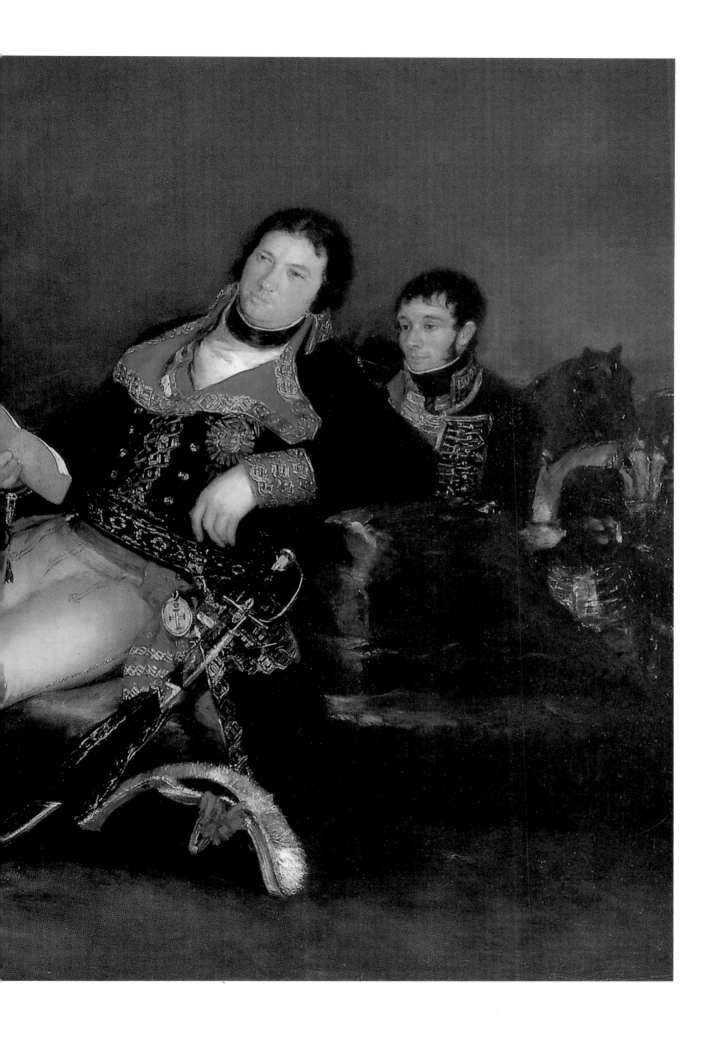

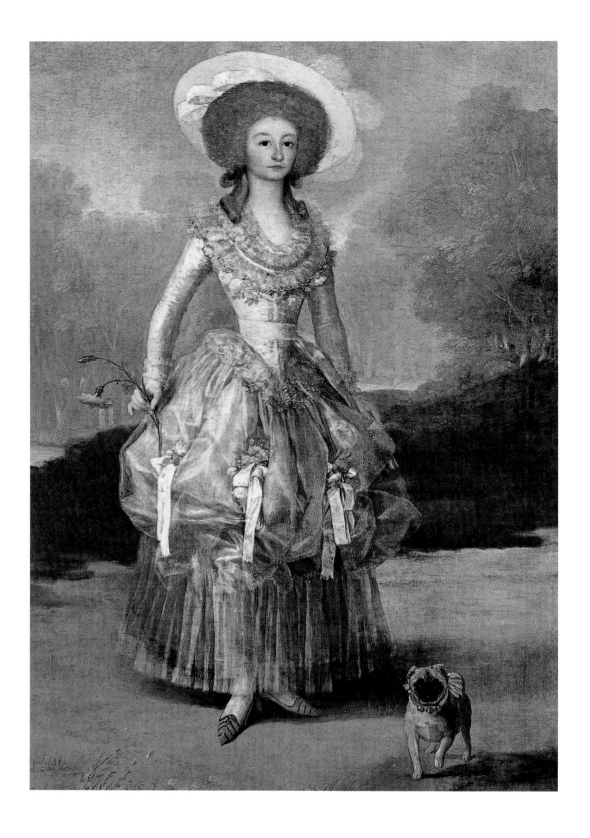

The Marquesa de Pontejos, 1786,
oil on canvas, 211 x 126 cm,
National Gallery, Washington.

Countess-Duchess of Benavente,
1785, oil on canvas, 104 x 80 cm,
Bartolomé March Severa, Madrid.

Doña Isabel de Porcel,
1804-1805, oil on canvas,
82 x 54 cm, National Gallery,
London.

Francisca Sabasa y García,
1804-08, oil on canvas,
71 x 58 cm, National Gallery,
Washington.

Goya painted the *Duchess of Alba* (p.43) while staying at the Alba estate in Andalusia, where he was a guest on several occasions. The Duchess of Alba was the grandest lady in Spain after the queen, and a legendary beauty. A French traveller wrote, "The Duchess of Alba has not a hair on her head that does not provoke desire. When she passes, everyone looks from their windows and even children leave their games to look at her." She was highly spirited and whimsical; she once feigned poverty and forced a young seminarian to take her to a café where she ate more than he could afford and then made the youth settle the account with his trousers. She married the thirteenth Marquis of Villafranca when she was thirteen but their marriage was not a success and she embarked on a series of short-lived love affairs. There is no doubt that the friendship between Goya and the Duchess was very close and reached a height in 1797, when this portrait was painted, a year after the death of her

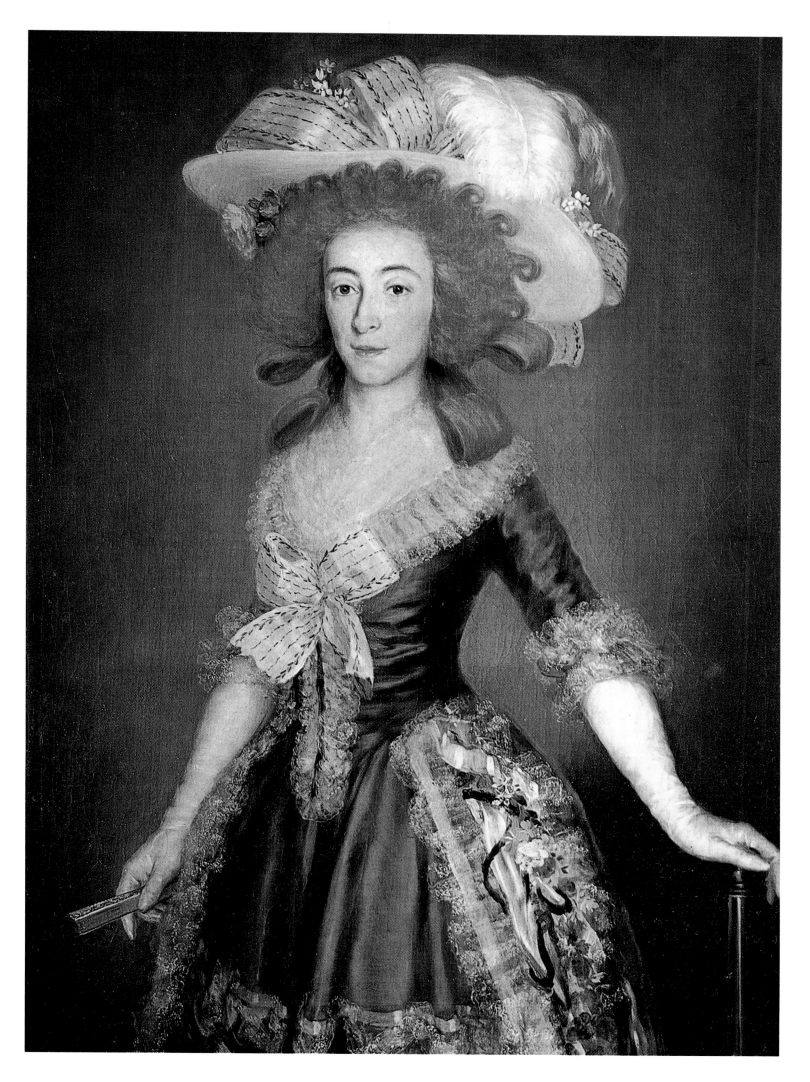

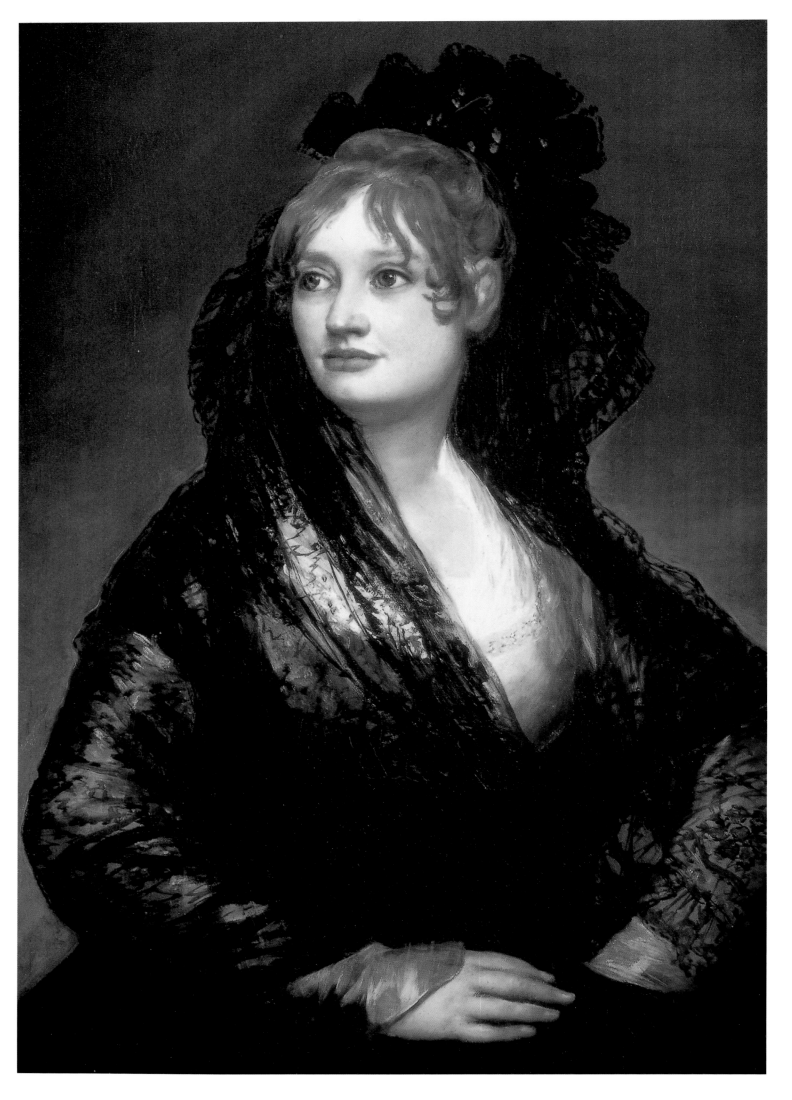

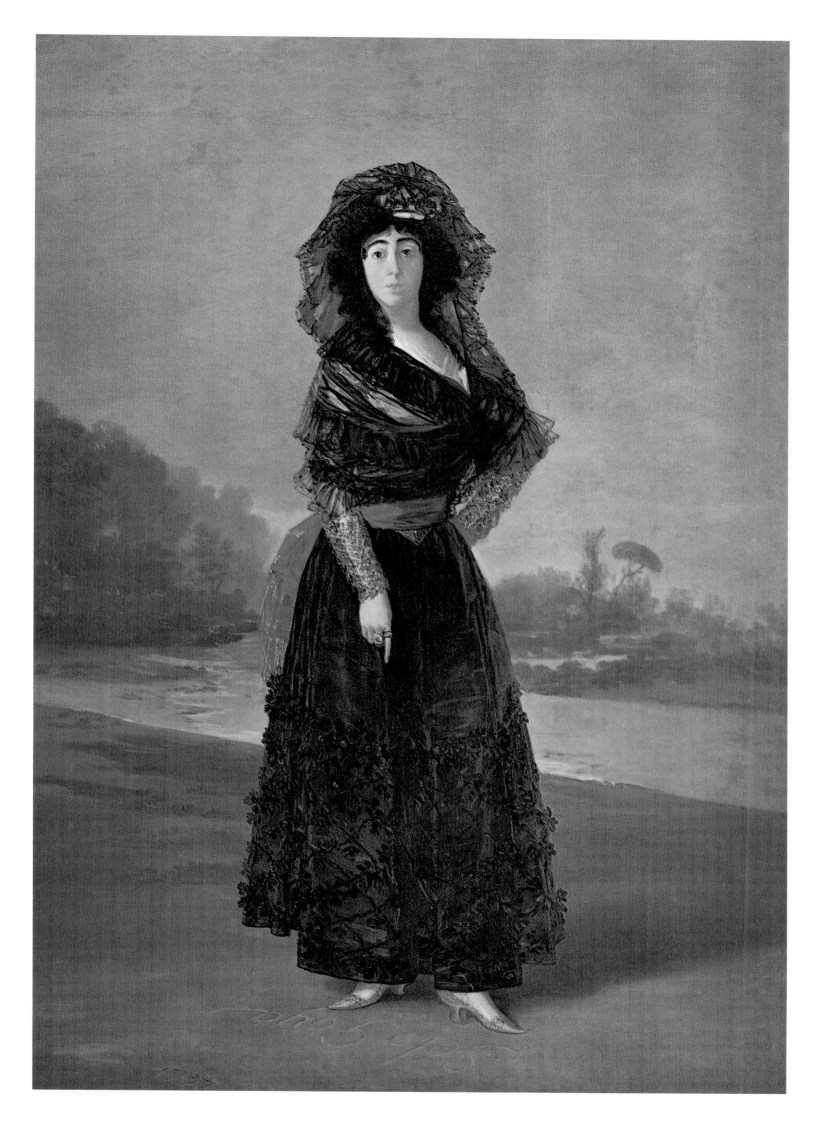

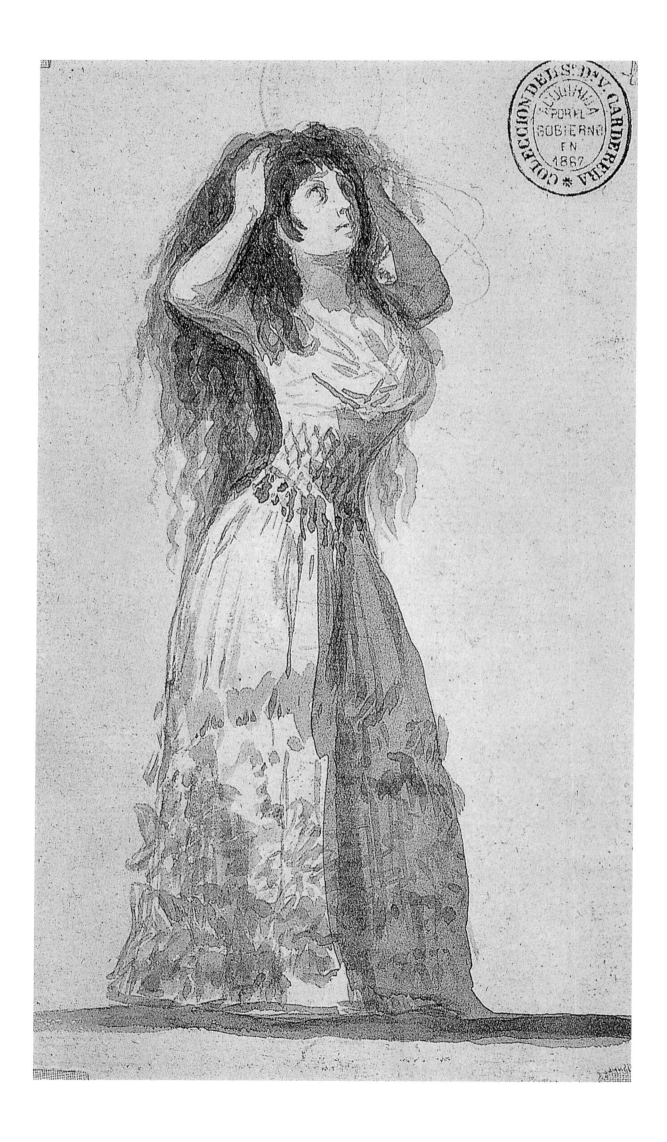

42

The Duchess of Alba Arranging Her Hair, 1796-1797, Album A (Sanlúcar), Indian ink wash, 17.1 x 10.1 cm, National Library, Madrid.

Duchess of Alba, 1797, oil on canvas, 210.2 x 149.3 cm, Hispanic Society, New York.

husband. Goya recorded their intimacy in sketches he made of her everyday activities, including the *Duchess of Alba Arranging Her Hair* (p.42). There is, however, no evidence to prove the popular legend that a romantic liaison existed between the artist and his patron.

In the full-length portrait, set in front of a distant landscape, the Duchess wears the costume of a maja — a black mantilla and gown with a scarlet sash — and Goya may have applied the heavy make up to her face himself, a common practice of painters and their sitters. She wears two rings, one inscribed 'Goya', the other 'Alba', and points down to the motto at her feet, 'Solo Goya' ('Only Goya'). The inscription may refer to the fact that only Goya could paint such a magnificent portrait, or could alternatively be seen to spell out his affection for the Duchess. Whatever the meaning, Goya kept the portrait in his studio where it was recorded in 1812, ten years after her death.

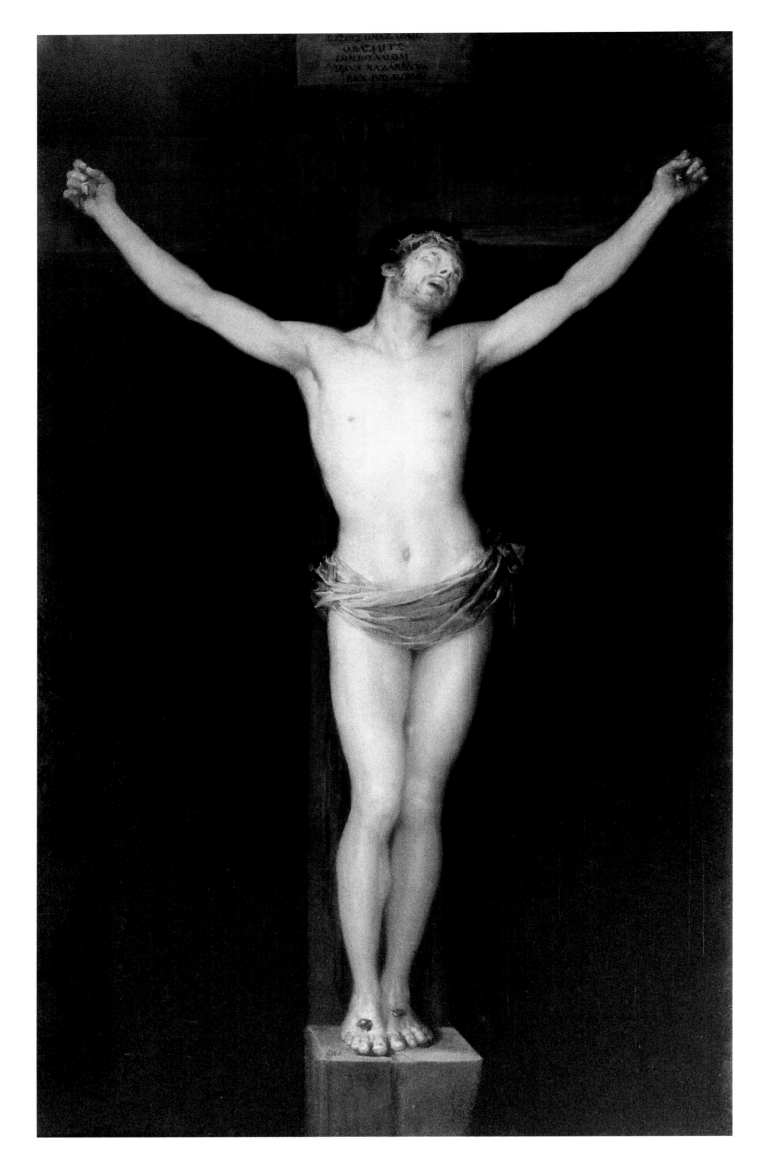

III

Religious Paintings

The importance of Christianity in Spain during the eighteenth century is manifest in the number of churches that were built or remodelled at that time, their highly decorated interiors designed to reinforce the faith of the masses. Religious patronage established Goya's career in Saragossa, where his paintings of the Virgin, Christ and the saints were in great demand. For much of his life, Goya was involved in large projects for religious foundations. In his early works, he had to conform to the demands of his patrons but, in later years, with his position assured as painter to the court in Madrid, he had the confidence to interpret traditional themes in inventive and daring ways.

The Basilica of El Pilar

Soon after his return from Italy in 1771, Goya's first major commission came from the Basilica of El Pilar in Saragossa. Legend had it that the Basilica stood on a site where, in 40[AD], the Virgin had appeared to St James, the patron saint of Spain. She gave him a present of her likeness in the form of a statue placed on a pillar of jasper. A church was then established on the site, named after the jasper pillar. The Basilica had been rebuilt several times and by the 1770s, was being remodelled once more, this time in the neo-classical style. Goya was asked to produce sketches for the ceiling of the small choir in the Chapel of the Virgin as part of the redecoration of the interior.

Early in November 1771, Goya submitted a painting in fresco to show his mastery of the technique and an oil sketch, which won the Canon's approval. The commission was worth 15,000 reales, equivalent to the annual salary of a court painter, a large sum for such a small fresco and particularly for an unknown artist just embarking on his career.

The Crucifixion, 1780,
oil on canvas, 253 x 153 cm,
Prado Museum, Madrid.

*Adoration of the Name
of God by Angels*, 1772,
fresco, 700 x 1500 cm,
El Pilar, Saragossa.

The *Adoration of the Name of God by Angels* (pp.46-7) glorifies the church triumphant in traditional baroque fashion. In the centre of the composition, the Name of God appears in Hebrew on a triangle, which represents the Trinity. Behind it, an explosion of golden light illuminates a host of angels floating on billowing clouds in an infinite space. The fresco's astounding illusionistic effects attracted much attention and established Goya's career, making him within three years the most prosperous painter in Saragossa.

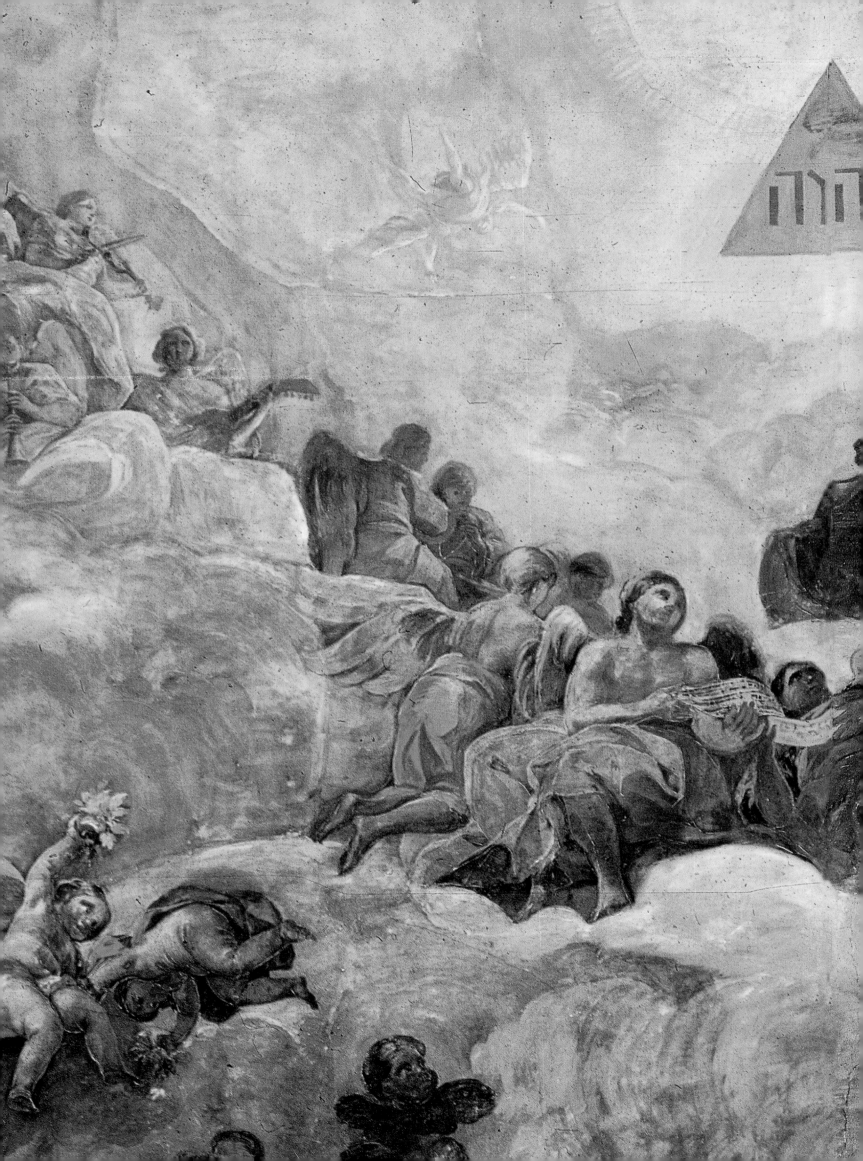

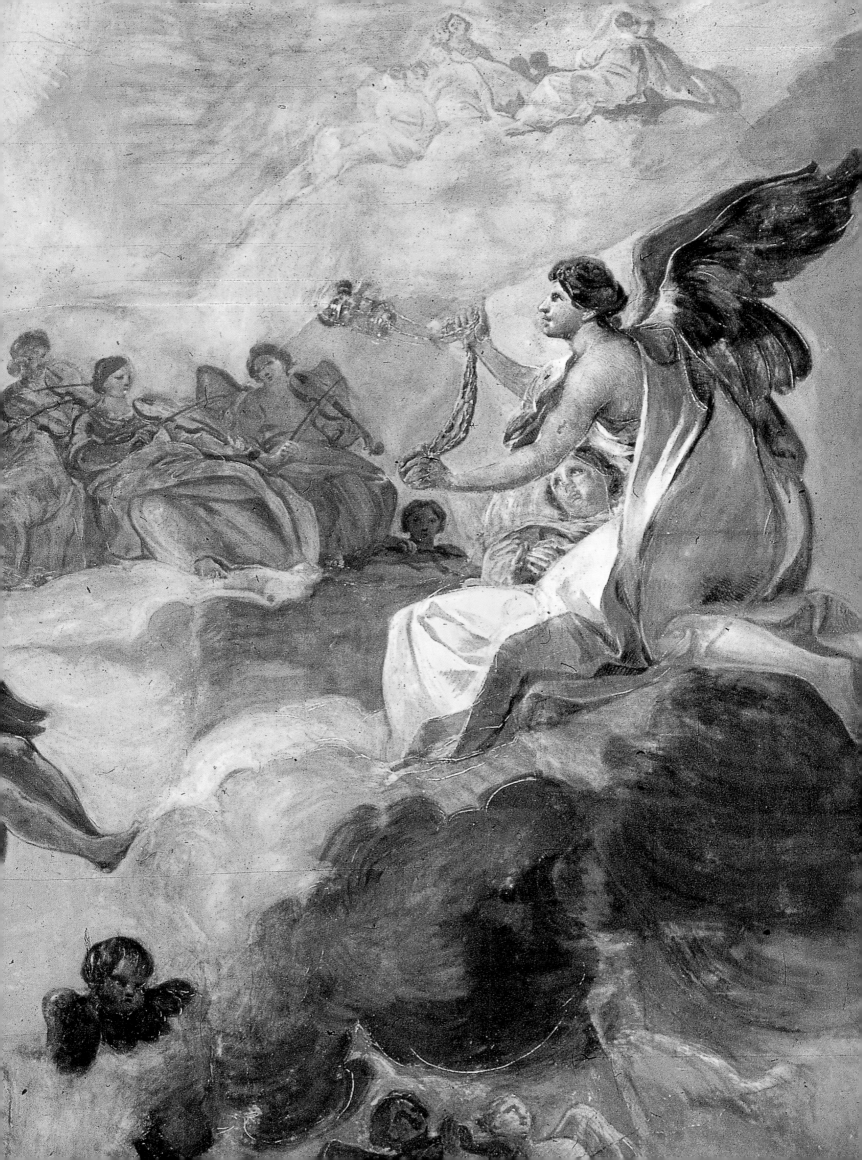

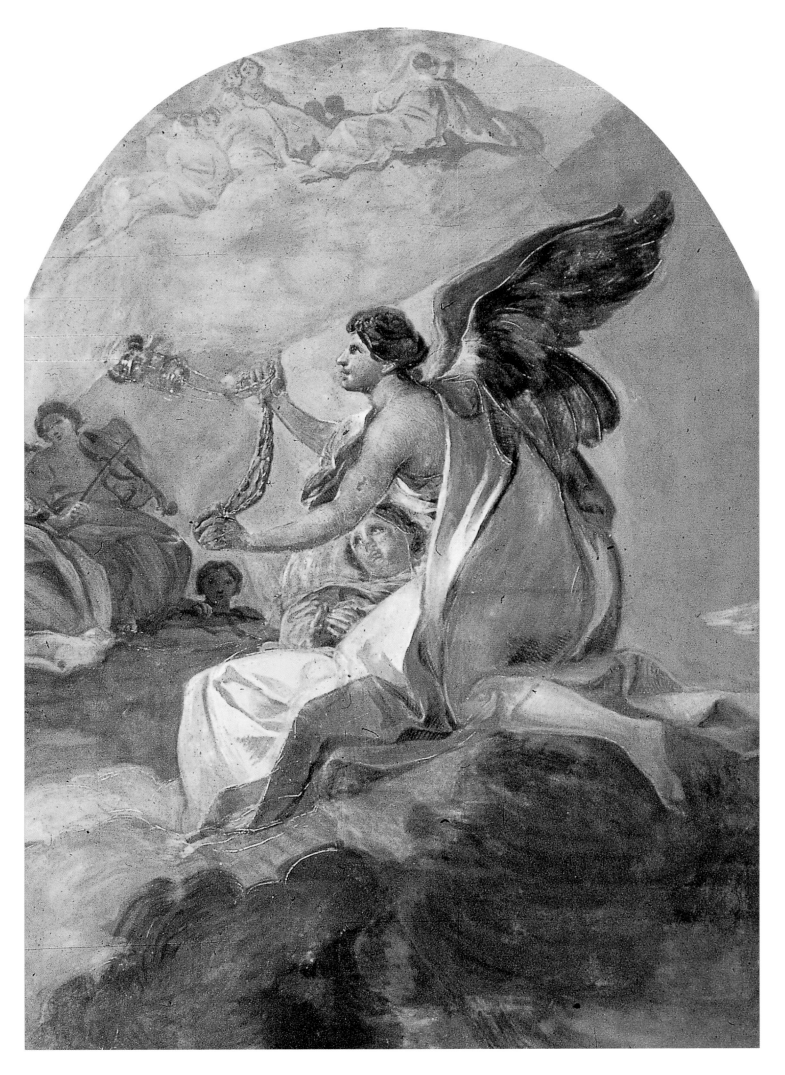

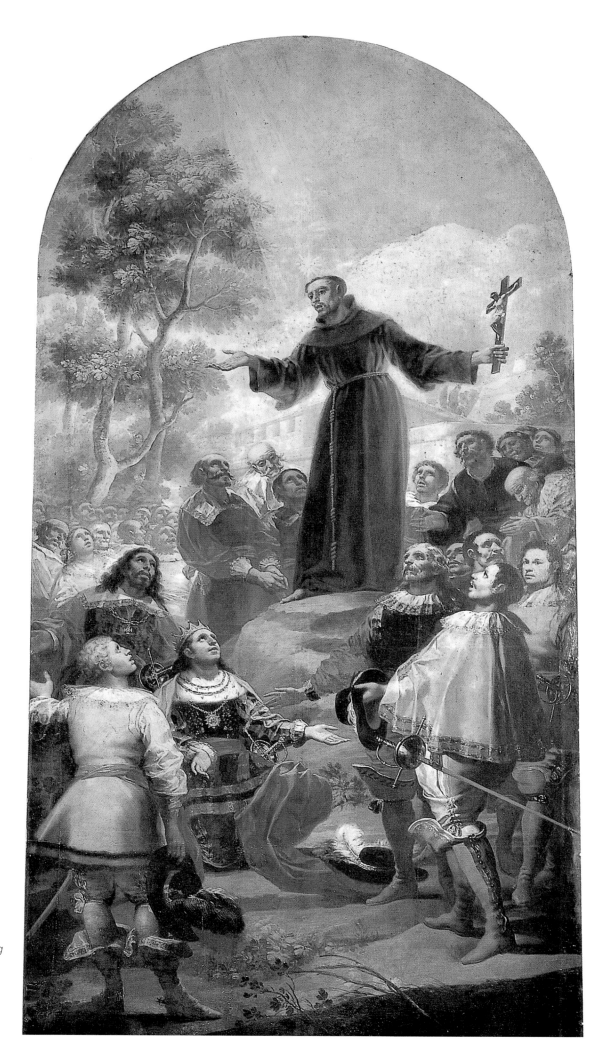

Adoration of the Name of God by Angels, detail, 1772, fresco, 700 x 1500 cm, El Pilar, Saragossa.

St Bernardino of Siena Preaching before Alonso V of Aragón, 1781-1783, oil on canvas, 480 x 300 cm, San Francisco el Grande, Madrid.

The monastery of Aula Dei

Goya's second large undertaking was a series of episodes from the Life of the Virgin painted for the Carthusian monastery of Aula Dei. Of the eleven compositions Goya painted for the monastery's chapel, only seven survive. Painted in oil directly onto plaster, these vast compositions are each approximately eight metres by ten metres in size. In *The Betrothal of the Virgin* (p.51), Goya has placed the monumental life-sized figures on an illusionistic flight of steps, like actors on a stage. To the right of the painting, Joseph accepts the Virgin's hand as a priest blesses the union. The frieze of figures, with their classical features and drapery, echo the classical works that Goya had seen during his recent visit to Rome. The neo-classical format is appropriate to the solemnity of the subject, although the restraint and control are in strong contrast to his later religious works.

Gains admission to the Royal Academy

When in 1774 his brother-in-law, Francesco Bayeu, summoned him to assist with designs for tapestry cartoons for the royal family, Goya seized the opportunity of working in Madrid. Although gratified to be employed by the court, Goya still wanted official recognition. He had failed twice to gain admission to the Royal Academy of San Fernando; in 1780, his presentation piece, *The Crucifixion*, made his third attempt a success.

The Crucifixion (p.44) was an uncontroversial choice of subject and was deliberately painted in the tenebrist style, a style that had become popular throughout Europe in the seventeenth century. Pioneered by Caravaggio, the style uses exaggerated contrast of light and shade to increase dramatic impact. Taking crucifixion scenes by Mengs and Velázquez as his models, Goya depicts an isolated figure of Christ, looking up in private agony. However unimaginative, the painting finally secured his place in the Academy by unanimous election.

Goya quarrels with Bayeu

In March 1780, financial problems forced work at the Royal Tapestry Factory to stop, and Goya was free to accept other commissions. He was invited to return to work on the Basilica of El Pilar where, under Francisco Bayeu's supervision, he was contracted to decorate one of the domes, for a fee of 60,000 reales. However, he was later to regret the commission.

Goya worked at extraordinary speed and painted 212 square metres in four months. *Mary, Queen of Martyrs* (p.52), shows the celestial world of saints and angels circulating around the Virgin in Glory. Beneath her are saints with their attributes, the objects with which they were martyred; St Paul carries a sword, St Laurence kneels beside a gridiron and St Engracia holds a hammer and nail. The loose brush work and bold composition, with its spacious layout and command of grand illusionistic perspective, were in complete opposition to the aesthetics of neo-classicism favoured by Bayeu. Bayeu requested Goya to make certain alterations, but in December he told the administrator of works that Goya had refused. The fresco was inspected and a Board of Work minute records that "defective areas" were found. In February 1781, Goya was told to present sketches for the pendentives of the dome, the subjects being Faith, Fortitude, Charity and Patience; a month later these were rejected because they were considered "unfinished" and showed "the same faults" as the fresco. In particular, his image of Charity was considered indecent and the completed frescos in the dome had "aroused the censure of the public".

Goya protested furiously to the Pilar administration, pleading the creative freedom of the artist. Initially, he refused to comply with their demands and threatened to leave, but he was eventually persuaded to make the corrections required, after which he returned to Madrid. So enraged was he about the affair that he kept away from Bayeu and Saragossa for many years. "When I think about Saragossa and painting," he wrote to Zapater, "my blood boils."

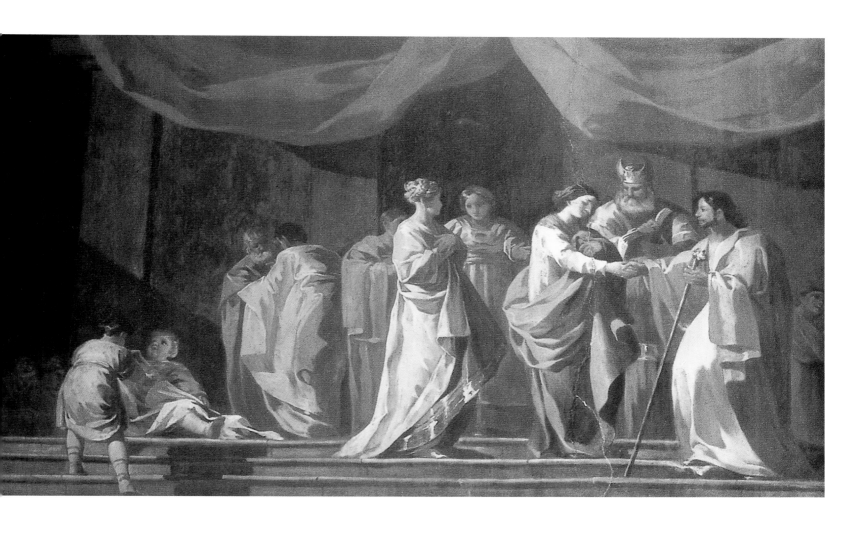

Betrothal of the Virgin, 1774,
oil on plaster, 306 x 790 cm,
Aula Dei, Saragossa.

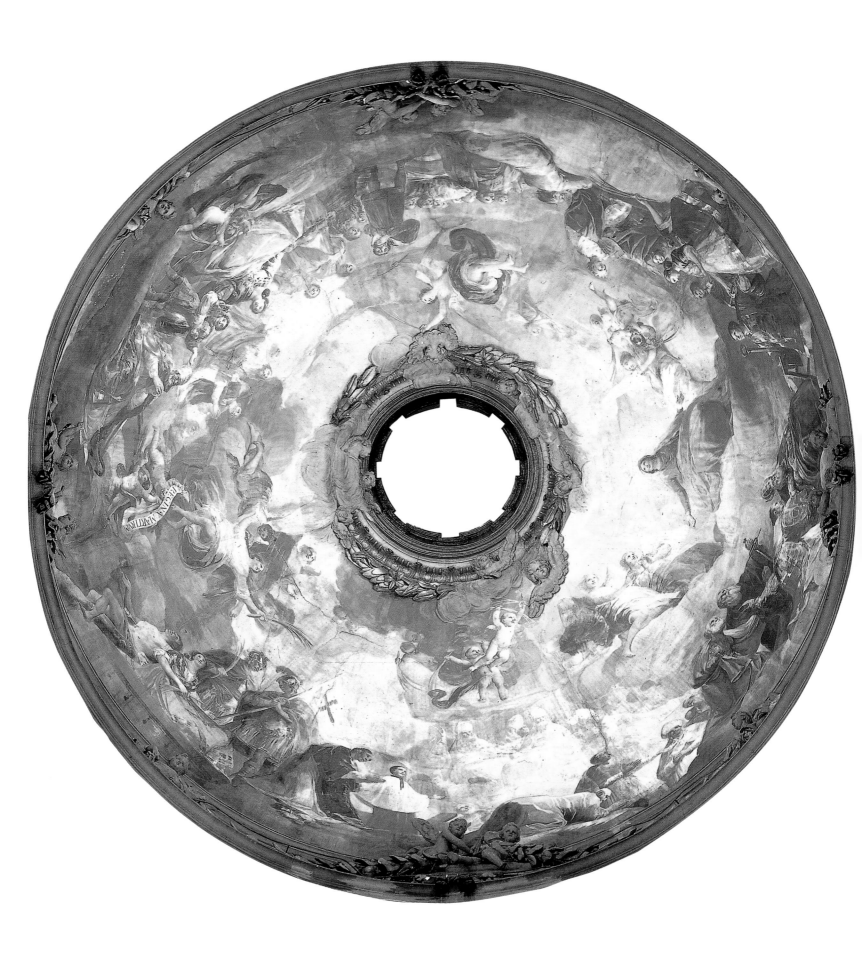

Mary, Queen of Martyrs,
1780-1781, fresco on the church's
dome, El Pilar, Saragossa.

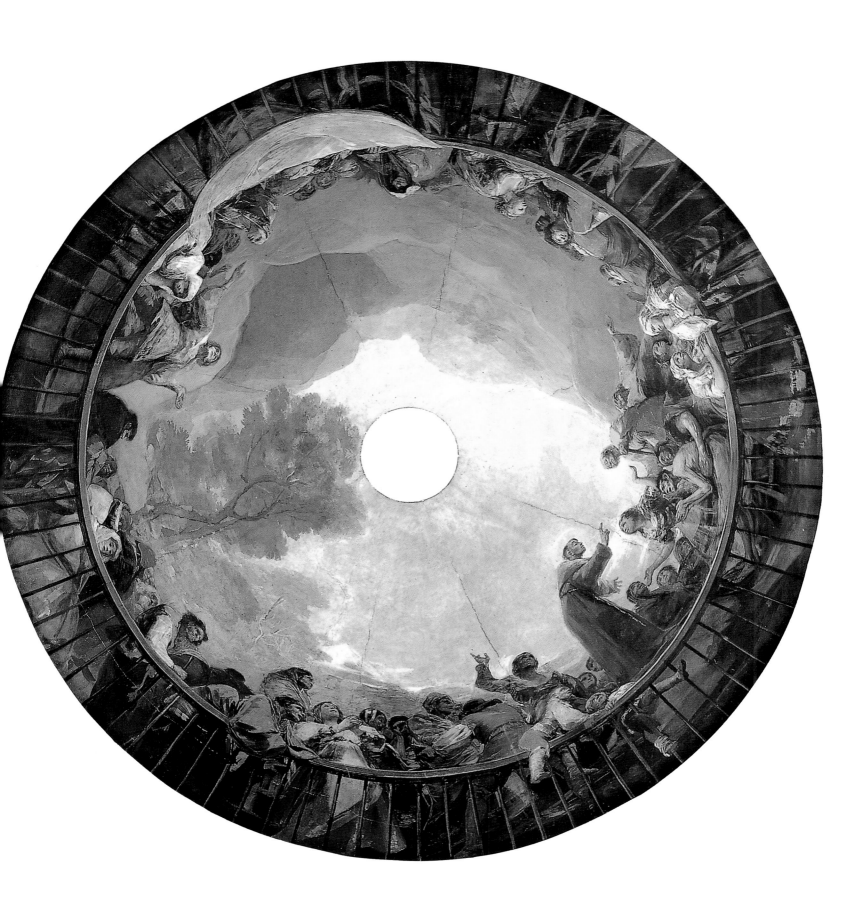

Miracle of St Anthony of Padua,
1798, fresco, 5.5 m diameter,
San Antonio de la Florida, Madrid.

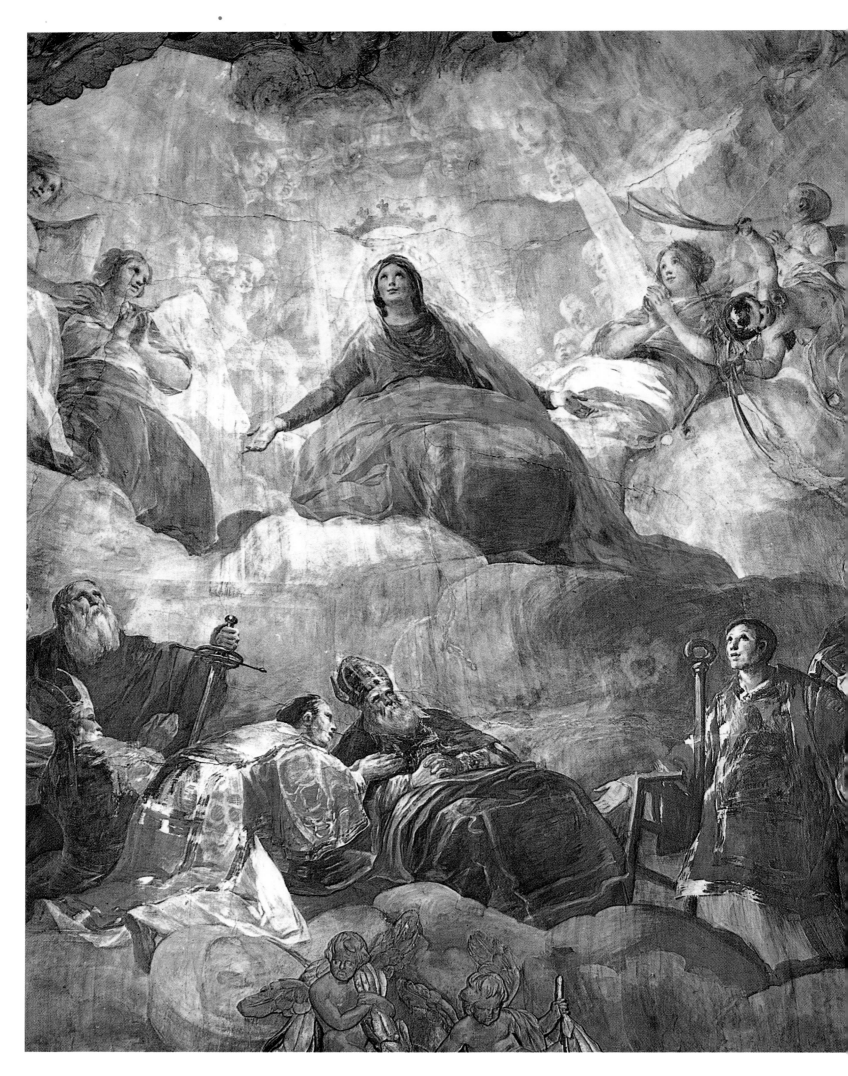

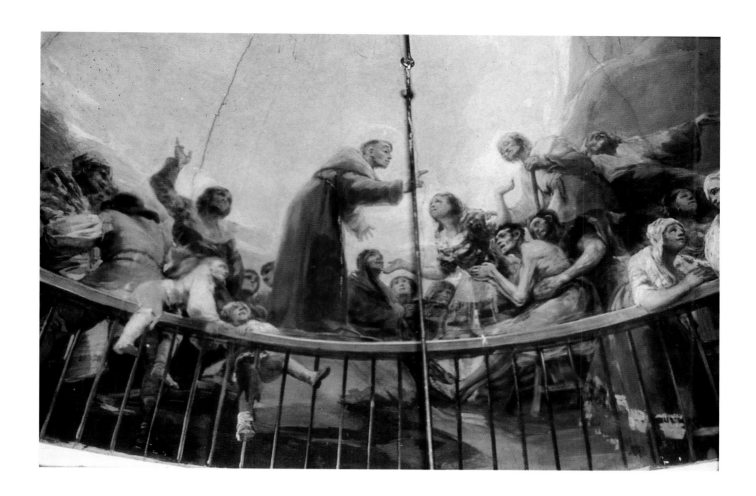

The Church of San Francisco el Grande

Back in Madrid, Goya was nominated along with six other artists to paint altarpieces for the Church of San Francisco el Grande, a prominent landmark that features in several of Goya's views of the capital. The subject of Goya's large altarpiece, *St Bernardino of Siena Preaching before Alphonso V of Aragón* (p.49), was chosen by the artist himself. In the centre of a conventional triangular composition stands the saint with a star above him. According to legend, St Bernardino of Siena (1380-1444) was preaching in the presence of the king, and, as he was praising the coronation of the Virgin, the congregation were amazed to see a brilliant star descend from Heaven, bathing the saint in divine light. The astonished king kneels with outstretched arms among members of his court. To the right, like a signature, Goya has depicted himself, looking not towards the miracle, but confidently out at the spectator; it is almost as if he knew that this painting was to be the real start of his career.

The Royal Chapel of San Antonio de la Florida

Over the next few years, Goya was preoccupied with designing tapestry cartoons and with painting portraits. In 1792, he was struck by a serious illness that left him totally deaf, and unable to accept large-scale commissions for several years. However, in the spring of 1798, he was asked by Queen Maria Luisa to paint frescos for the Royal Chapel of San Antonio de la Florida. The chapel had been built by Francesco Sabatini between 1772 and 1798, on the site of a shrine dedicated to St Anthony, and a route through woodlands and gardens to the shrine became a fashionable excursion. The Portuguese saint had been in Italy when he heard that his father, a gentleman of good repute, was about to be condemned to death on a false charge of murder. The saint asked leave to go to Portugal and miraculously found himself transported home. Unable to convince the judges of his father's innocence, Anthony asked that the corpse of the murder victim be brought before him; the dead man rose up, declared that the accused was not his murderer and promptly fell back in his coffin.

Mary, Queen of Martyrs, 1780-1781, fresco on the church's dome, El Pilar, Saragossa.

Miracle of St Anthony of Padua, detail, 1798, fresco, 5.5 m diameter, San Antonio de la Florida, Madrid.

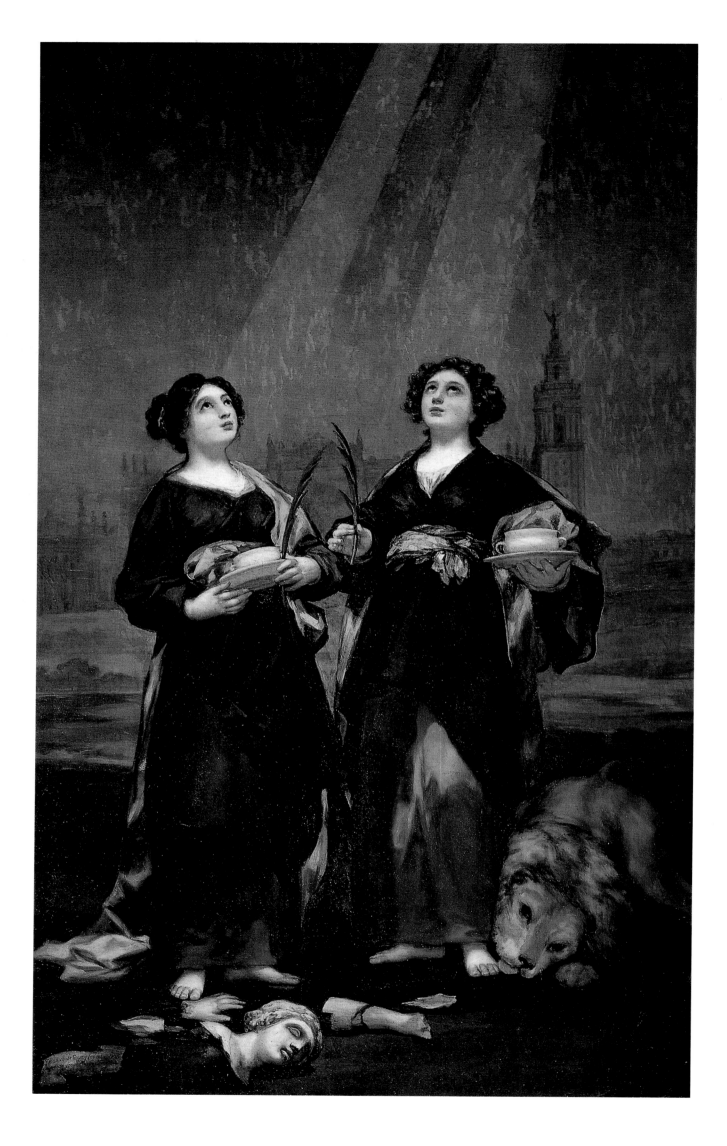

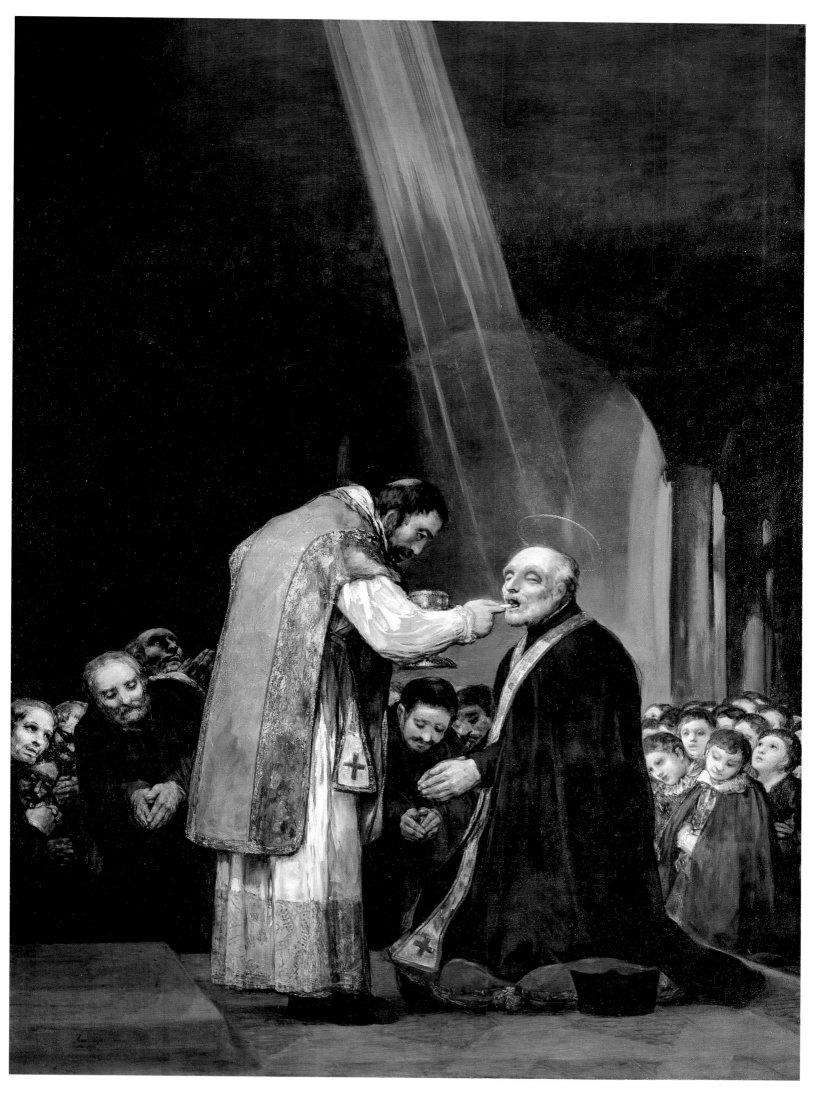

The chapel was built on a Greek Cross plan, which emphasized its dome. Here Goya painted the *Miracle of St Anthony of Padua* (p.53). He broke with traditional baroque ceiling decorations in which figures fly through billowing clouds in a burst of light; rather than painting the apotheosis of the saint or the saint in flight, he chose to depict the miracle on earth. The scene is lit by the natural daylight of the lantern and the scene takes place behind a plain circular balustrade broken only by a patch of white cloth. St Anthony is placed directly above the altar, facing the entrance to the chapel. He is raised above the crowd and questions the murdered man he has brought back to life. Around the dome, leaning on or standing behind the balustrade, are assorted figures of different ages, social classes and cultural backgrounds, against the vague outline of a mountainous landscape. They respond in varying ways to the miracle; some react in wonder, others appear oblivious. To the left of the saint, a man appears to be leaving in a hurry, his hat pulled over his head — possibly the guilty party.

Goya took only four months to complete the dome, sketching the composition directly onto the fresh plaster and modifying the original drawing as he went along. Close up, the fresco is roughly painted with broad loose strokes, which only take on meaning when seen from beneath. Today, the chapel is not only visited for the frescos but also as a monument to Goya, whose tomb lies between the altar steps.

The Sacristy of the Cathedral of Seville

Nearly two decades later, in 1817, Goya was commissioned to paint an altarpiece for the Sacristy of the Cathedral of Seville. Apparently his friend, Juan Agustin Ceán Bermúdez, had difficulty encouraging him to produce a suitably devotional image. Now in his seventies, the impetuous artist had to produce several sketches before satisfying his patrons. The composition of *Saints Justa and Rufina* (p.56), situated in the sacristy for which it was designed, derives from a version by Murillo. The full-length saints look heavenwards and shafts of light fall on their faces, as if from the real window high up and to the right of the painting. The saints were sisters and potters from Seville. They lived in the time of the Roman occupation and were martyred for refusing to sell their wares to a priest for use in pagan rites. They hold their attributes, the pots of their trade, and their martyrs' palms. Fragments of a broken pagan statue lie at Justa's feet as a symbol of the triumph of Christianity over paganism. To the right is the tower of the Cathedral of Seville, which the sisters saved from an earthquake in 1504 by descending from heaven to clasp the tower in their arms, preventing its collapse.

The Escuelas Pias commission

If Goya had difficulty in producing an appropriately pious image for the Cathedral of Seville, two works from his final years in Spain are unusual in their religious intensity. In 1819, the fathers of the Escuelas Pias in Madrid commissioned an altarpiece for their chapel. Begun in May, *The Last Communion of Saint Joseph of Calasanz* (p.57) was completed in four months, in time for the saint's feast day on 27 August.

Like Goya, St Joseph was originally from Aragón. He had started a free school in a poor district in Rome known as the Escuelas Pias. The system of education spread rapidly; schools were established in Spain, Bohemia and Poland, and Goya himself had attended the Escuelas Pias de San Antón in Saragossa. St Joseph was canonized in 1767 when the artist was twenty-one. Goya's sympathetic illustration shows the saint, aged ninety-two and seriously ill, taking his last communion on 10 August 1648; he died fifteen days later. Using lighting and a colour scheme similar to that used by Rembrandt, Goya shows the frail saint taking the host, surrounded by his faithful followers. Having delivered the altarpiece, the artist returned nearly half the payment and wrote to the rector saying that he had "to do something in homage to my countryman". A few days later he sent the small *Agony in the Garden* (p.59) as a gift to the school.

Saints Justa and Rufina, 1817, oil on canvas, 309 x 177 cm, sacristy of the cathedral of Seville.

Last Communion of St Joseph of Calasanz, 1819, oil on canvas, 250 x 180 cm, church of St Anthony Abbot, Madrid.

Agony in the Garden, 1819, oil on canvas, 47 x 35 cm, Colegio de los Padres Escolapios de San Anton, Madrid.

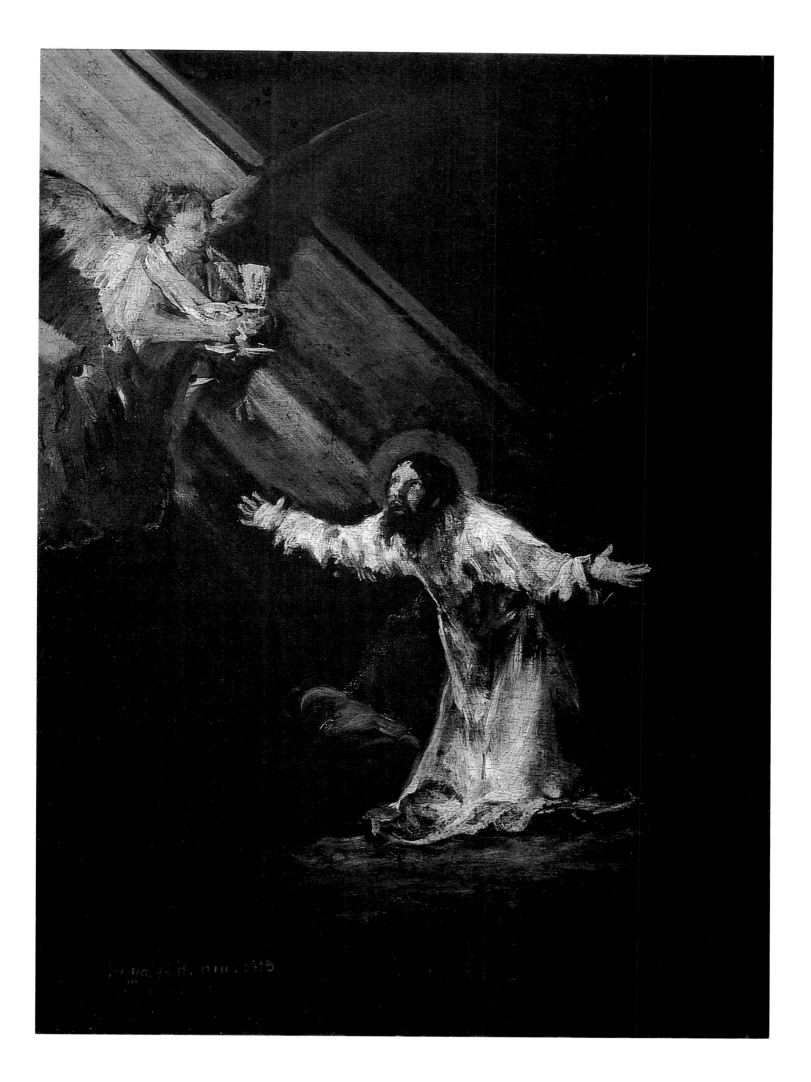

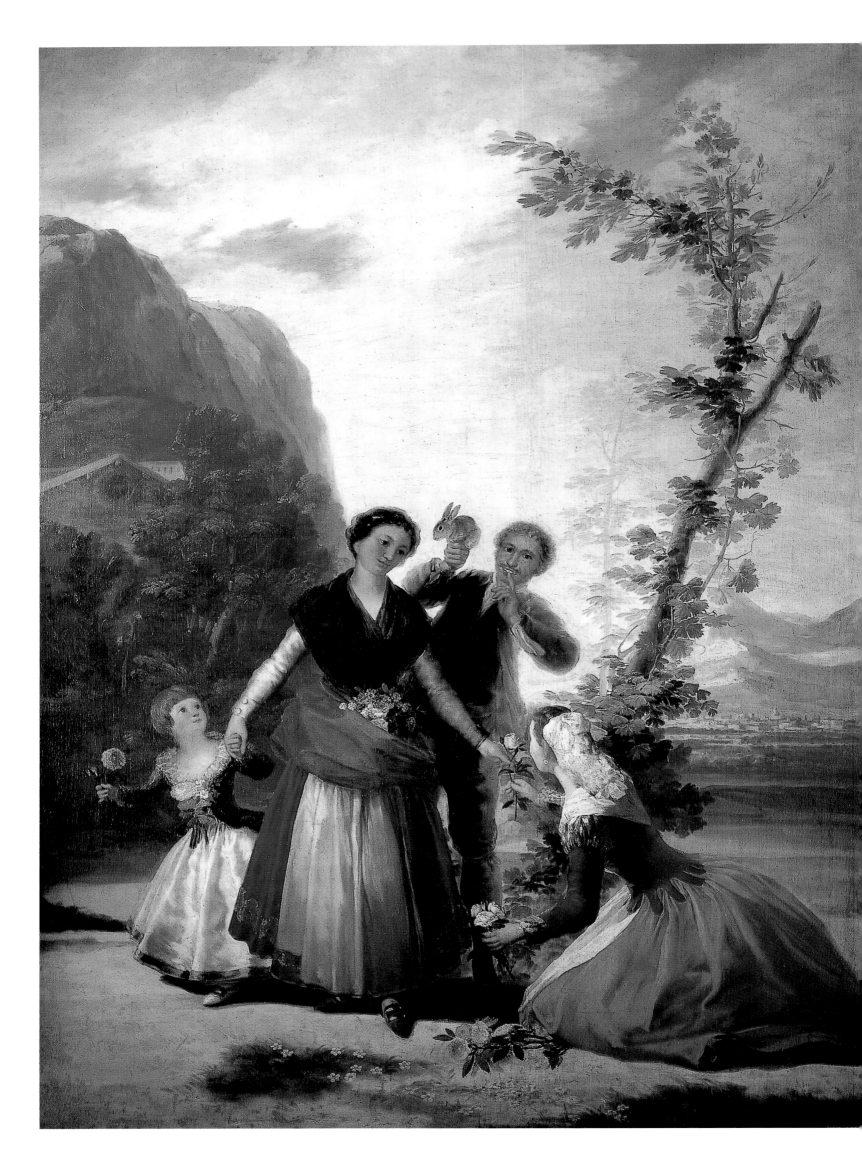

IV

Spanish Life

While Goya's success as a painter of portraits and religious subjects alone would place him alongside the great masters, much of his career was devoted to recording various aspects of contemporary Spanish life. A large number of works were painted of his own volition or recorded in one of his many private notebooks, but his employment at the Tapestry Factory of Santa Bárbara, designing cartoons for the royal palaces, offered him further opportunity to execute a wide range of scenes observed from everyday life.

Bullfighting

Throughout his life, Goya was fascinated by bullfights. Early in his career, around 1779, he painted *La Novillada* (a bullfight with young bulls) (p.68), in which young men amuse themselves as a bull is let into the enclosure. Goya portrays himself in pink as a torero, or fighter on foot, turning to catch the spectator's eye as he shows off his skill with his cape. In later life, between 1812 and 1819, Goya was to record a bullfight (pp.62-3). The viewer watches from high up above the crowd as a mounted picador goads a bull with a pike. Matadors circle around, tricking the bull to come close. Within their muletas, or fan-shaped capes, their swords are concealed.

In 1816, Goya advertised the first edition of *La Tauromaquia,* or *The Art of Bullfighting.* This series of thirty-three etchings work together to create a picture of the sport as a whole. The first thirteen plates trace the history of bullfighting, introduced into Andalusia by the Moors. Included are several plates celebrating heroes and monarchs — amongst them El Cid and Charles V — vying with the bull.

Spring (The Flowergirls),
1786-1787, oil on canvas,
177 x 192 cm, Prado Museum,
Madrid.

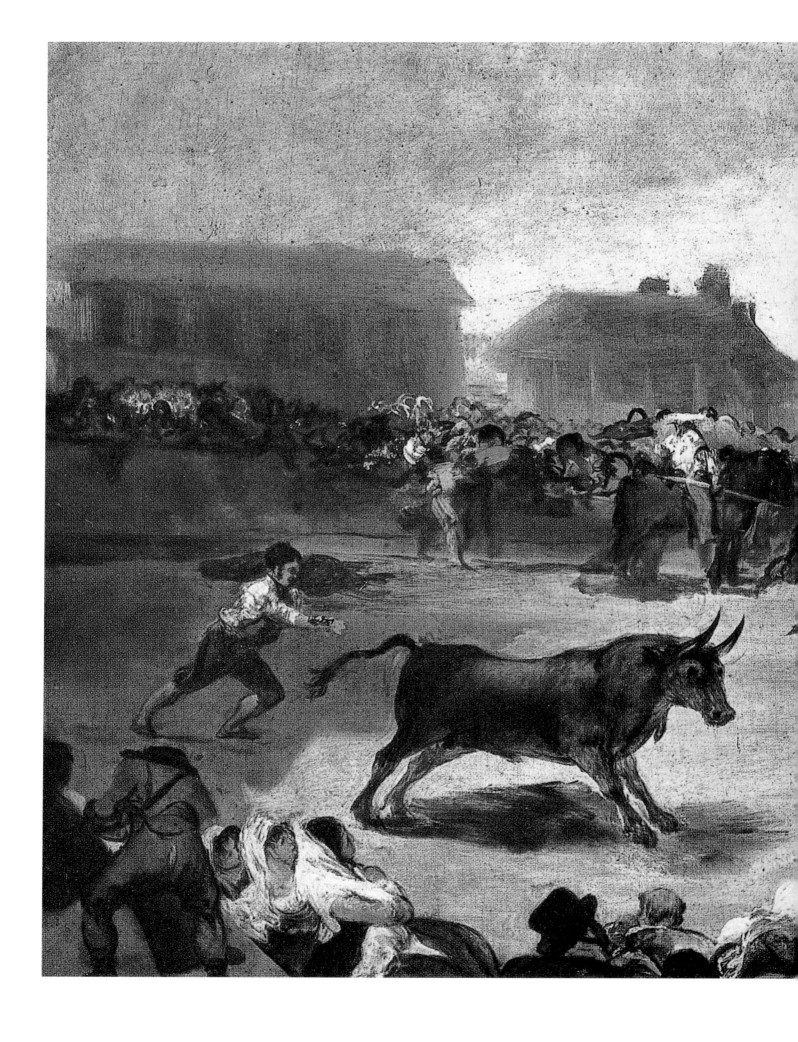

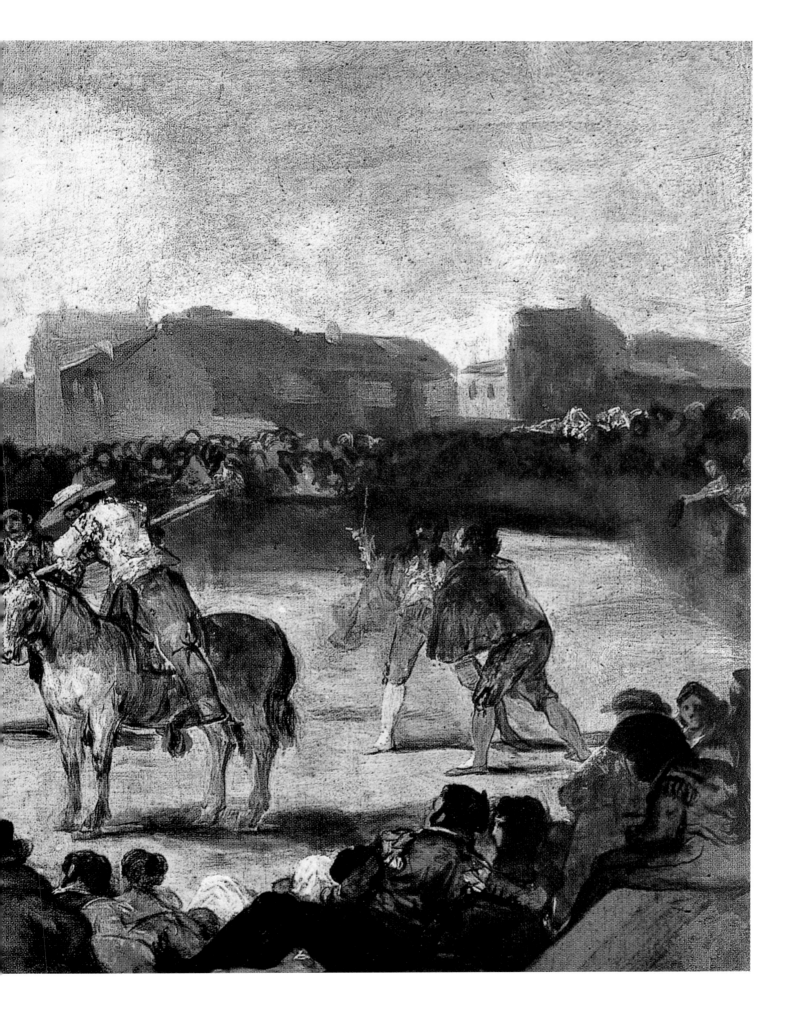

The Bullfight, 1812-1819,
oil on panel, 45 x 72 cm,
Royal Academy of San Fernando,
Madrid.

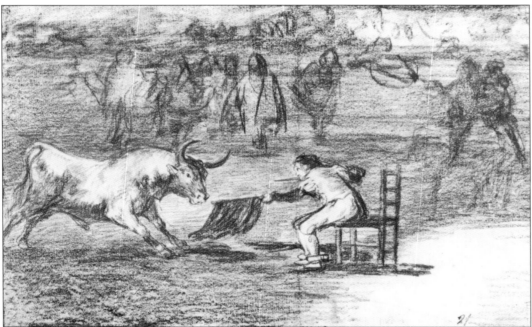

Banderillas de Fuego (Banderillas
with Fire Darts), 1815-1816,
etching with aquatint,
24.5 x 35 cm.

La Tauromaquia (The Art of
Bullfighting), 1816, *The Bullfighter
Martincho Performing a Daredevil
Feat in the Saragossa Ring*,
1815-1816, sanguine,
18.2 x 29.6 cm, preliminary drawing
for a separate print on the same
subject as no.18 of the print series
La Tauromaquia.

*El famoso Fernando del Toro,
barilarguero, obligando a la fiera
con su garrocha* (The Celebrated
Fernando del Toro Draws the Fierce
Beast with His Pike), 1815-1816,
etching with aquatint,
24.5 x 35 cm,
La Tauromaquia, no.27.

*Desgracias acaecidas en el tendido
de la plaza de Madrid, y muerte del
acalde de Torrejón* (Unfortunate
Events in the front Seats of the Ring
of Madrid, and the Death of the
Mayor of Torrejón), 1815-1816,
etching with aquatint, 24.5 x 35 cm.

Diversión de España
(Spanish Entertainment), 1825,
lithograph, 30 x 41 cm.

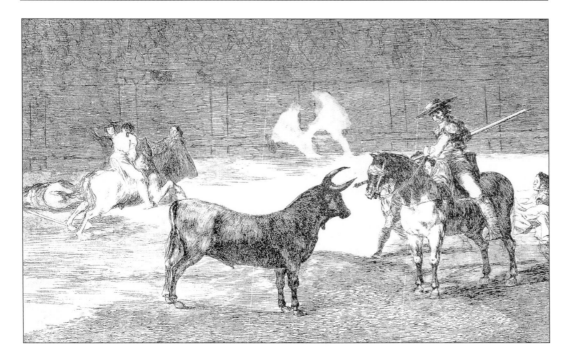

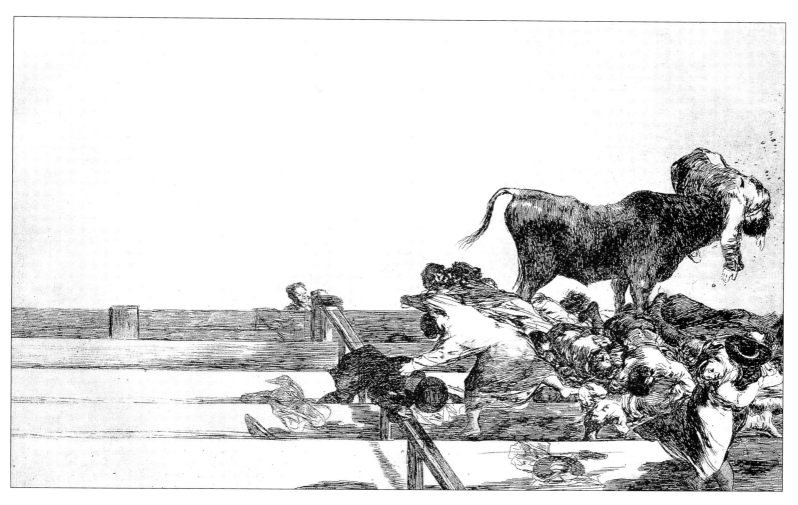

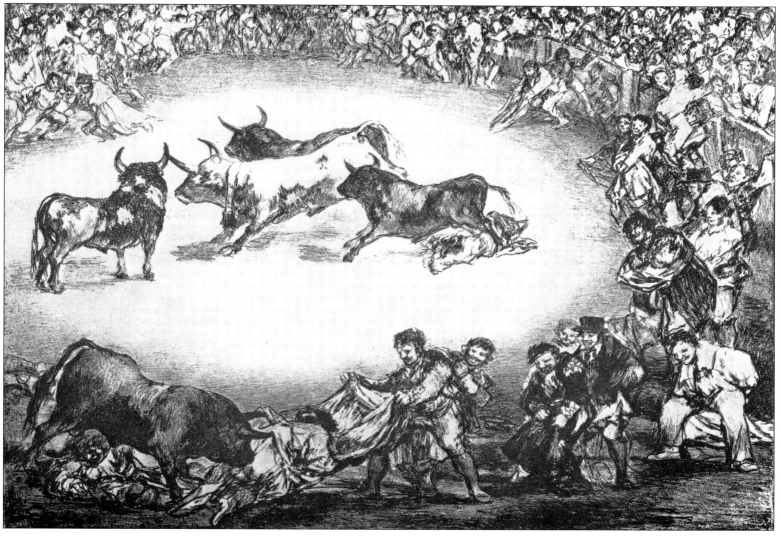

Famous toreros entertained the audience with idiosyncratic methods of snaring the bull. For example, the preparatory drawing for the eighteenth plate shows the bullfighter Martincho performing a daredevil feat in the Saragossa ring (p.64) in which Martincho goads his adversary from a chair, and the twenty-seventh plate, *The Celebrated Fernando del Toro Draws the Fierce Beast with His Pike* (p.64), the hero does just as the title suggests.

The *Banderillas de Fuego* (or Banderillas with Fire-darts, p.64), shows matadors placing fire darts in the bull's neck. During this part of the fight the matadors might vault onto the bull's back or leap between its horns.

As well as the bravura of the contest, Goya also shows its dangers. *The Unfortunate Events in the Front Seats of the Ring of Madrid and the Death of the Mayor of Torrejón* (p.49) recalls 15 June 1801, when a bull broke through the barrier of the ring and bolted into the stands, killing the Mayor of Torrejón. Goya shows the triumphant bull with the unfortunate mayor thrust up on its horns.

During his retirement in France, Goya set to work on four prints of bullfighting scenes. Experimental to the end, *The Bulls of Bordeaux*, produced in 1825, are among the first prints made using the new technique of lithography. Traditionally, prints were made by engraving .an image into wood or metal, which was then inked. With lithography, the line is drawn in wax crayon directly onto stone, rather than cut, enabling the artist to achieve softer forms. *Spanish Entertainment* (p.65) shows the broad strokes of the crayon used to describe the lively movement of the crowd as it participates in the fight.

Hunting

Goya was excited by the bullfight but his favourite pastime was the hunt. In one of his many letters to Martin Zapater he wrote, "as far as I am concerned there is no better entertainment in all the world." The letters recount his success with the gun, how he hit partridges like flies and hares like tame rabbits. His knowledge of hunting no doubt brought him closer to patrons such as Charles III and the Infante Don Luis, who shared Goya's love for the sport. Goya's sketch book, known as Album F (p.74), contains several scenes of a man and his dog hunting. In quick washes of brown ink, Goya captures the physical strength, alertness and coordination required for the sport.

In 1775, Goya produced a series of hunting scenes for his first royal commission. Commissioned for the dining room in the Escorial Palace, these cartoons were designed to be transferred into tapestries. Goya first made small sketches in oil for approval by Anton Mengs and the king, Charles III, before repeating the composition and making revisions and adjustments on the full-scale version. On completion the cartoons served as patterns for the tapestry weavers, after which they were rolled up and stored away. Today many of the full-scale compositions hang in the Prado Museum, but the sketches remained the property of the artist and were sold as paintings in their own right.

The Escorial commission

The subjects of the tapestries were originally to have been traditional French pastorals or Dutch scenes, but Charles proposed a change of subject. He wanted "entertainments and clothing of the present time" which he felt would be more suited to the informal atmosphere of his country residence. This request offered Goya the opportunity of studying his fellow citizens at work and play.

Autumn (The Vintage), 1786-1787, oil on canvas, 275 x 190 cm, Prado Museum, Madrid.

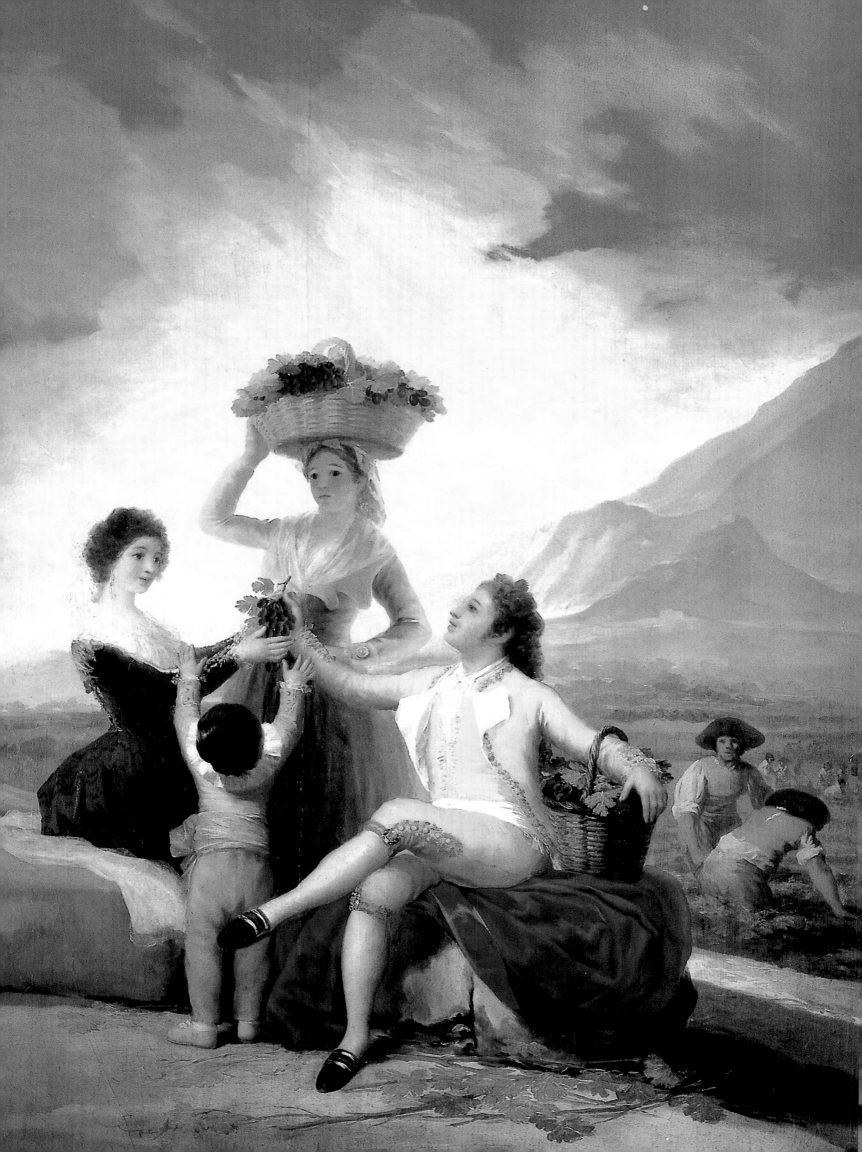

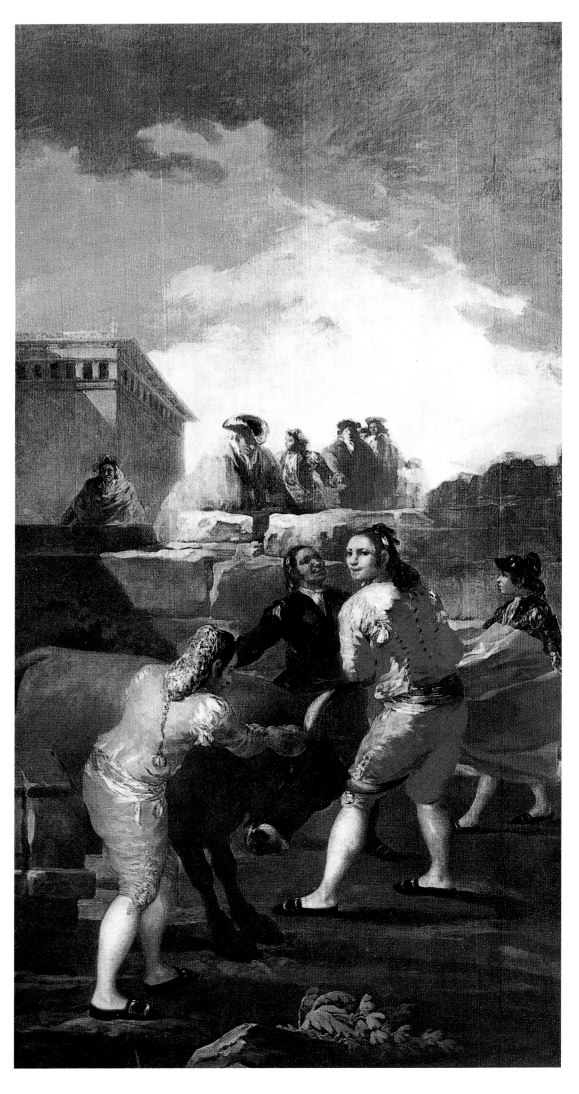

La Novillada, 1780,
oil on canvas, 259 x 136 cm,
Prado Museum, Madrid.

Las Gigantillas (Little Giants),
1791-1792, oil on canvas,
137 x 104 cm, Prado Museum,
Madrid.

Dancing by the River Manzanares,
1777, oil on canvas, 272 x 295 cm,
Prado Museum, Madrid.

The Picnic, 1776, oil on canvas,
272 x 295 cm, Prado Museum,
Madrid.

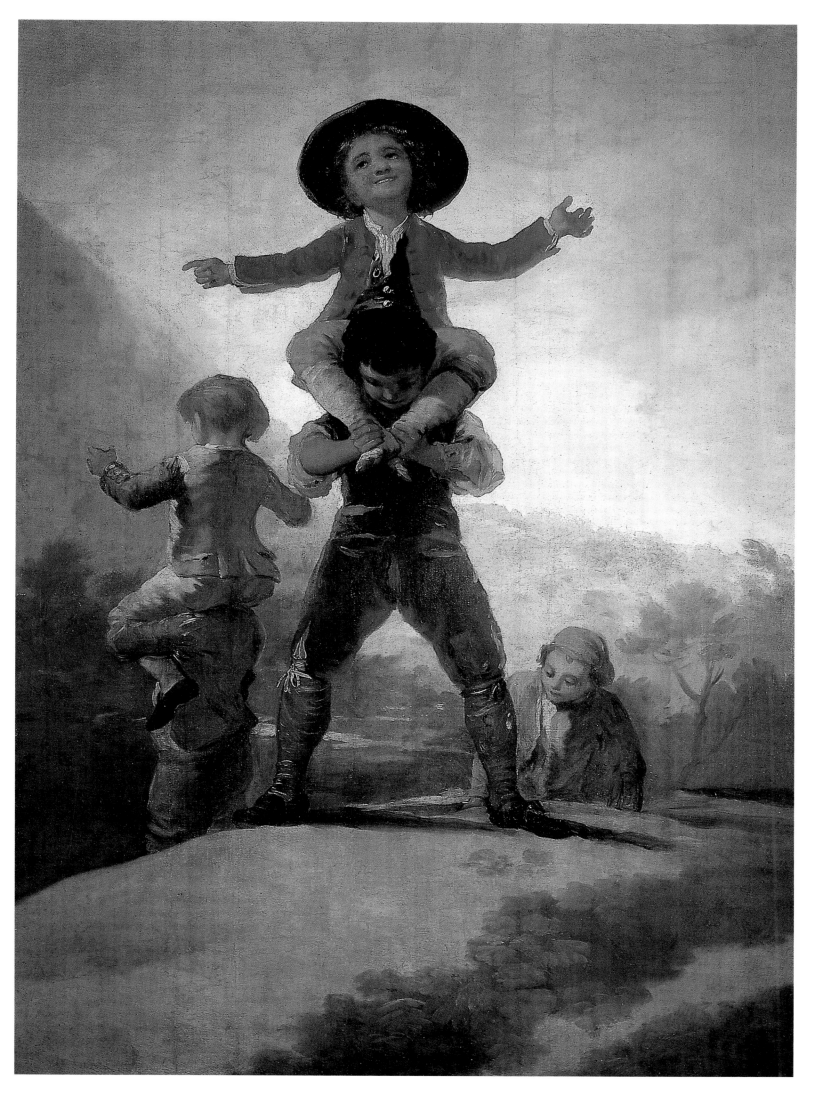

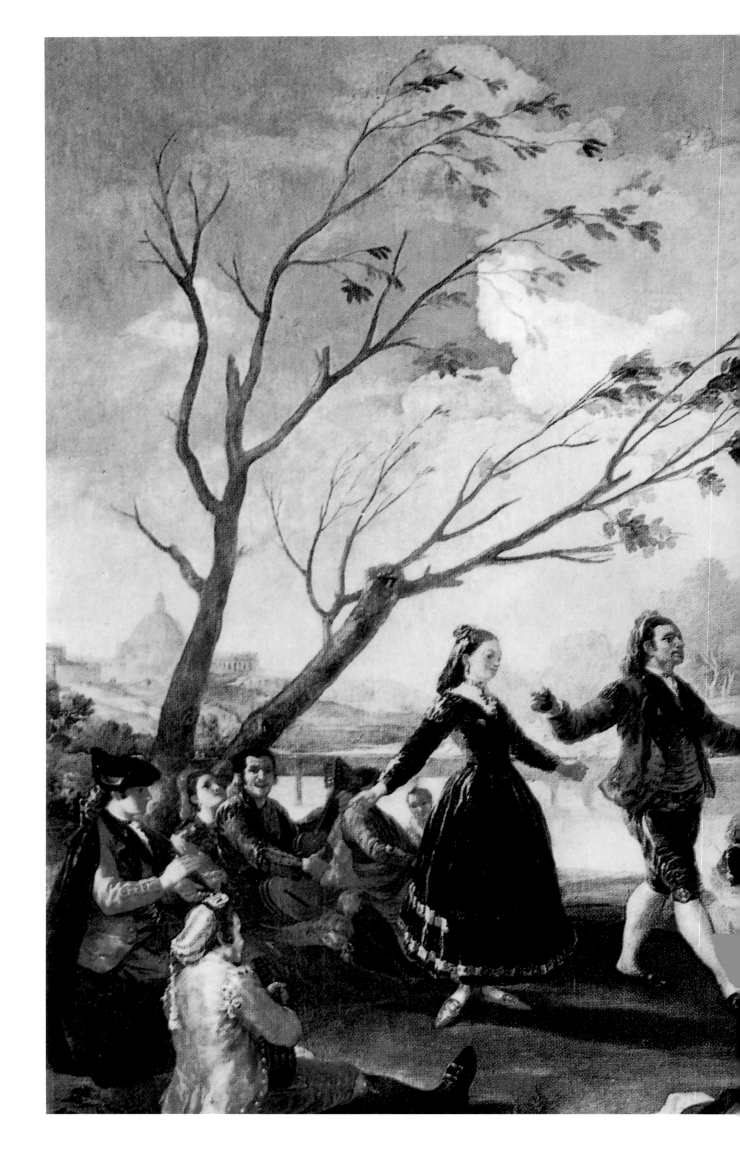

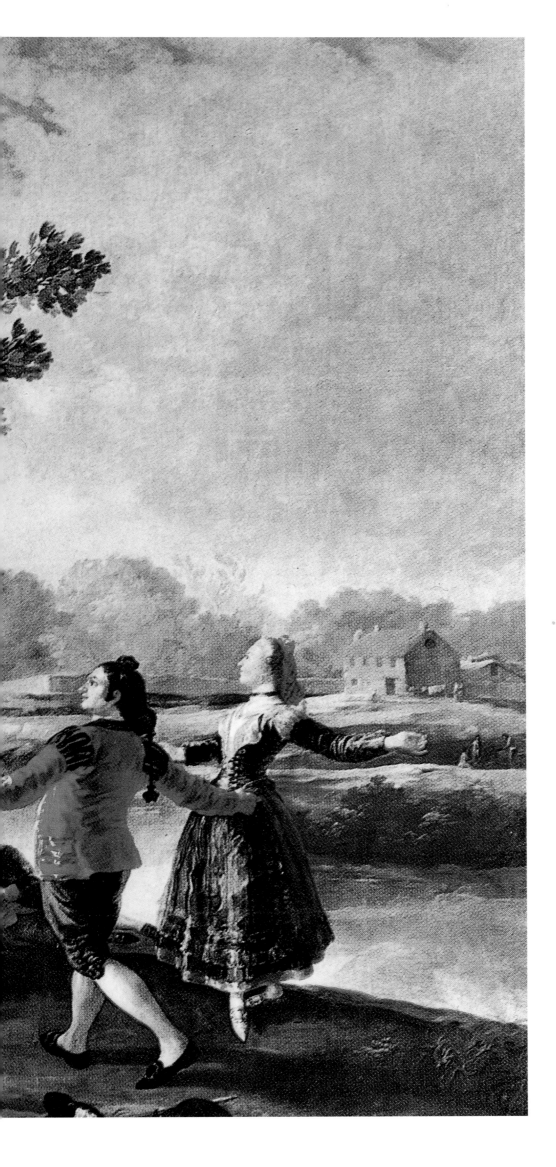

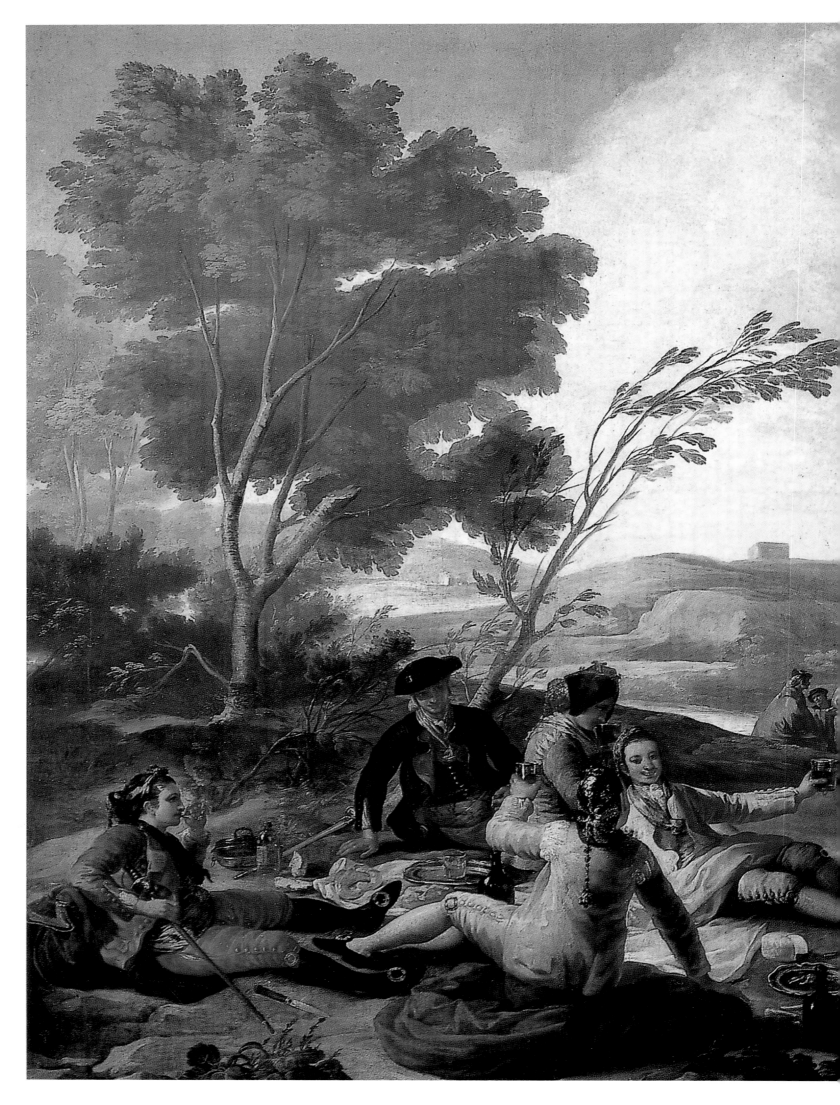

73

Goya's representations of daily life include a tavern brawl, washer women and costermongers selling their wares. *Dancing by the River Manzanares* (pp.70-1) shows figures chatting, singing and playing in accompaniment to dancers. These majos and majas, the poor hardworking members of society, wear the colourful costumes characteristic of Madrid's artisan class; what is not clear, however, is whether these figures are genuine artisans, or whether they represent the idle aristocracy, who considered it fashionable to dress up in clothes of the artisan style. The rough-looking musicians suggest the former while the elegant steps of the dancers suggest the latter.

In *The Picnic* (pp.72-3), a group of merrymakers sprawl on the ground, having consumed their picnic and a quantity of wine. They raise their glasses to an orange-seller, who sways her basket of fruit suggestively towards them. Even more coquettish is the young girl in *The Parasol* (pp.80-1): seated on a hill with her tiny lap-dog, she is protected from the sun by a boy who holds a parasol over her. Her arresting gaze and open gesture suggests she is fully aware of her charms.

The El Pardo dining room

In 1780 the Tapestry Factory was forced to close temporarily, owing to financial difficulties brought about by the wars with England. During this period Goya found work painting portraits and decorating religious institutions. When the factory re-opened in 1786 Goya was commissioned to design a new series of cartoons for the dining room at the El Pardo Palace, and they were to include the largest canvases Goya had ever worked on. The theme of the series was the four seasons. *Spring* (p.60), *Summer* (pp.76-7) and *Autumn* (p.67) are represented by figures enjoying the pleasures of each particular time of year. *Spring* shows a graceful young girl sitting on the ground; she offers a flower to another girl, who is about to be surprised by a comic figure holding a rabbit. In *Summer*, a vast composition depicting harvesters taking a rest from their work, the figures form a frieze in the foreground.

On the left, four peasants stop work for a drink. The group in the centre is arranged in a pyramid formation; a woman feeds her baby, figures laugh together, and one man plays with a child while another lies fast asleep. Children play on the straw and, behind them, a woman raises her hands, fearful that they might fall. The apex is marked with a fork, the tool with which the figures labour on the land belonging to the castle in the background.

In *Autumn*, a man dressed as a majo offers a bunch of grapes to an elegant lady, just out of the reach of a small boy. In the centre of the composition a woman personifying autumn carries on her head a basket overflowing with grapes, representing the success of the year's harvest gathered by the men who toil in the vineyards behind.

In stark contrast, *Winter* (p.85) presents a dismal scene. Three men, huddled in blankets, walk closely together through a snowy landscape. They shield each other from the icy wind that bends the trees backwards and blows open the cloak of the figure to the right. Only the dog seems to be aware of the armed man who approaches, followed by a further figure leading a donkey. On the donkey's back lies a large domestic pig. Rather than following traditional convention of associating winter with the annual slaughter of a pig, a symbol of sustenance for the bleak months, Goya chooses to concentrate on the plight of the starving poor.

Blind Man's Buff

The following year, Goya accepted a commission from Charles III to design cartoons for his daughter's bedroom. Appropriate to the room, the cartoons illustrate merry pastimes in Madrid. *Blind Man's Buff* (pp.86-7) shows fashionable members of society on the edge of a mountain lake, playing a nursery game in which a blindfolded man attempts to touch the other players with a wooden spoon.

Hunter Loading His Gun, 1812-1813, sepia wash, 20.5 x 14.5 cm, Private Collection, Paris.

Hunter with His Dog, Waiting, 1812-1823, sepia wash, 20.5 x 14.5 cm, Private Collection, Milano.

Hunter with His Dog, 1812-1823, sepia wash, 20.5 x 14.2 cm, Private Collection, Paris.

Hunter with His Dog Bringing back a Rabbit, 1812-1823, sepia wash, 20.5 x 14.6 cm, The Metropolitan Museum of Art, New York.

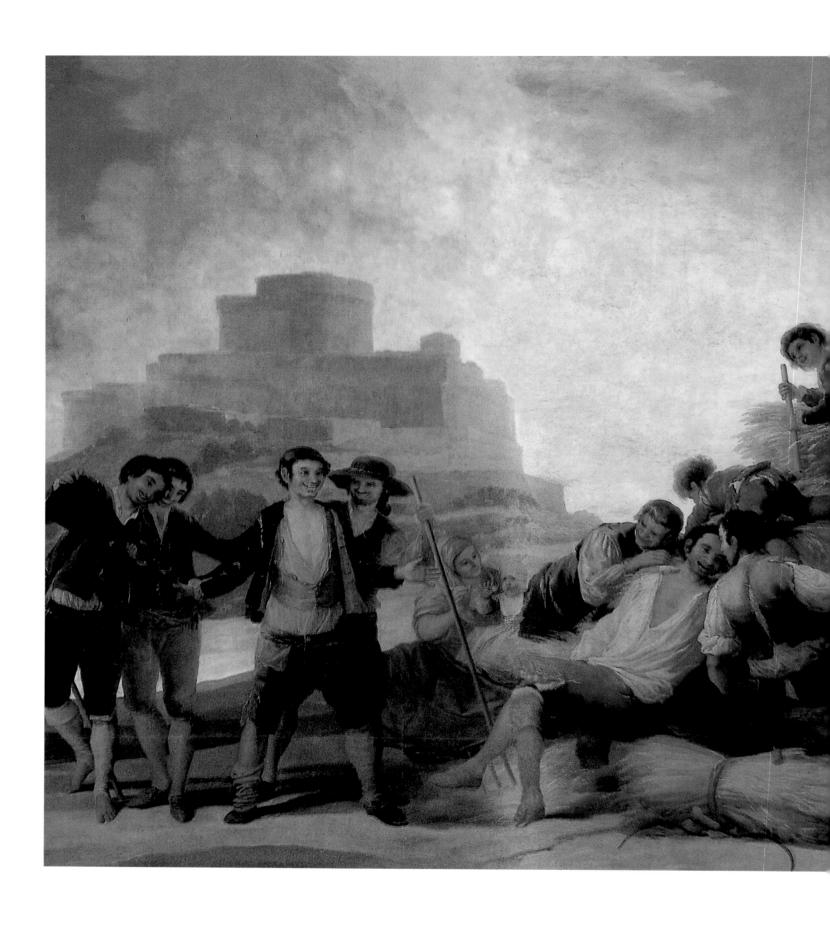

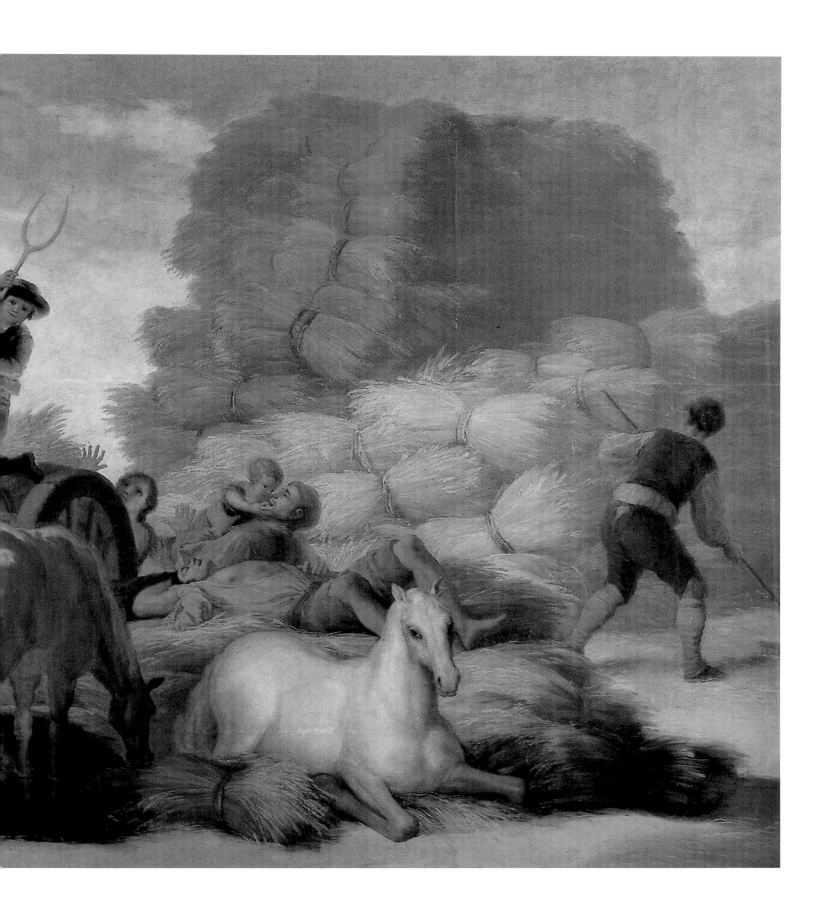

Summer (Harvesting),
1786-1787, oil on canvas,
276 x 641 cm, Prado Museum,
Madrid.

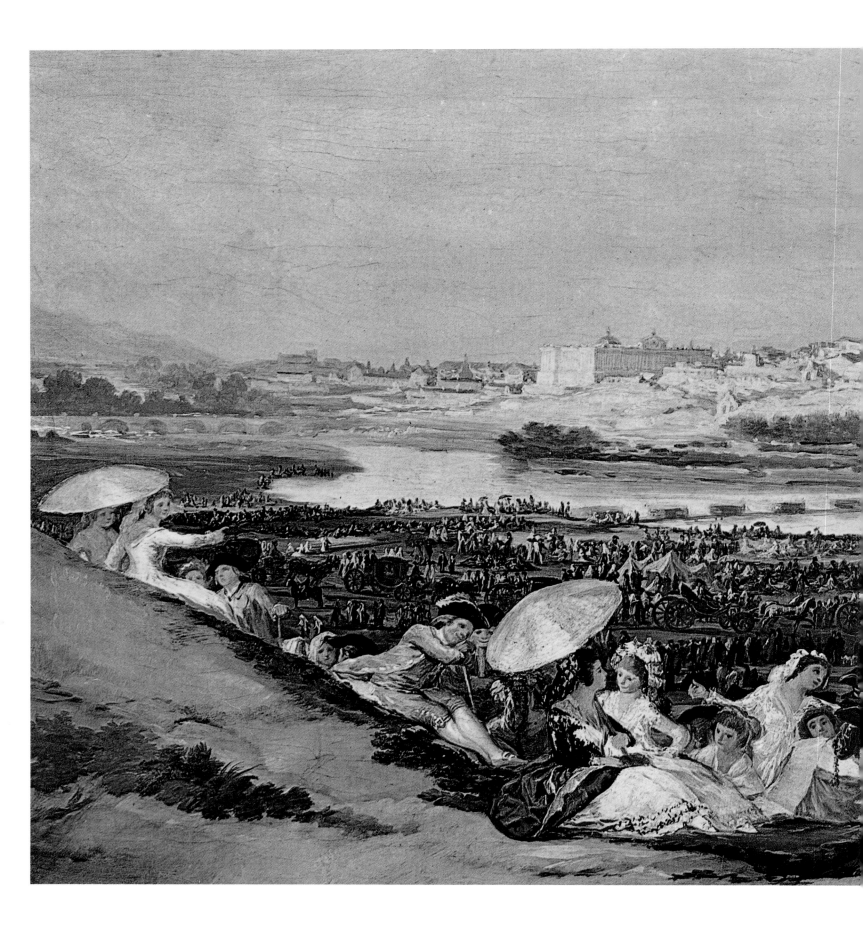

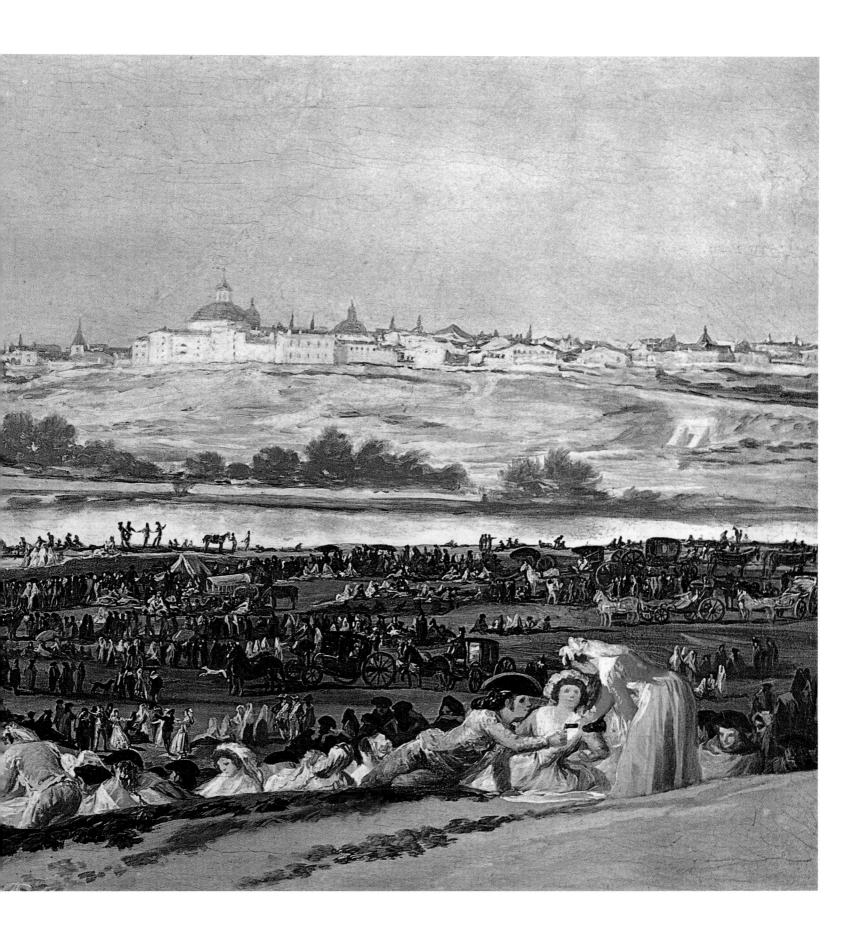

The Meadow of San Isidro, 1788,
oil on canvas, 44 x 94 cm,
Prado Museum, Madrid.

The Parasol, 1777, oil on canvas,
104 x 152 cm, Prado Museum,
Madrid.

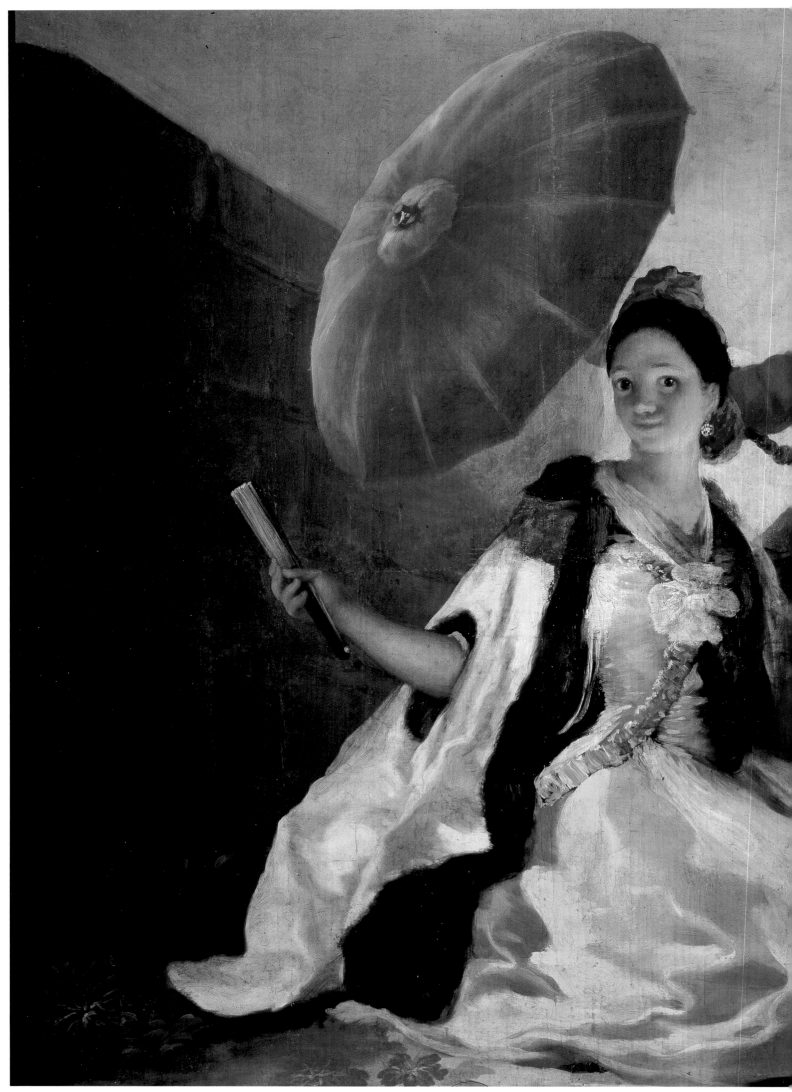

The Meadow of San Isidro

A rare example of a landscape by Goya, *The Meadow of San Isidro* (pp.78-9) shows the feast day of San Isidro, the patron saint of Madrid. This important festival, celebrated on 15 May, involved a procession of pilgrims to the Hermitage of St Isidoro followed by a picnic on the meadow in front of the saint's shrine. Goya gives an impression of the vast number of people who took part and evokes an overall sense of bustle and commotion.

In the middle distance carriages wait for the picnickers who are occupied chatting, flirting and promenading. The panoramic view looks across the River Manzanares to Madrid. In the distance can be seen the church of San Francisco el Grande and the Royal Palace bathed in the afternoon sun. The sketch was never transferred to a cartoon, because Charles III died in 1788.

"Rustic and comic themes"

The new king, Charles IV, asked Goya to produce a series of tapestry cartoons "on rustic and comic themes" for his study at the Escorial, the palace he preferred to El Pardo. The series is dominated by the large painting entitled *The Wedding* (p.83), which depicts a tragicomic marriage of convenience.

Here Goya mocks the union of a girl and a rich ugly old man. In the centre of the composition, silhouetted against the sky, the groom's dark complexion suggests that he is of mixed blood, possibly from the New World. Spectators jeer as he passes by for although his clothes are fine they are several years out of date. The procession walks under rather than over the bridge, the arch apparently leading nowhere, a device Goya uses in his scenes of prisons or madhouses.

The three ages of man are represented in the frieze of figures; age is represented by the old man to the right, the bride represents youth, while to the left a boy dancing on a cartwheel represents childhood. The child is not unlike the boy being carried in *Pick-a-Back* or *Las Gigantillas* (Little Giants) (p.69), another cartoon produced for the king's study. Today it is hard to appreciate the humour generated then by a distorted figure. The simpleton marks Goya's interest in the monstrous — his gesture is repeated in *Yard with Lunatics* (p.139), painted the year after *The Wedding* — and is reminiscent of Velázquez's famous portraits of the dwarfs of the court of Philip IV.

Also in this series is *The Straw Mannequin* (p.89), of 1791, one of the last of Goya's designs for the Royal Tapestry Factory. On Ash Wednesday, a life-sized straw mannequin was traditionally hung in the main street, taken down at dusk and tossed in the air. Goya's human-like doll, masked and dressed in a frock coat, is humiliated by four smiling girls, an allusion to women who toy with men's emotions.

The Wedding, 1791-1792, oil on canvas, 267 x 293 cm, Prado Museum, Madrid.

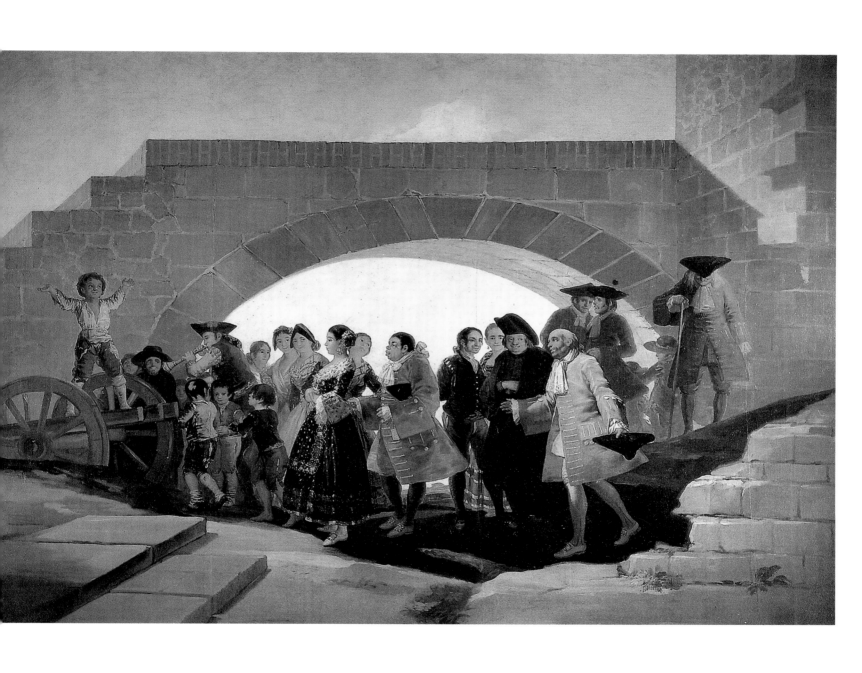

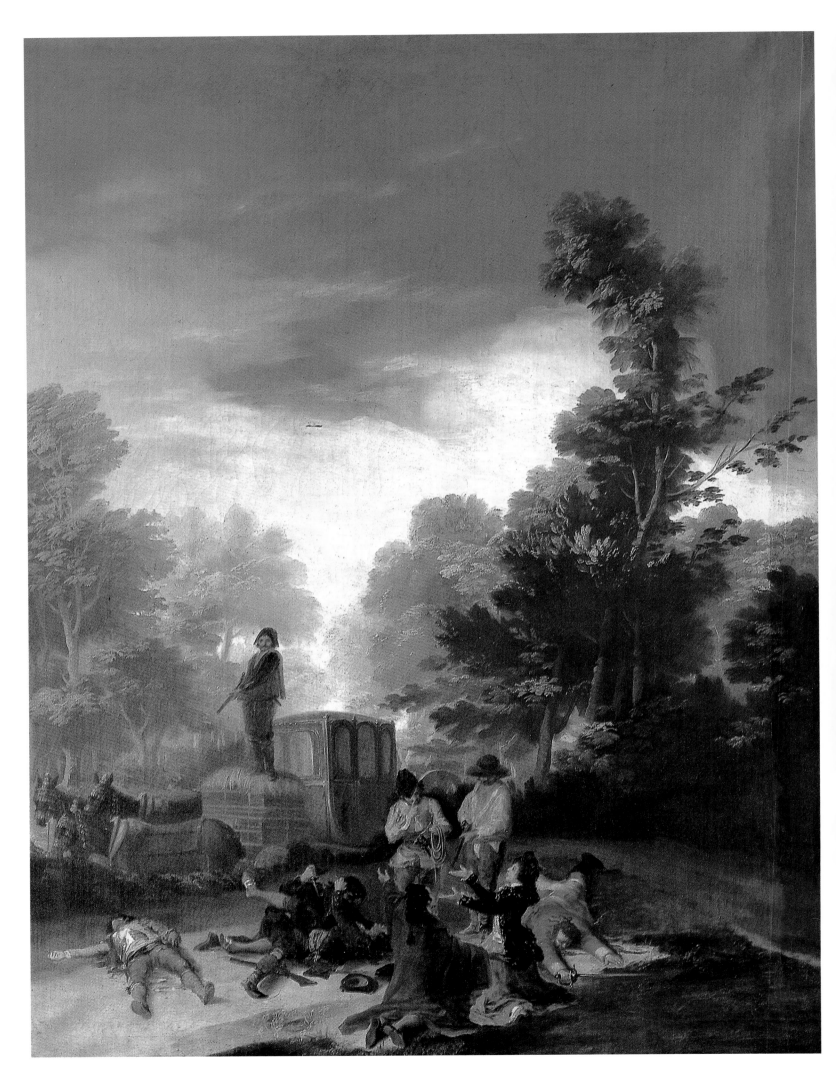

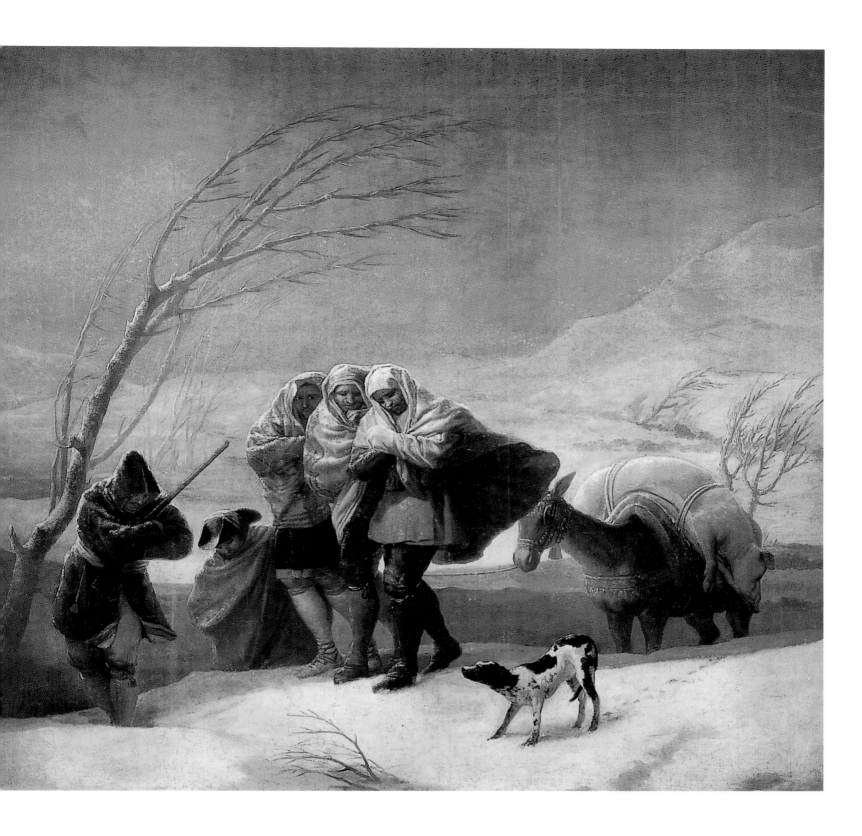

Highwaymen Attacking a Coach,
1787, oil on canvas,
169 x 137 cm, Duke of
Montellano Collection, Madrid.

Winter (The Snow Tempest),
1786-1787, oil on canvas,
275 x 293 cm, Prado Museum,
Madrid.

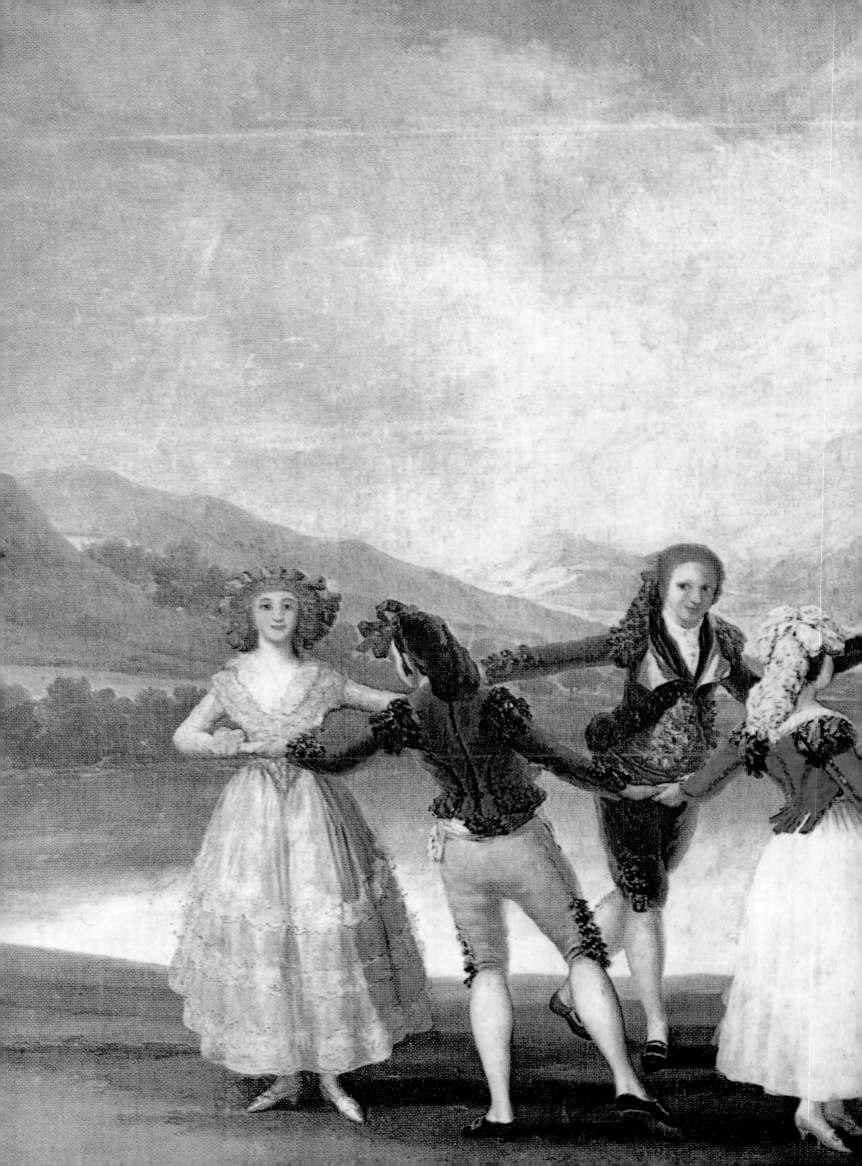

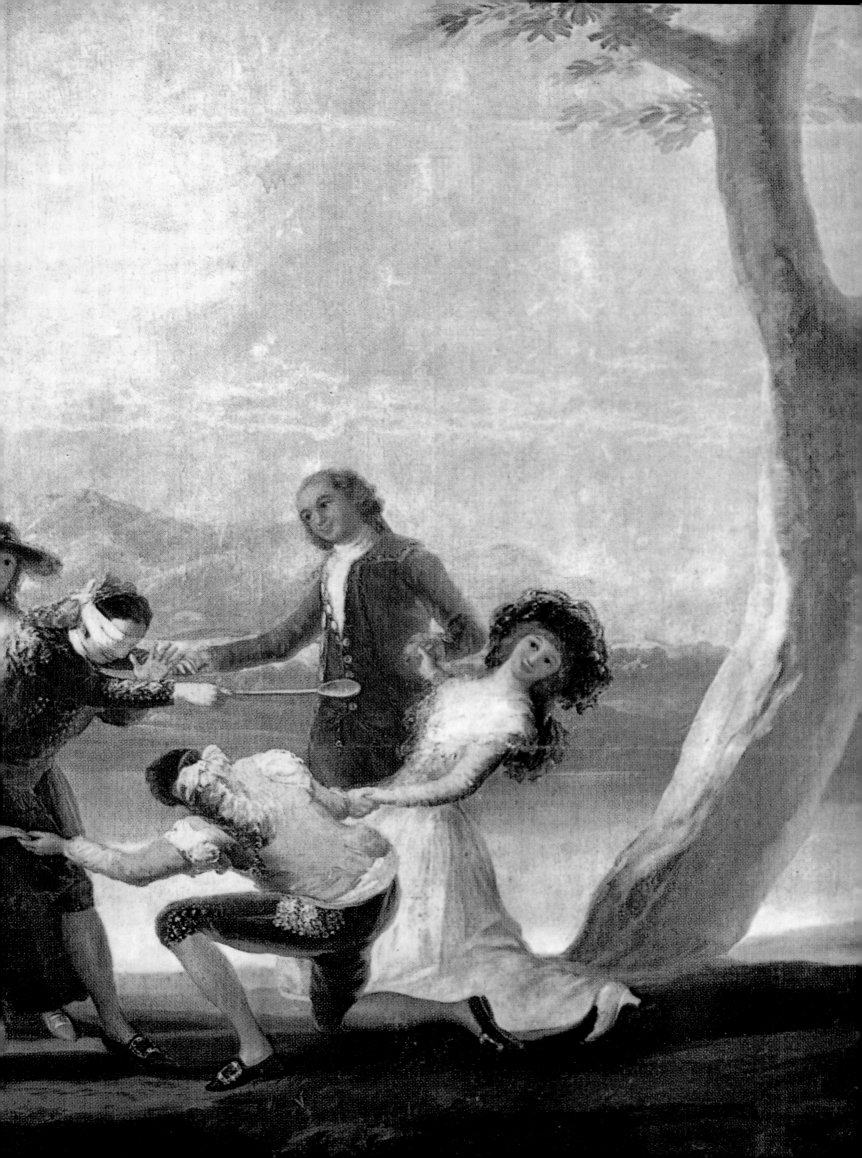

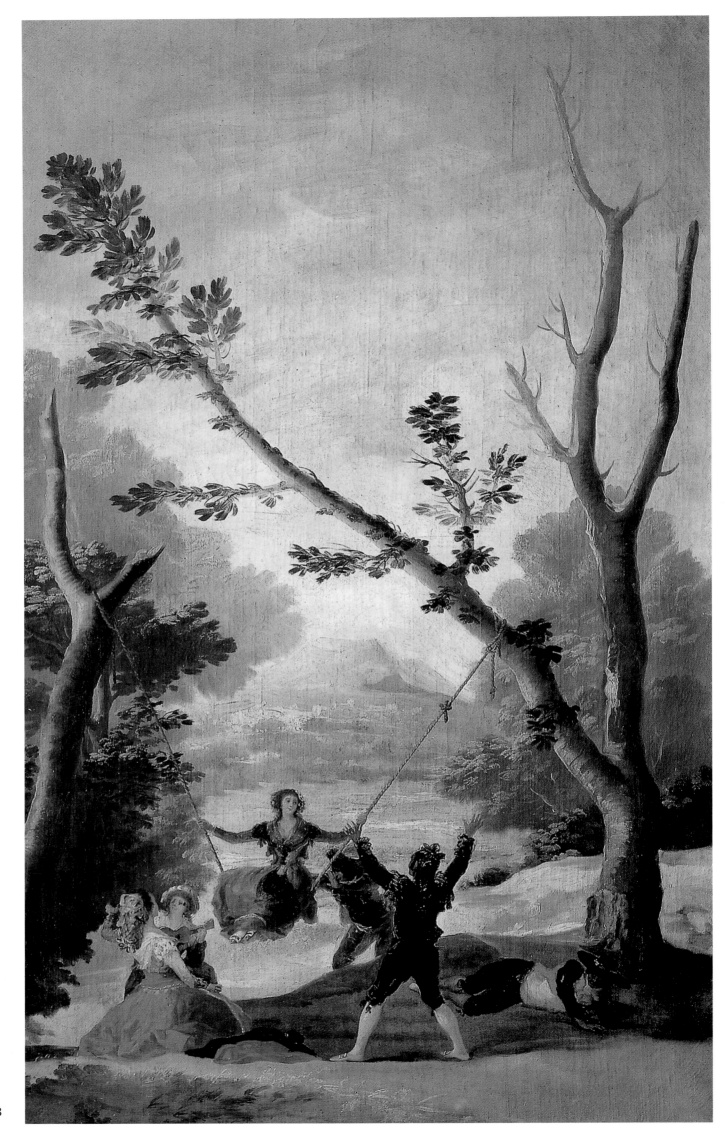

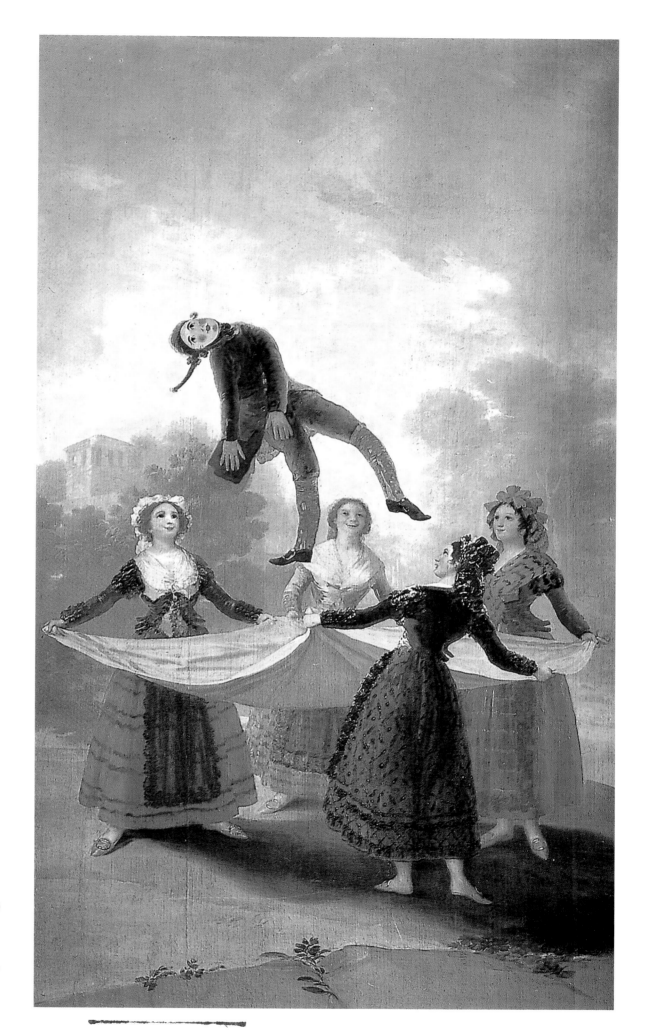

La Gallina Ciega (Blind Man's Buff),
1788-1789, oil on canvas,
269 x 350 cm, Prado Museum,
Madrid.

The Swing, 1787, oil on canvas,
169 x 100 cm, Duke of Montellano
Collection, Madrid.

The Straw Mannequin, 1791-1792,
oil on canvas, 267 x 160 cm,
Prado Museum, Madrid.

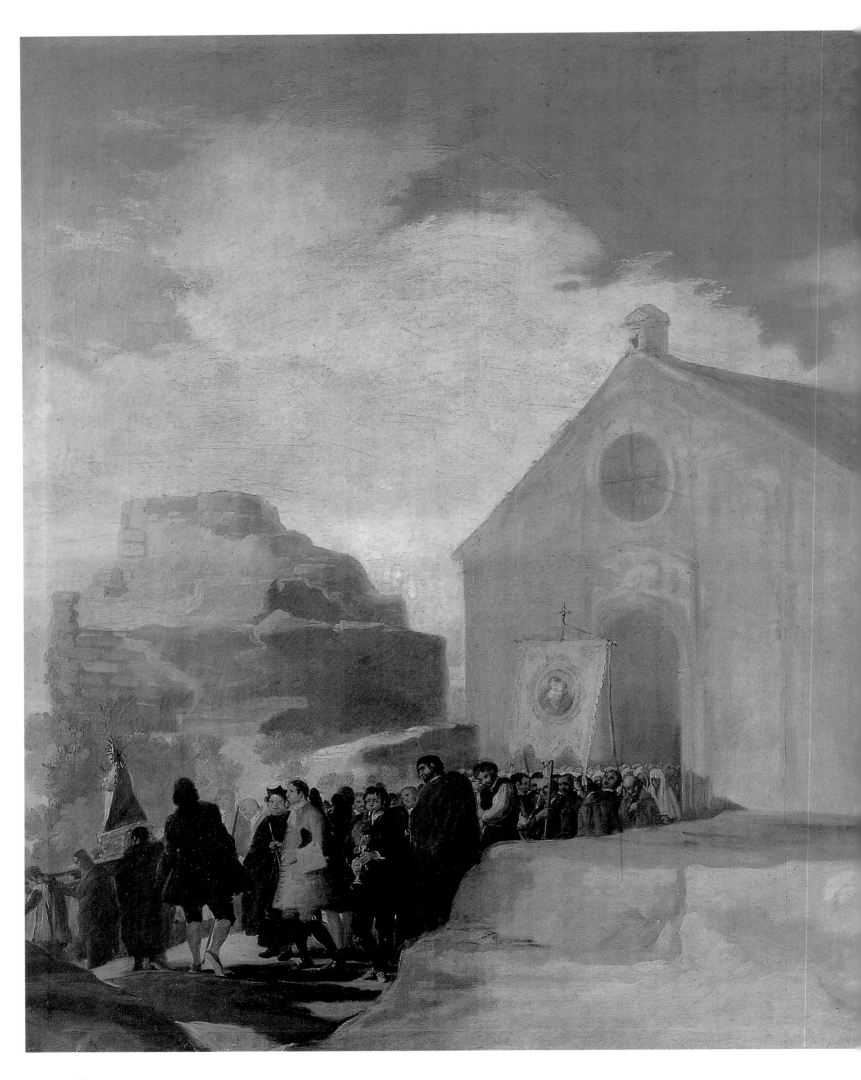

The Duchess of Osuna's commission

While fulfilling his post as painter to the king, Goya also made a series of paintings for the Duchess of Osuna, who commissioned him to paint both modern and traditional subjects for one of the principal salons of her summer residence on the outskirts of Madrid. The paintings were to be 'country scenes' appropriate to the rural location and to dwell on subjects including the theatre and nature. In April 1787 he delivered seven paintings including *The Swing* (p.88), *Village Procession* (p.90) and *Highwaymen Attacking a Coach* (p.84).

Images similar to *The Swing* would have been found in countless European boudoirs; the frivolous scene, set in an idealized landscape, is strongly influenced by French Rococo artists. The diagonals of the rope of the swing and the branch from which it hangs echo the swing's gentle rhythm. An equally balanced composition, *Village Procession*, shows the two most prominent figures of the Spanish village, the priest and the mayor, leading the congregation as they follow an effigy down a hill.

Such processions, which combined faith and folklore, occurred frequently, particularly in times of drought and disease. Criticized by reformers, these processions were the topic of debate of members of enlightened society, such as the Osunas and their circle.

Highwaymen Attacking a Coach represents the contemporary problem of highway robbery, a common occurrence along the approaches to Madrid. A coach has been stopped and a highwayman keeps guard while another stabs one of the passengers below. Two victims — the driver and a uniformed soldier who stood up to the robbers — already lie dead.

The thieves are about to tie up the two aristocratic figures in the foreground and ignore their appeals for clemency. Such attacks tended to take place in mountainous areas and, although Goya depicts the typical way in which these events took place, he has chosen to set the scene in a picturesque landscape.

The Nude Maja and The Clothed Maja

In 1798, Manuel Godoy offered Goya the opportunity to compete with the reputation of his most prominent predecessor as court artist, Diego Velázquez (1599-1660). On the death of the Duchess of Alba, Godoy had bought Velázquez's *Rokeby Venus*, painted around 1650 (p.98), from her collection. It hung in a special cabinet along with other paintings of Venus, and Godoy commissioned from Goya a nude to hang beside it.

The nude is uncommon in Spanish art, owing to church disapproval. In this case the model is probably Godoy's mistress Pepita Tudo, a beautiful and celebrated actress, and not, as has been supposed, the Duchess of Alba.

Village Procession, 1787, oil on canvas, 169 x 137 cm, Private Collection, Conde de Yedes, Madrid.

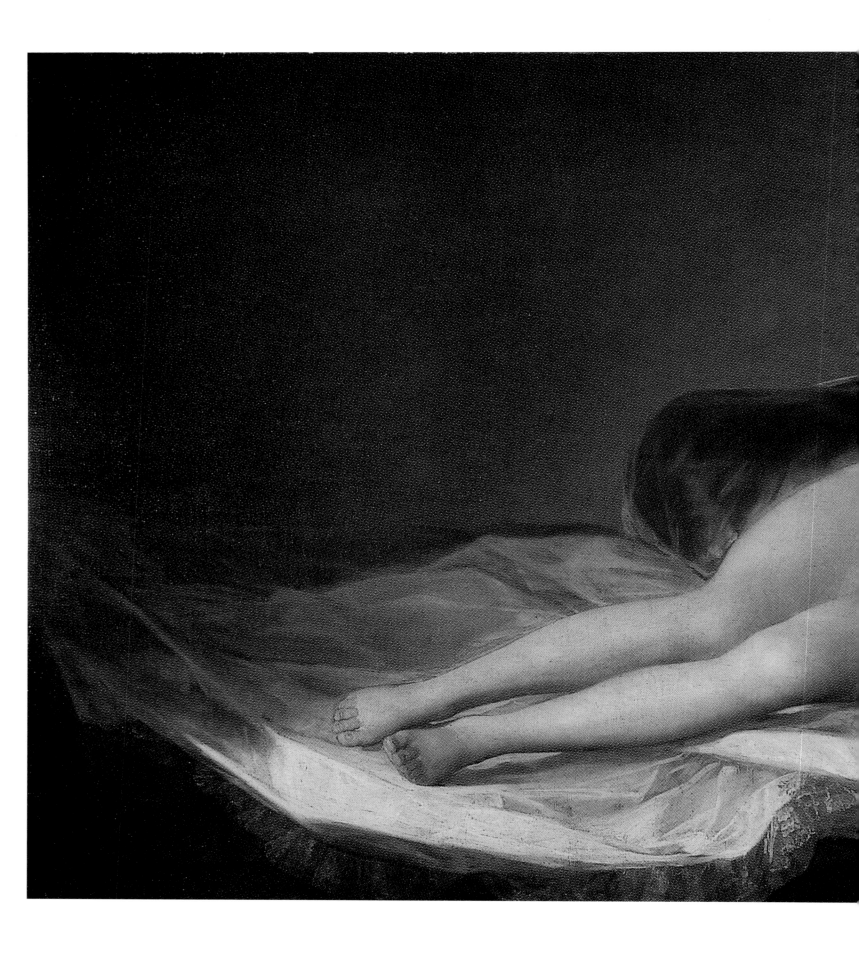

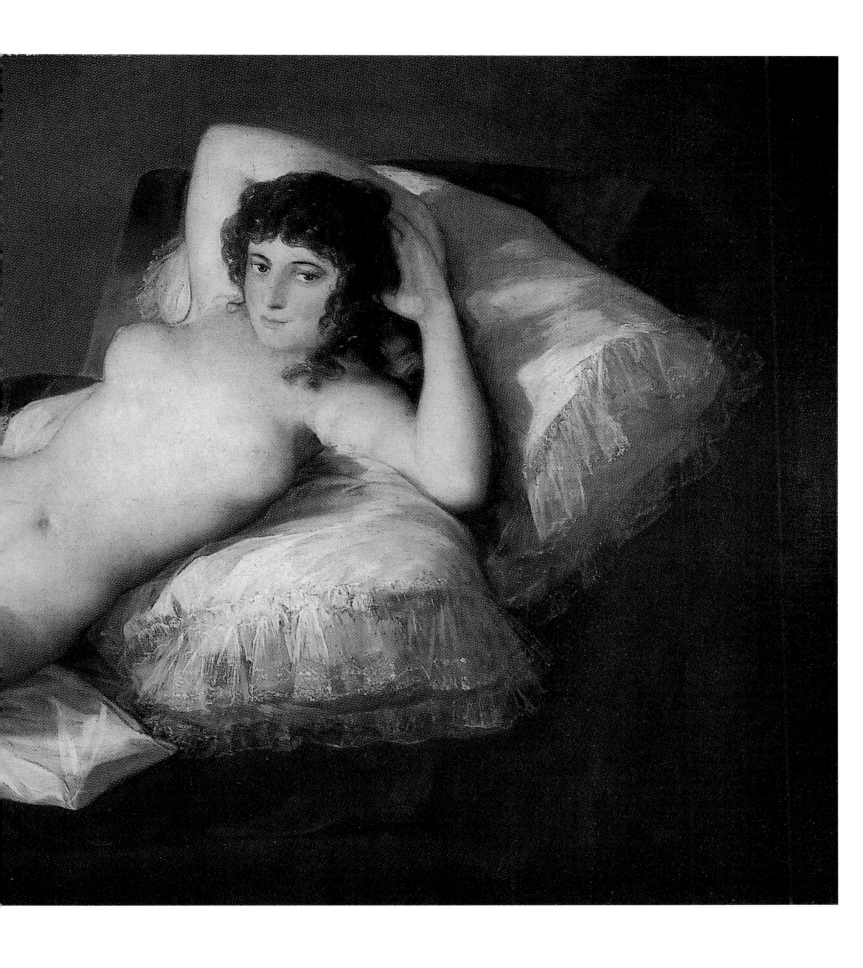

The Nude Maja, 1798-1805,
oil on canvas, 97 x 190 cm,
Prado Museum, Madrid.

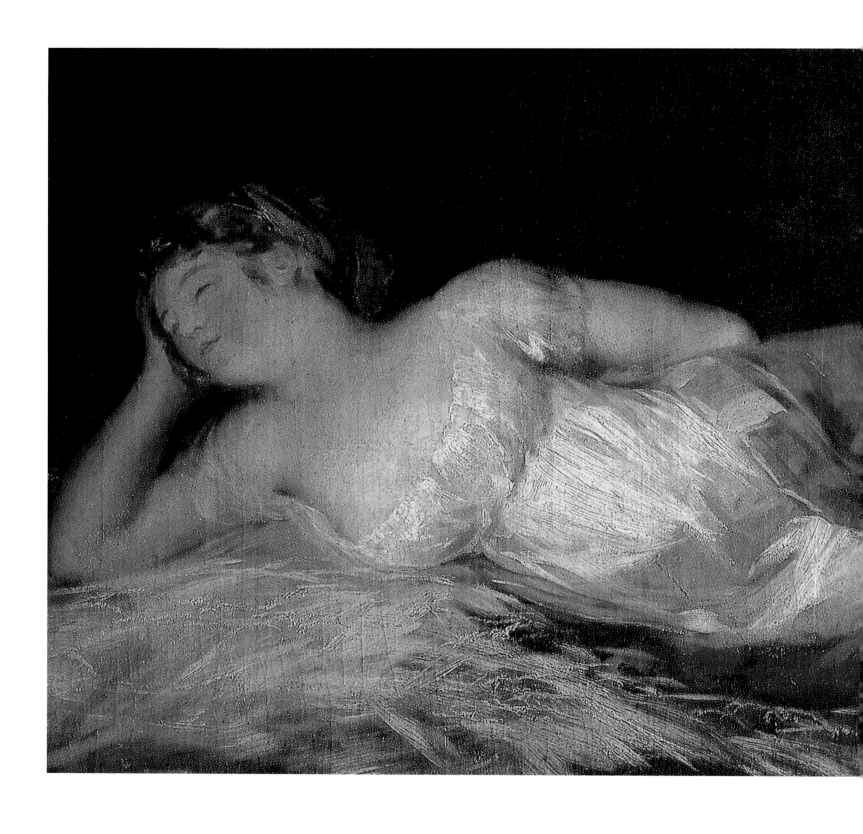

The Marquesa de Santa Cruz, 1805,
oil on canvas, 124.7 x 207.9 cm,
Prado Museum, Madrid.

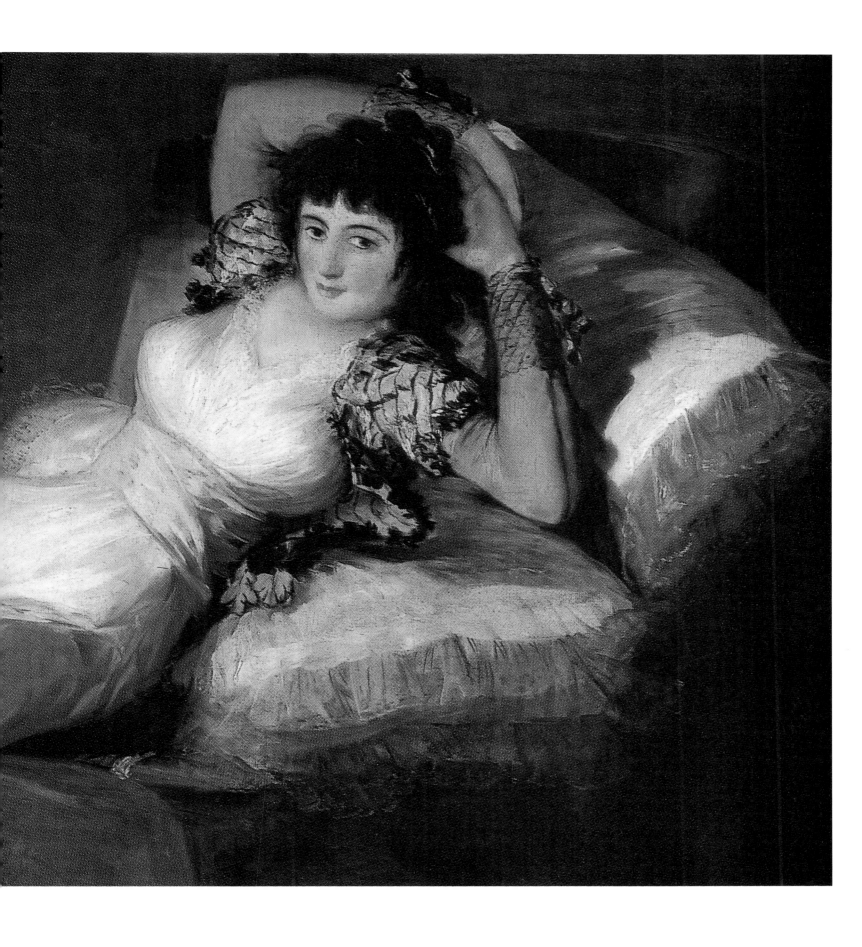

The Clothed Maja, 1798-1805,
oil on canvas, 95 x 190 cm,
Prado Museum, Madrid.

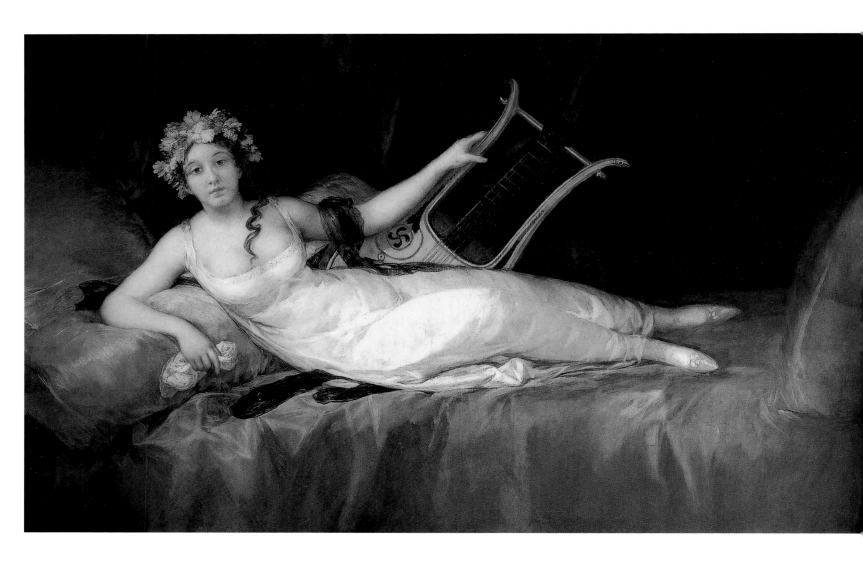

Diego Velázquez, *Rokeby Venus*,
ca.1648, oil on canvas,
122.7 x 177 cm,
National Gallery, London.

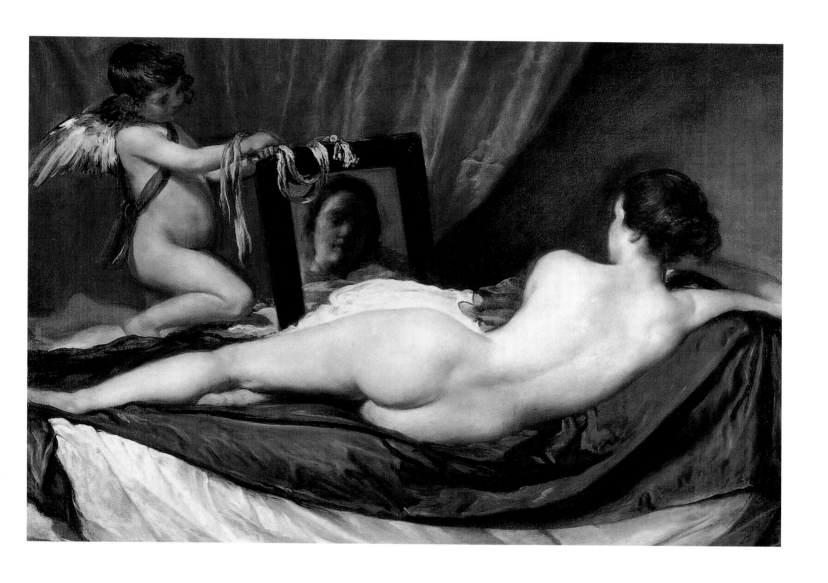

Young Woman Asleep, ca.1792,
oil on canvas, 59 x 145 cm,
Antonio MacCrohon Collection,
Madrid.

As the title of the painting suggests, *The Nude Maja* (pp.92-3) has no mythological disguise; she is no goddess, but a woman of the world. Her purpose is to seduce; her provocative pose, with her hands behind her head, displays her slim waist and softly rounded form. Her open manner seems to invite the spectator to come and lie with her on her bed of silk and velvet. When Godoy fled from Spain in 1808 the painting was hidden in a backroom of the Academy, where it stayed until 1901, when it was transferred to the Prado Museum.

Within Goya's lifetime the painting came to the notice of the Inquisition who considered it obscene and immoral, and in March 1815 the Inquisitor General summoned Goya for questioning. The artist's reply is unknown, but it is hard to imagine how Goya defended this overtly sensual nude.

It is not known if *The Clothed Maja* (pp.96-7) was painted before or after *The Nude Maja*. In exactly the same pose, but in a bolder style than her nude counterpart, the figure is just as inviting and desirable. Her clothes barely disguise her voluptuous figure, the shadows of her dress outline the shape of her legs and the pink sash accentuates her waist. Her lips form a half-smile as if she too is enjoying the comparison between her dressed state and her unashamed nudity (pp.92-3; 96-7).

Private sketches

Goya was fascinated by women from all walks of life and in different situations. His sketchbooks include the *Andalusian Dancer and a Guitarist* (p.102) and the erotic *Young Woman Bathing at a Fountain* (p.102). In the sketchbook known as 'Album B' there is a sequence of drawings on the nature and customs of prostitutes. Goya often refers to the beguiling nature of women. *Nice Teachings* (p.103) carries the caption, "The advice is worthy of her who gives it. The worst of it is that the girl will follow it absolutely to the letter. Unhappy the man who gets anywhere near her!"

The Milkmaid from Bordeaux

In his voluntary exile in France, Goya was described by his friend Moratin, with whom he was staying, as "deaf, old, feeble, weak, not knowing a word of French, but so happy and so anxious to try everything." Even in his old age, Goya loved to paint pretty women. *The Milkmaid from Bordeaux* (p.101), the last great painting of his life, immortalizes an ordinary rosy-cheeked girl. Owing to his habit of reusing canvases, Goya's milkmaid seems to face a shadowy figure of a bearded man in a hat who emerges through the surface of the paint. Produced when he was about eighty and free from commissions, Goya paints with extremely loose brushwork that anticipates the techniques of the Impressionists.

Milkmaid from Bordeaux, 1825-1827, oil on canvas, 74 x 68 cm, Prado Museum, Madrid.

Young Woman Bathing in a Fountain, 1796-1797, Album A, (Sanlúcar), Indian ink wash, 17.1 x 10.1 cm, National Library, Madrid.

Andalusian Dancer and a Guitarist, 1796-1797, Album A (Sanlúcar), Indian ink wash, 10.6 x 9.2 cm, Prado Museum, Madrid.

Bellos Consejos (Nice Teachings),
1797-1798, from *Los Caprichos*,
pl. 15, etching with aquatint,
21.8 x 15.3 cm,
Calcografía Nacional, Madrid.

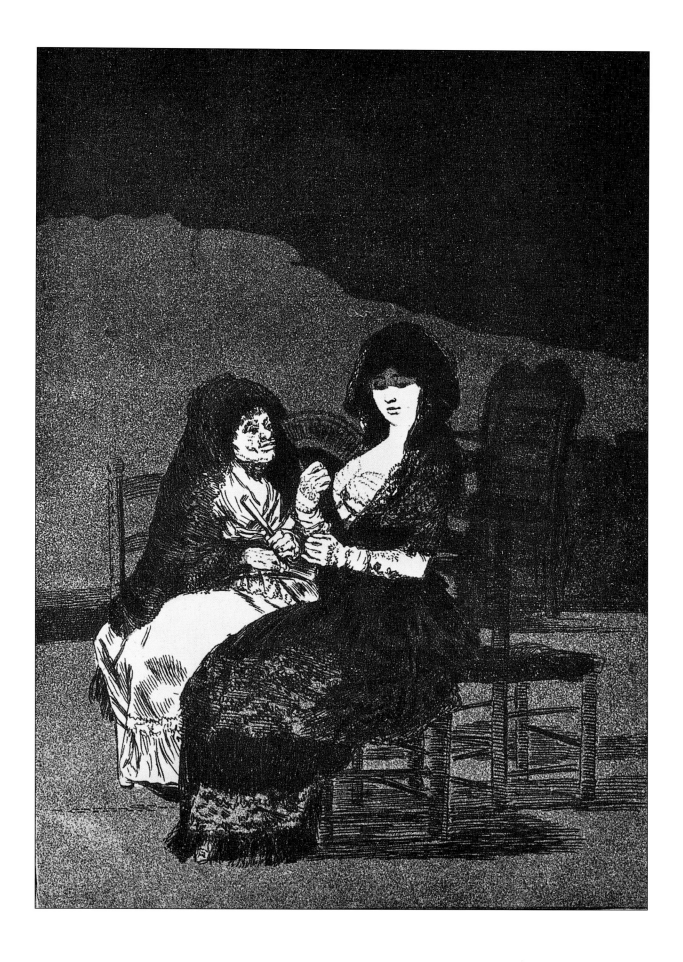

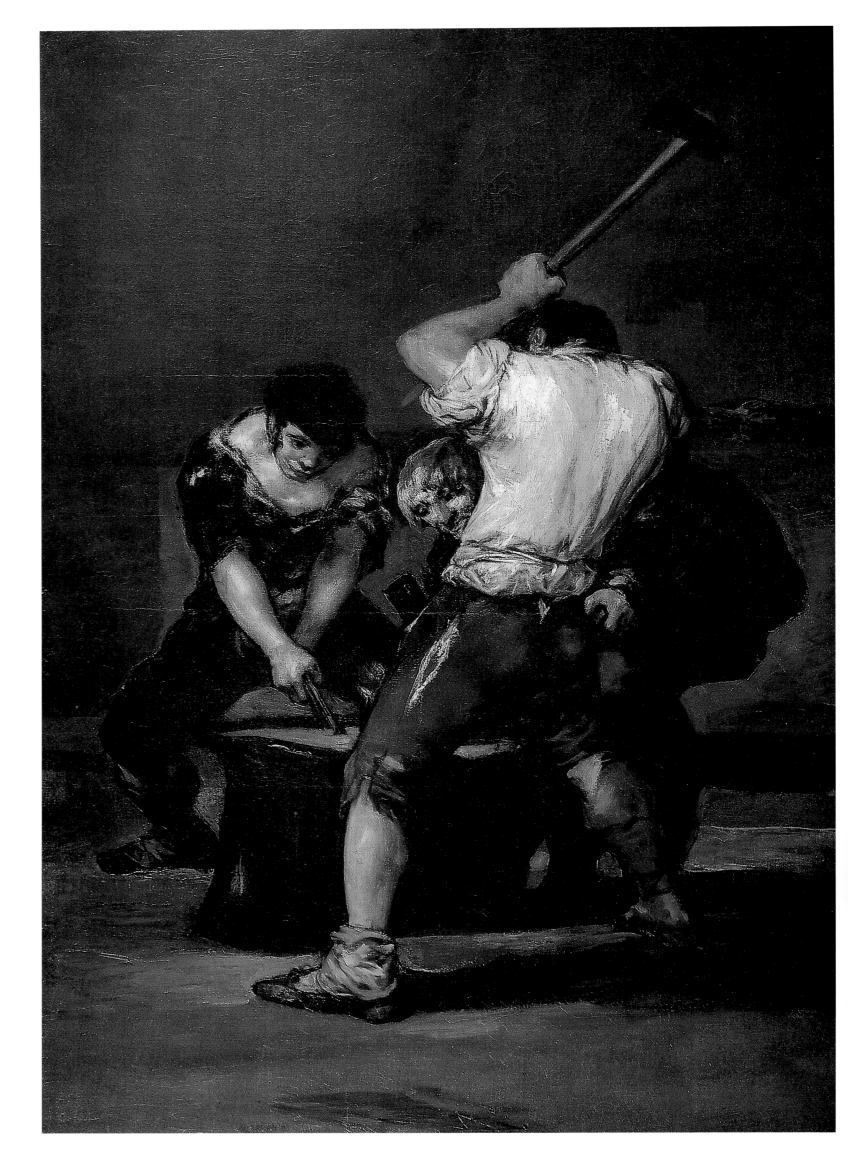

V

Social Comment

The several royal commissions received by Goya for tapestry cartoons enabled him to record his observations of the world around him. The majority were light-hearted depictions of life in and around Madrid, but also among them are early examples of Goya's more socially critical work.

In the tapestry cartoon of 1786, *The Wounded Mason* (p.118), Goya shows the dangers labourers faced while carrying out their work. Traditionally, scaffolding was sometimes used in calendar illustration to represent summer, and *The Wounded Mason* hung beside the four seasons in the dining room at El Pardo (see 'Spanish Life'). The painting depicts two men carrying an injured mason who has presumably fallen from the scaffolding seen in the background. The image reflects Charles III's genuine desire to improve working conditions; so common were scaffolding accidents that in 1778 Charles had issued an edict which set down standards for the construction of scaffolding and made provisions for the injured and their families.

The Forge

In *The Forge* (p.104), painted nearly thirty years later between 1812 and 1816, Goya portrays blacksmiths at work. Two powerful men work at an anvil while an elderly man crouches between them. The figures illustrate heroic types who show no resentment at the drudgery of their task, nor the anonymity of their lives. The painting has been interpreted as a political allegory, alluding to the role of the common people during the Napoleonic war, who hammered away at the enemy and helped to forge the constitutional government that the enlightened had wanted to establish in Spain.

The Capture of the Bandit Maragato

Goya's imagery is usually of a generalized nature but occasionally he records specific events. From 1806-7 he produced a series of six small paintings entitled *The Capture of the Bandit Maragato* (p.109; pp.110-111). The six panels, with a vivid narrative style, one panel leading into the next like a comic strip, illustrate how Pedro de Zaldivia, a brave and determined monk, disarmed the bandit known as 'El Maragato' and brought about his arrest. The event caught the popular imagination of Spain and was celebrated in poems, ballads and tales.

The Forge, 1812-1816,
oil on canvas, 181.6 x 125 cm,
Frick Collection, New York.

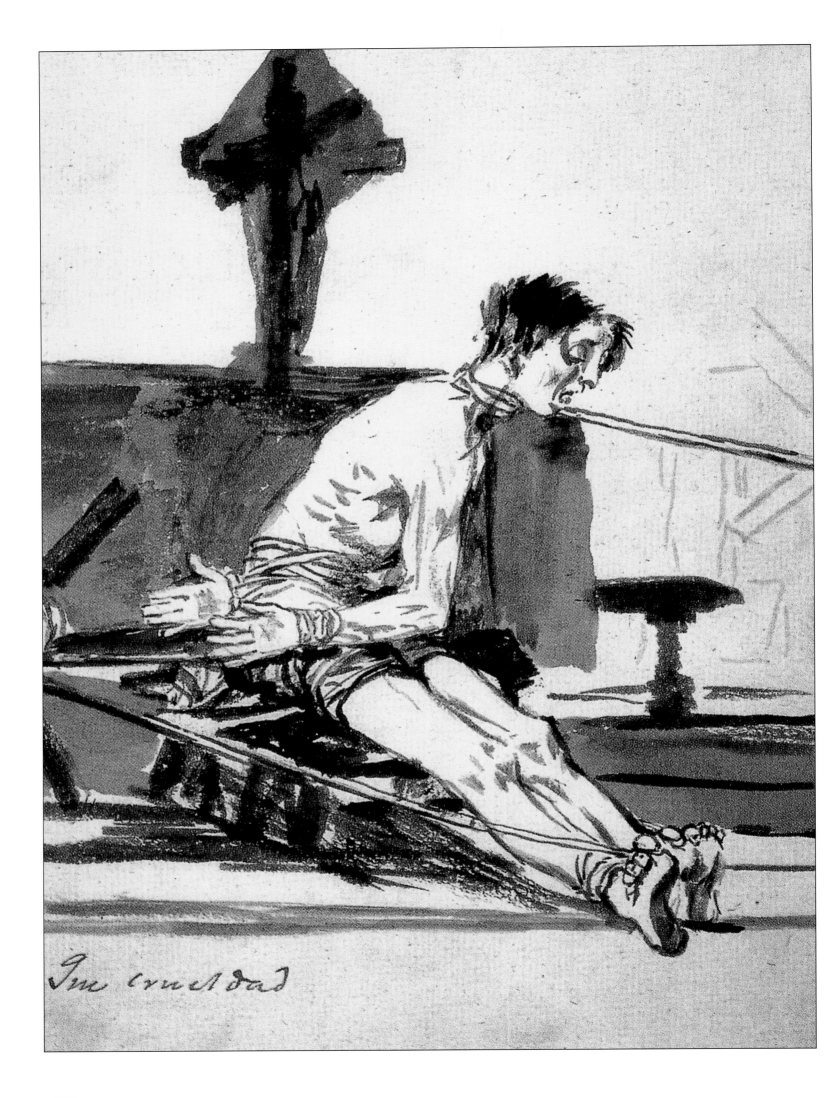

Que crueldad

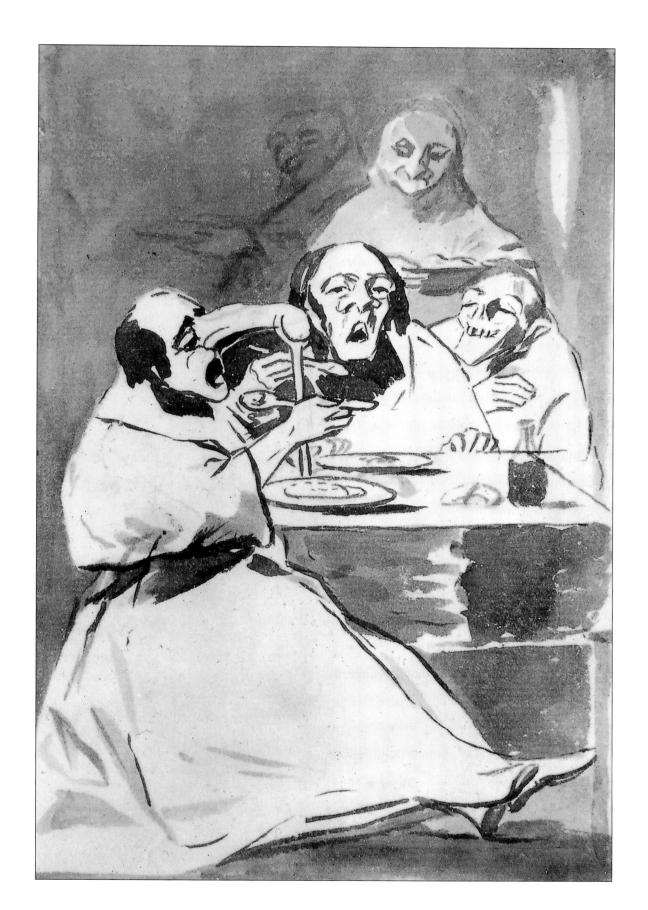

Que crueldad! (What Cruelty!),
1814-1823, Album C, pl. 108,
sepia wash, 20.5 x 14.2 cm, Prado
Museum, Madrid.

Caricatura alegre (Merry
Caricature), 1796-1797,
Indian ink wash, 19 x 13 cm,
Prado Museum, Madrid.

Que se rompe la cuerda!
(May the Rope Break!),
ca. 1815-1820, etching with
aquatint, 17.5 x 22 cm,
Prado Museum, Madrid.

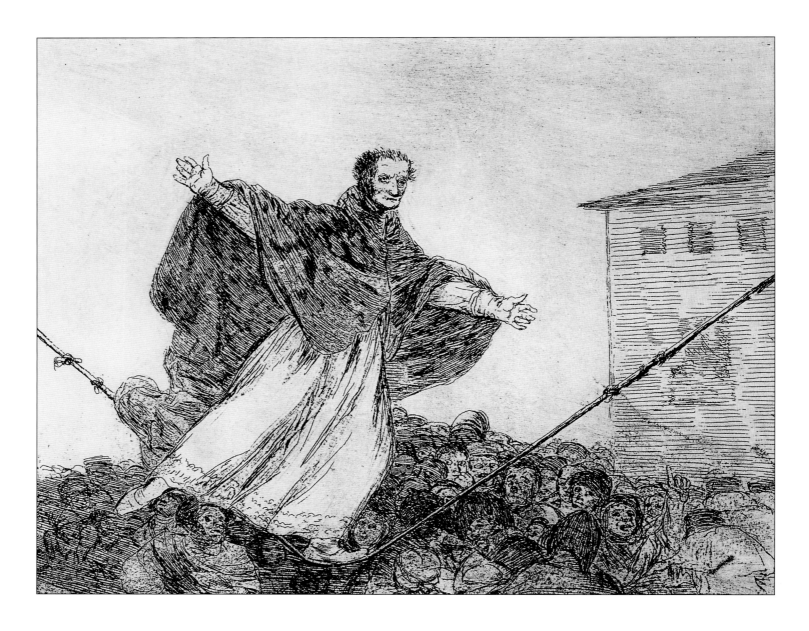

The story was recorded in an official publication, which Goya's series follows closely. In 1806, El Maragato, imprisoned and condemned to die for his crimes, escaped and, stealing guns and a horse, made his way to a house near Toledo, where he held the residents hostage. Among them was Father Pedro, a monk seeking alms. El Maragato noticed that one of his hostages wore shoes in better condition than his own and ordered him to hand them over. Father Pedro took his chance, saying, "Brother, I have a pair here which I think will suit you very well."

As Father Pedro approached to give him the shoes he grabbed the bandit's gun. During the ensuing struggle El Maragato ran to grab another gun from his horse. As he did so, Father Pedro fired and the horse fled. El Maragato tried to escape but the priest fired, wounding the bandit in the back of the knees. The priest then tied him up and prevented the other men, who had done nothing to help, from attacking the wounded man in cowardly revenge.

Goya's criticism of the Church

At Goya's time, Catholicism was a major force in Spanish society. The Church owned about one-fifth of the nation's wealth and, ruled by bureaucracy, fostered economic stagnation; the countryside was overpopulated by parish priests who were often ill-prepared for their work and in need of the support of an impoverished populace. Supporters of the Enlightenment sought to reform the Church. In numerous drawings and engravings, Goya mocks the clergy's stupidity and vice. *Merry Caricature* (p.107) represents the church as a parasite; surrounded by figures with gaping mouths and blank

El Maragato Points a Gun at Friar Pedro, about 1806-1807,
oil on panel, 29.2 x 38.5 cm
The Art Institute of Chicago,
Chicago.

Friar Pedro of Zalvidia Diverts El Maragato's Gun.

Struggle between Friar Pedro and Maragato.

Friar Pedro Strikes El Maragato.

El Maragato Threatens Friar Pedro of Zalvidia.

Friar Pedro of Zalvidia Binds Maragato's Hands and Feet.

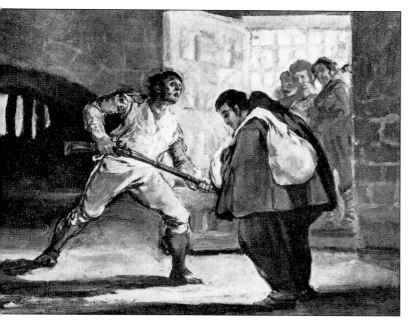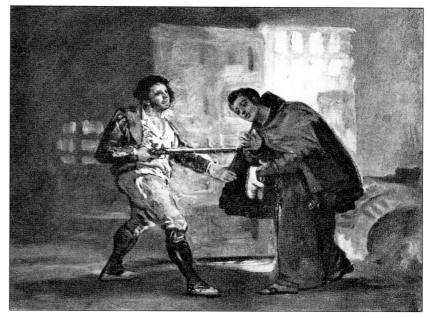

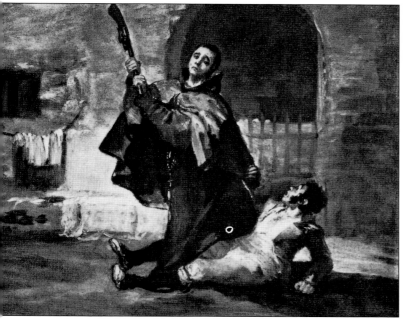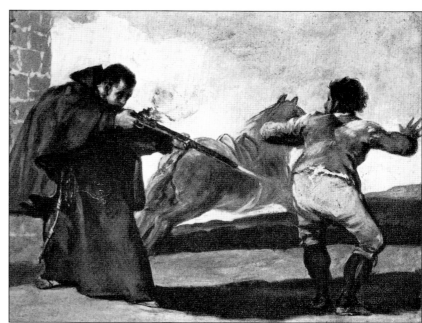

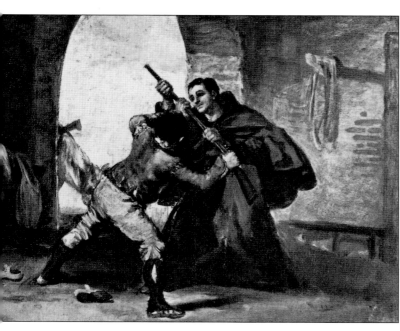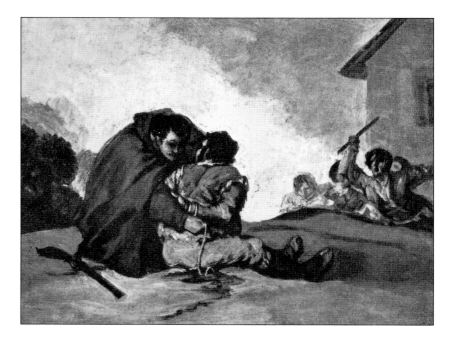

expressions, a monk can feed himself only if his huge phallic nose is supported by a crutch. *Friar Playing the Guitar* (p.113), comes from an album of drawings made between 1824 and 1828 in which Goya depicted figures who appear to have been crossbred with a race of giants. The monk's large hands make him seem hardly capable of playing the instrument he holds.

In the etching *May the Rope Break!* (p.108), made between 1820 and 1823, an ecclesiastical dignitary balances on a frayed tightrope, apparently unaware that it is about to snap. By tradition the Church had relied on the monarch for stability, and Goya takes the expression 'To dance [or walk] in the slack rope' — comparable to the modern phrase 'to skate on thin ice' — and interprets it as the precarious position of the Church on the eve of the establishment of a constitutional government that wished to weaken its powers.

Goya's condemnation of the Inquisition

The Church held a powerful grip on the intellectual life of Spain through the Holy Office of the Inquisition, an ecclesiastical tribunal dedicated to the purification of the Roman Catholic faith through the elimination of heresy. Established in the Middle Ages, its power waxed and waned according to the whims of the sovereigns who manipulated its activities. Although less active by the end of the eighteenth century, the presence of the Inquisition was still keenly felt in Goya's time. No Spanish intellectual or artist could be sure of not being hauled in front of one of its tribunals and questioned, as Goya himself was, in 1815, about *The Nude Maja*.

No se puede mirar (This Is too Painful to Look at), 1814-1823, Album C, pl. 101, brush, sepia, with Indian ink wash, 20.5 x 14.2 cm, Prado Museum, Madrid.

Use of a Pulley, 1812-1823, Album F, pl. 56, sepia wash, 20.5 x 14.3 cm, Hispanic Society, New York.

Friar Playing the Guitar, 1824-1828, Album H, pl. 3, black stone, 18.3 x 13.6 cm, Prado Museum, Madrid.

Divina Libertad (Divine Liberty), 1814-1823, Album C, pl. 115, Indian ink and sepia wash, 20,6 x 14,4 cm, Prado Museum, Madrid.

In his sketchbooks, Goya made many drawings of the physical, mental and spiritual punishments inflicted on individuals by those in power, including the Inquisition. By suggesting that extremely harsh punishments were inflicted for only minor offences, Goya's sketches highlight and condemn the injustice of the Holy Office and its unreasonable curtailment of human liberty.

As heresy was difficult to prove, the Inquisitors employed torture to extract the confessions and repentance that they considered necessary for the salvation of the soul, as well as proof of guilt. *What Cruelty* (p.106) shows a body grotesquely distorted, the awkward angles echoing the crucifix above which identifies the Inquisitors as the torturers. Physical distress and extreme pain are similarly described in both the image and the title of *This is too Painful to Look at* (p.112). *Use of a Pulley* (p.112) shows a helpless man, bound with his wrists behind him, being hauled up from the ground and let to fall repeatedly with such force that his arms are dislocated from his shoulders. Goya also expressed the relief felt by those released. *Divine Liberty* (p.113) shows a kneeling man with his arms and head raised in gratitude. The nearby inkstand and sheet of paper infer that he is a writer.

The *Inquisition Scene* (pp.114-5) was painted between 1812 and 1819 after the return of the tyrant King Ferdinand VII and Goya's own summons to appear before the tribunal. In a gloomy atmosphere, the painting shows the ceremonial reading out of charges. In the foreground, before a gathering of monks, the accused sit, in downcast resignation at their fate, wearing the conical hats circled with flames which show that they have been condemned

to death at the stake. Above them a torch illuminates the figure at the pulpit who reads out the charges with his eyes closed. He has memorized the lines and, with this figure, Goya represents how the system is blind to justice. To suggest that Spain had regressed, Goya has painted the secretary on the left of the composition in clothes of an earlier date.

The Disasters of War

The most horrific of Goya's images were provoked by the political upheavals that racked Spain during the Peninsular War of 1808-14. Aged sixty, Goya travelled through the war-torn countryside to record the events of the siege of Saragossa. On 2 October 1808 he wrote to the Secretary of the Academy that he had been asked by General José Palafox, defender of the city, "to go this week to Saragossa, to see and study the ruins of the city, in order to paint the glorious deeds of her citizens, a request which I cannot refuse since the honour and glory of my homeland are so close to my heart." Goya then returned to Madrid, where he would have heard how Saragossa fell to the French in February 1809 and the last troops of the Spanish army were defeated. In the spring of 1810 Spain attacked the French with renewed vigour, a struggle that was to reduce the country to a state of ruin; fields lay unattended, villages were ransacked and burned, and terrible atrocities were committed on both sides. As Napoleon's troops occupied most of Spain, Goya began work on a series of eighty-five prints devoted to the fearful fight, entitled *The Disasters of War*. These do not illustrate specific battles, or ruins, nor the heroes of patriotic deeds, but the suffering that men inflict upon each other. Goya drew on the incidents he witnessed on his journey to and from Saragossa, his visual powers no doubt made more acute by his deafness.

For all the prints, Goya made preparatory drawings, mostly in red chalk, and the brutal scenes have the vivid reality of having been witnessed at first hand; one print showing refugees fleeing in panic through the countryside is actually inscribed "I saw this." Among the eighty-five prints of *The Disasters of War* we see robbery, pillage, mindless killing, wounded soldiers, corpses lying in heaps and the rape of a woman in front of her husband. To emphasize the horror, Goya added ironic comments. In *Great Deeds! With Dead Men!* (p.116), mutilated naked bodies are strung up on the branches of a tree. The positions of all three men suggest the amount they suffered prior to their death. *This is Worse* (p.116) shows a mutilated body impaled on the broken trunk of a tree, the face contorted in an agonizing cry. A single branch pierces through the top of the man's back while, in the background, French soldiers savage other victims. *Charity* (p.117) focuses on naked bodies being tipped into a common grave. Peasants have stripped the corpses of their clothes and throw them into a gaping abyss, witnessed by an old man who has been identified as Goya himself.

Plates 48-64 of *The Disasters of War* depict the terrible famine which lasted from 1811 to 1812. During the war, civilian food supplies was curtailed as agricultural land was abandoned and the majority of available food was taken for the French and allied armies. Madrid suffered severely and during that year 20,000 people died of starvation. On 17 August 1812 a city newspaper, the Dairio de Madrid, reported that, "One cannot walk down the street without even the most hardened heart softening at the sound and sight of some ... who already have death painted on their faces; of others who faint from need; and others who have expired for the same reason; there one sees a group of children, abandoned by their parents, crying for bread; here a widow blackened and disfigured; and over there a maiden, assuming that she is begging in order not to compromise her chastity." *The Worst is to Beg* (p.117) illustrates a healthy young woman averting her eyes as she walks past a group of emaciated figures. Her liaison with the Napoleonic soldier will keep her from starvation for a while.

The Peninsular War was also the subject of some of Goya's most dramatic paintings. *The Colossus* (p.123) relates to the poem 'Profecia del Pirineo', by Juan Bautista Arriaza: "Lo on a height above yonder cavernous amphitheatre a pale Colossus rises; caught by the fiery light of the setting sun: the Pyrenees are a humble plinth for his gigantic limbs.

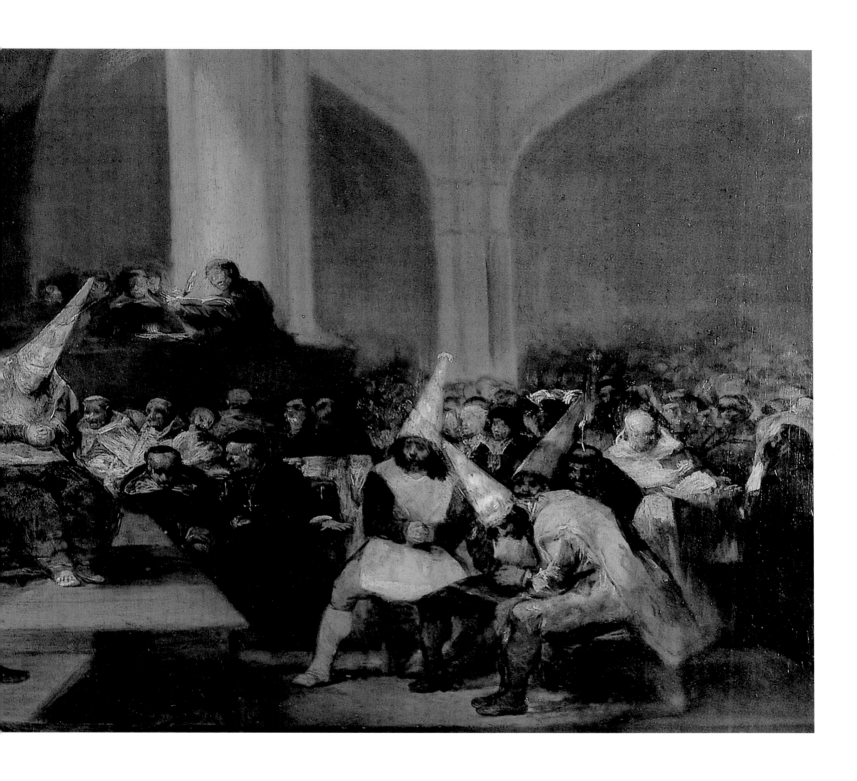

Inquisition Scene, 1812-1819,
oil on panel, 46 x 73 cm,
Royal Academy of San Fernando,
Madrid.

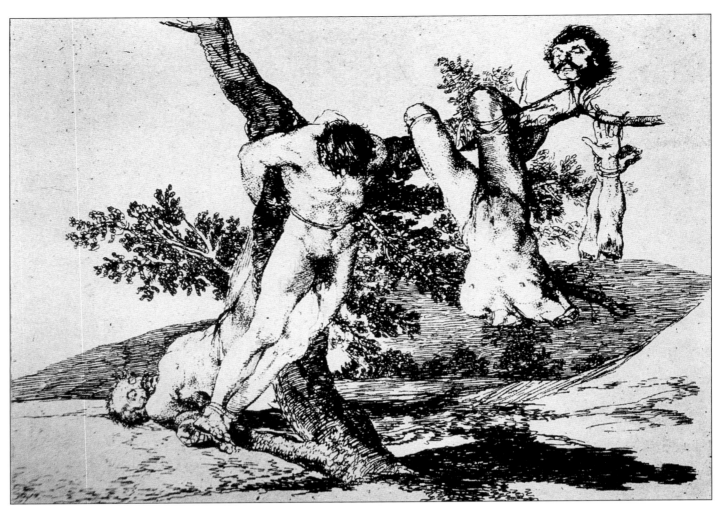

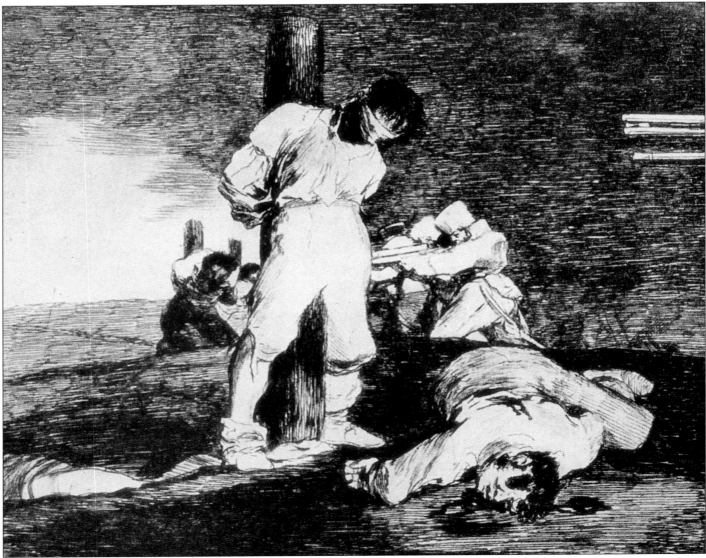

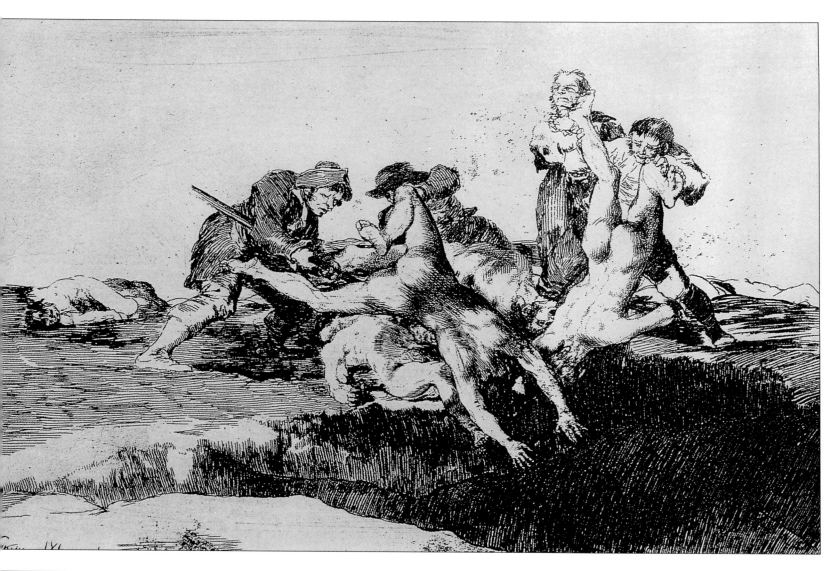

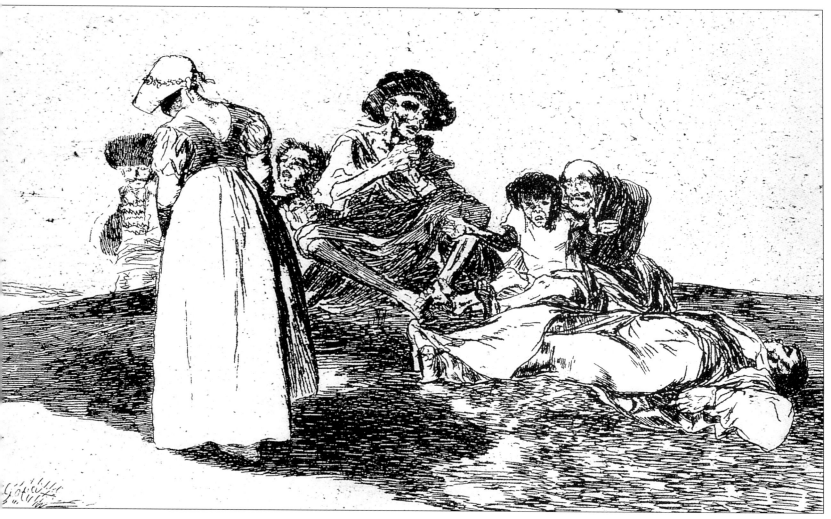

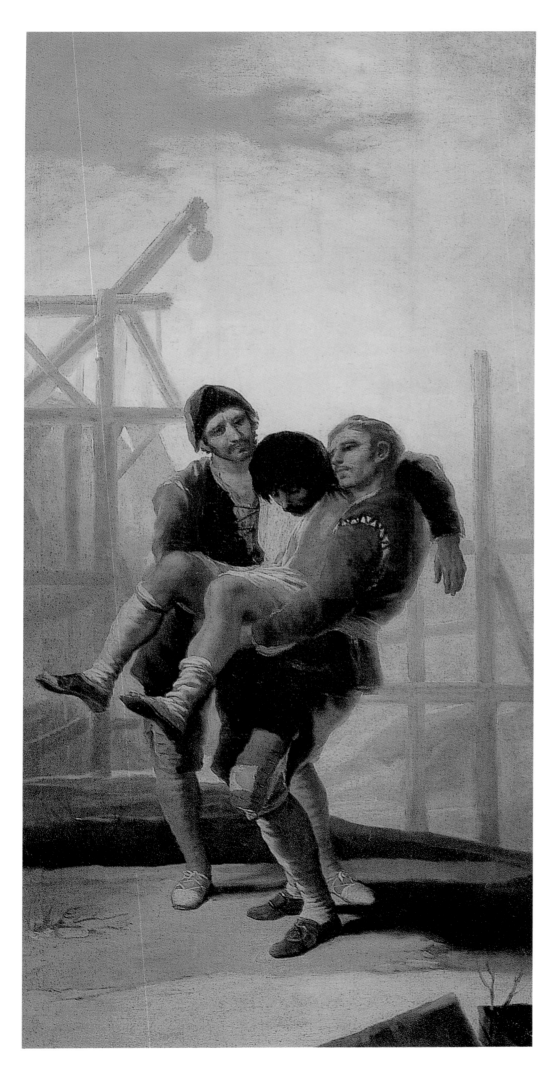

Grande Hazaña! Con muertos!
(Great Deeds! With Dead Men!),
ca. 1812-1815, *The Disasters of
War*, pl. 39, etching and tint,
15.5 x 20.8 cm.

Y non hai remedio (This Is Worse),
ca. 1810-1811, *The Disasters of
War*, pl. 15, etching,
14.1 x 16.8 cm.

Caridad (Charity), 1810,
The Disasters of War, pl. 27,
etching, 16.1 x 23.6 cm.

Lo peor es pedir (The Worst Is to
Beg), ca. 1812-1815,
The Disasters of War, pl. 55,
etching, 15.5 x 20.5 cm.

The red clouds of the west encircle his waist and the sad light in his fiery eyes make his countenance an awesome sight to see." Goya's giant rises above a valley in which people, carts, horses and cattle flee in panic. The Colossus is an ambiguous figure; he may represent the guardian spirit of Spain, turning to face his rival Napoleon, known as the 'Colossus of Europe', or he may be a representation of impotence, clenching his fists in vain against an irrepressible enemy. Folly is represented in the foreground by a donkey, standing immobile among the fleeing masses, and always a slave to the saddle, no matter who is its master.

The Second of May 1808 and The Third of May 1808

When Napoleon's troops were finally ousted in 1814 and the new liberal government installed, Goya sought the opportunity to record the incidents that marked the beginning of those violent years of conflict. He applied for, and was granted, official financial support "to perpetuate with the brush the most notable and heroic actions or scenes of our glorious insurrection against the tyrant of Europe." Goya produced two large canvases commemorating the brutal events of the 2 May and 3 May 1808; painted six years after these took place, Goya presents us with a deeply personal interpretation of what took place.

The Second of May 1808 (pp.120-1) recalls the fateful day in Madrid when a crowd of civilians gathered at the Puerta del Sol near the Royal Palace and rose up spontaneously against the French. The people of Madrid armed themselves with knives, bull-branding irons, spikes, pokers – anything that came to hand – and attacked. In response, Murat, the French Lieutenant-General, called out his cavalry to crush the rebellion and for two hours there were vicious skirmishes throughout the city. Goya's painting depicts a whirlwind of furious and violent action. In the centre of the composition a Mameluke – one of the hated Egyptian mercenaries – is pulled from his mount and repeatedly stabbed by one of the crowd. His red pantaloons sweep diagonally across the canvas, echoing the curved scimitars slashing wildly through the air. Around him chaos reigns, and above him a turbaned soldier raises his dagger to avoid a similar fate. To the left a couple wrestle for supremacy, and to the right horses surge forward in panic, a man plunging a knife into a horse's flank like a matador in the bull ring.

Badly armed and without leadership, the insurgents were brutally crushed by the strength of the French army. In response to the revolt Murat immediately issued the following statement: "The populace of Madrid, led astray, has given itself to revolt and murder. French blood has flowed. It demands vengeance." Throughout the night after the attack, and in the early hours of the following morning, the French executed, without trial, all those believed to have been connected with the uprisings.

The Third of May 1808 (p.122) recalls the executions of more than forty men and women, on the hill of Principe Pio. The focal point of the painting is a man who gasps and spreads his arms in horror at his fate. His gesture suggests that he faces death with both defiance and despair. Isolated from the shadowy figures around him, the severe light of a lantern set on the ground before his executioners highlights his white shirt and yellow trousers. His innocence is implied by the brightness of his clothes, while his gesture and wounded right palm remind us of Christ crucified. Beside him, his companions give varying reactions to their hopeless situation: a Franciscan priest hangs his head in prayer while another victim tightens his fists in futile resistance. To the left, a man shields his eyes from the sight of the carnage and the gruesome pile of dead. The head of the figure in the foreground is riddled with bullets; his arms hug the ground, outstretched like those of the central figure, while his blood pours onto the barren earth.

Time is frozen, but the outcome is clear. Within seconds the group will have fallen and been replaced by another that shuffles up the hill to face the firing squad. The merciless soldiers appear anonymous, their backs forming an impenetrable wall and their actions uniform as they prepare to fire, their feet set firmly apart to resist the rifles' recoil.

Wounded Mason, 1786-1787, oil on canvas, 268 x 110 cm, Prado Museum, Madrid.

Second of May 1808, 1814, oil on canvas, 266 x 345 cm, Prado Museum, Madrid.

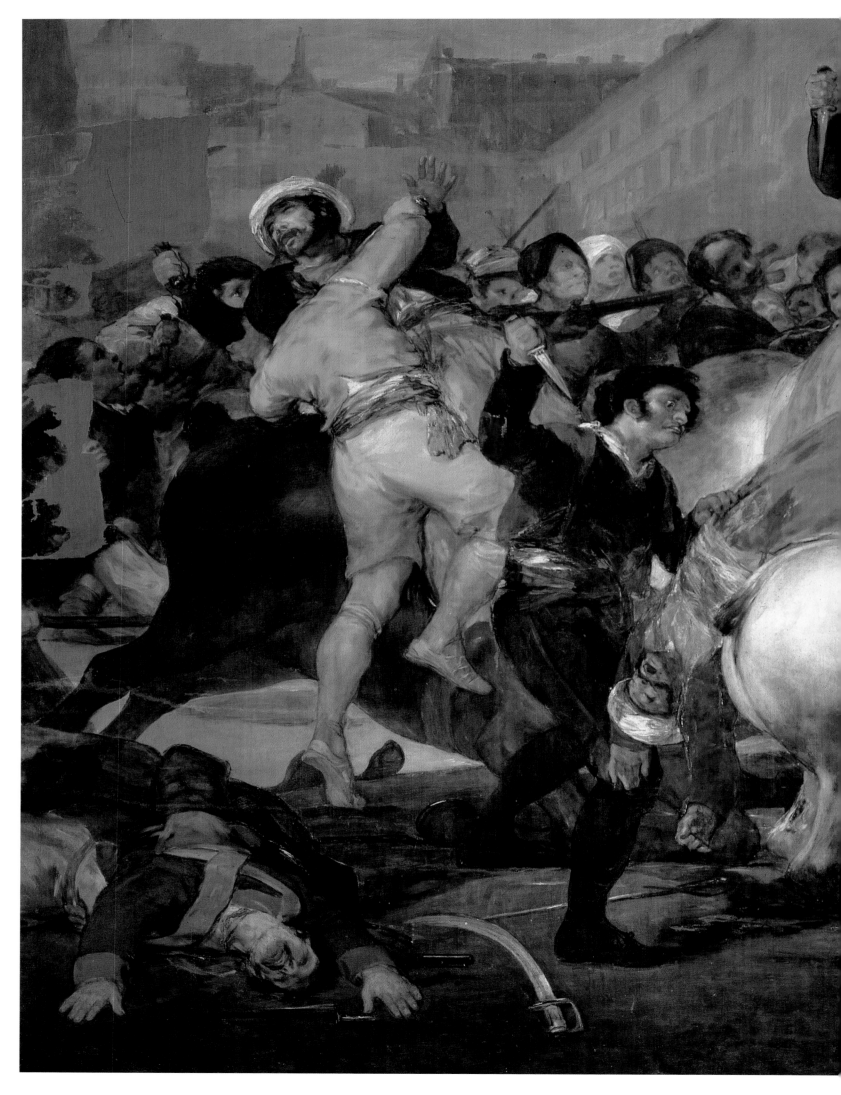

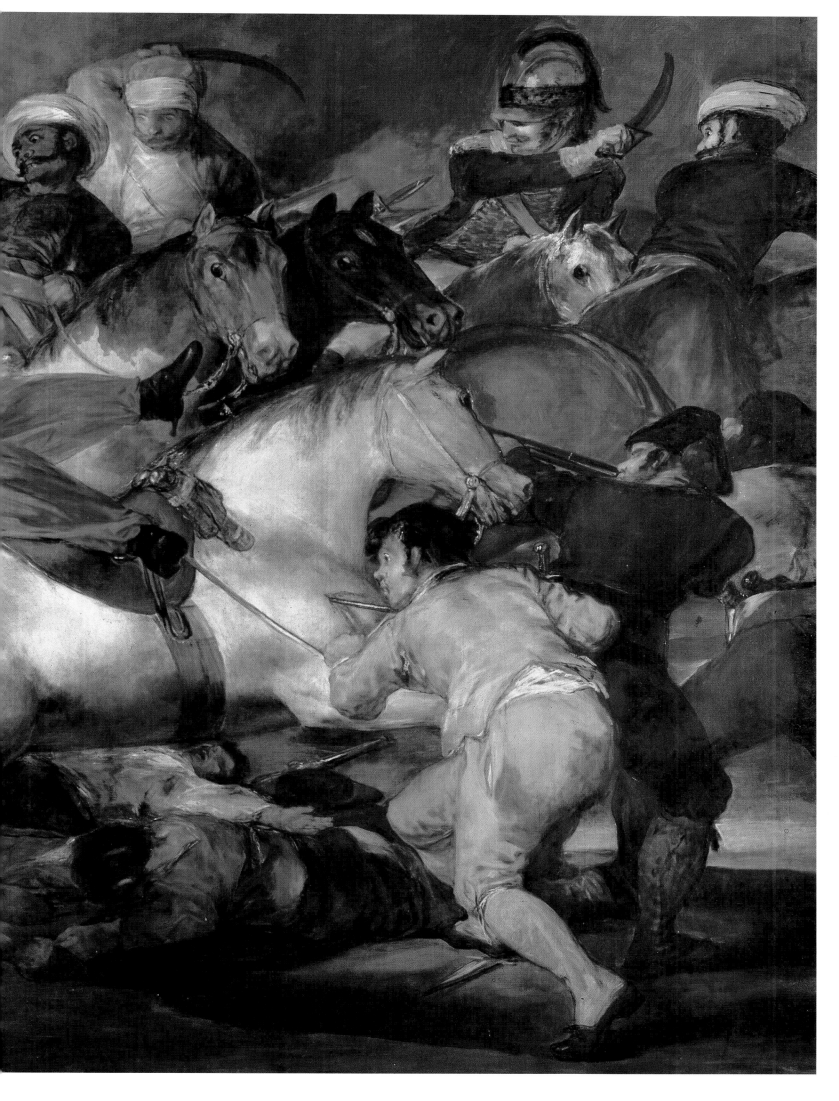

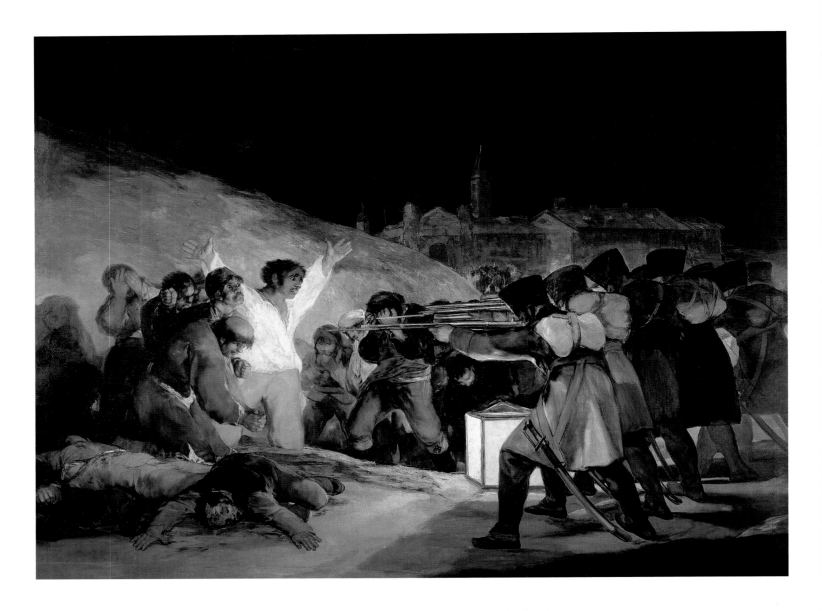

Despite the fact that Goya is reputed to have witnessed the executions and to have made sketches of the bodies, there are a number of anomalies in this work. The prisoners' hands would probably have been tied. No firing squad would shoot at point-blank range and the soldiers on the right would miss their targets; furthermore, the force of the bullets would have thrown the bodies backwards and not forwards, as Goya has shown. *The Third of May 1808* was not, however, intended as a historically accurate record but as a summation of the horror of the executions.

In order to heighten the dramatic effect, Goya has painted a bleak landscape. The outline of the church and monastic buildings in the distance locate the scene somewhere on the outskirts of the old city. The setting is vague because the executions occurred throughout the city; during that night, it was estimated that more than 400 Spaniards were shot.

Both paintings vividly evoke sound; in *The Second of May 1808* we hear the roar of battle and in *The Third of May 1808* a cry of anguish and the muffled groans of those who wait for the explosions from the guns. It is remarkable when we remember that these were painted by a man who was totally deaf.

The Third of May 1808 is a landmark in the development of nineteenth-century painting. Although on the scale of an official painting, Goya's subject is not a traditional classical hero in action but the agonizing tension of the moment before an ordinary man is shot. It is not known if this masterpiece was seen publicly during the artist's lifetime. On his death it was deposited in the Prado Museum, where four decades later it provided inspiration for that great painter of contemporary life, Edouard Manet.

Third of May 1808, 1814,
oil on canvas, 266 x 345 cm,
Prado Museum, Madrid.

The Colossus, ca. 1808-1812,
oil on canvas, 116 x 105 cm,
Prado Museum, Madrid.

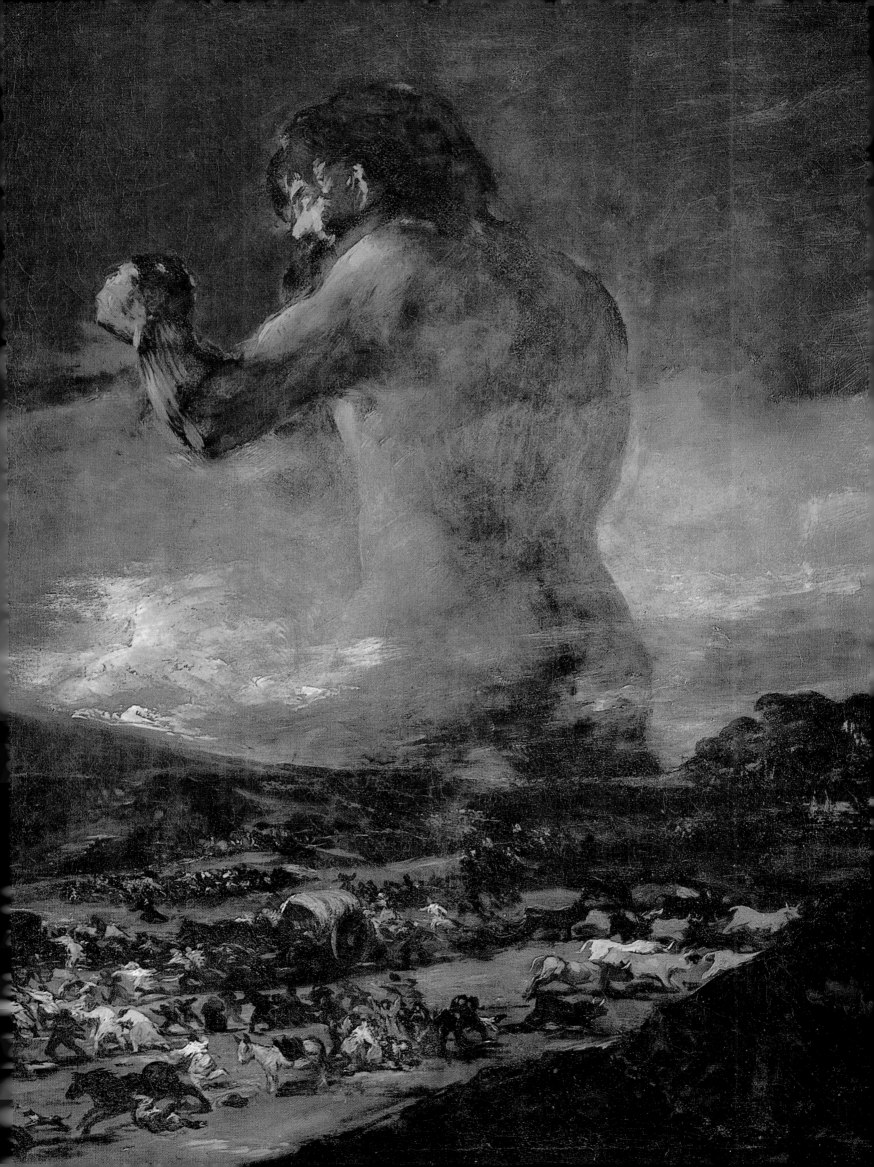

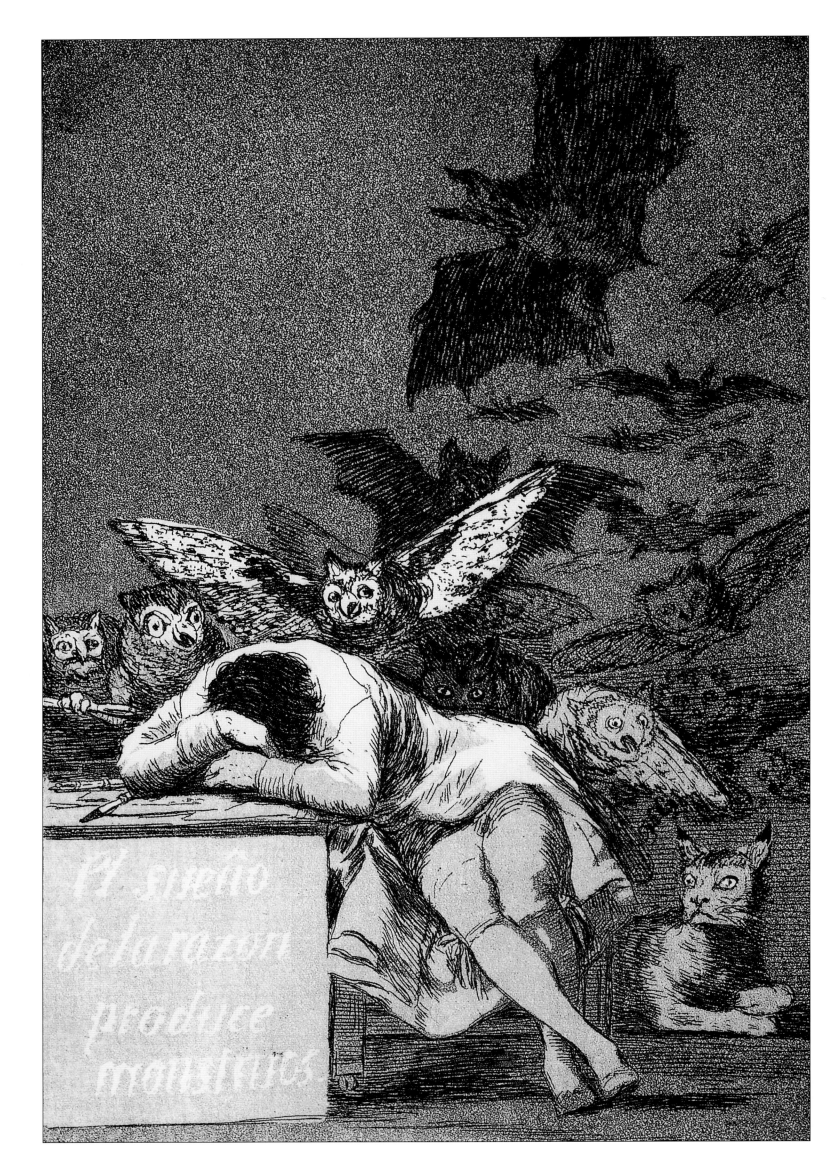

VI

Visionary

At the bottom of his *Self-Portrait with Dr Arrieta* (p.133), his homage to the man who nursed him through another debilitating illness, Goya wrote, "Goya thankful to his friend Arrieta; for the skill and care with which he saved his life during his short and dangerous illness, endured at the end of 1819, at 73 years of age". In an uncompromising image of frailty he shows how, unable even to sit up by himself, he became dependent on the physician, not only for medicine but also for the gentle way in which Arrieta literally supported him. In the background, three mysterious heads loom out of the darkness; their meaning is not clear but their ghostly forms seem to emphasize the precariousness of life.

After Goya's first major illness in 1792, dramatic subjects and obscure scenes began to emerge in the artist's work. During his convalescence, Goya painted a series of works on tinplate which he presented to the Academy. On 4 January 1794 he wrote to the Academy's Deputy, "In order to occupy my imagination which has been depressed through dwelling on my misfortunes ... I set myself to painting a series of cabinet pictures in which I have been able to depict themes that cannot usually be addressed in commissioned works, where caprice and invention have little part to play." This series comprises eleven paintings, of which six represent bulls, bullfights and strolling actors; the others are scenes of human suffering and despair where there is no cure for the ill and no hope for the desperate. Together the prints mark a new direction in Goya's career, the point at which he began to explore the dark side of human nature.

El sueño de la razon produce monstruos (The Sleep of Reason Produces Monsters), 1797-1798, *Los Caprichos*, pl. 43, etching, 21.6 x 15.2 cm.

Among the group is *Yard with Lunatics* (p.139). As our eyes become accustomed to the pale light, we are introduced into a world of insanity. In the centre, two naked men fight like beasts while a barbaric warden tries to bring them under control with a whip. Goya claimed to have witnessed this scene when he visited a lunatic asylum in Saragossa. He reveals the tragic reality of such institutions, which were filthy, overcrowded and claustrophobic. Madmen stare out of the painting at the world of the sane while, in the background, figures turn to the blank wall in an attempt to block out the yard of dehumanized people incapable of escaping the hell in which they live.

Cannibals Preparing Their Victims,
ca. 1800-1808, oil on panel,
32.8 x 46.9 cm, Museum of Fine
Arts and Archaeology, Besançon,
France.

Cannibals Gazing at Their Victims,
ca. 1800-1808, oil on panel,
32.7 x 47.2 cm, Museum of Fine
Arts and Archaeology, Besançon,
France.

Two Old Men, 1821-1823,
oil on plaster transferred onto
canvas, 144 x 66 cm,
Prado Museum, Madrid.

Saturn Devouring His Children,
1820-1823, oil on plaster
transferred to canvas,
143.5 x 81.4 cm,
Prado Museum, Madrid.

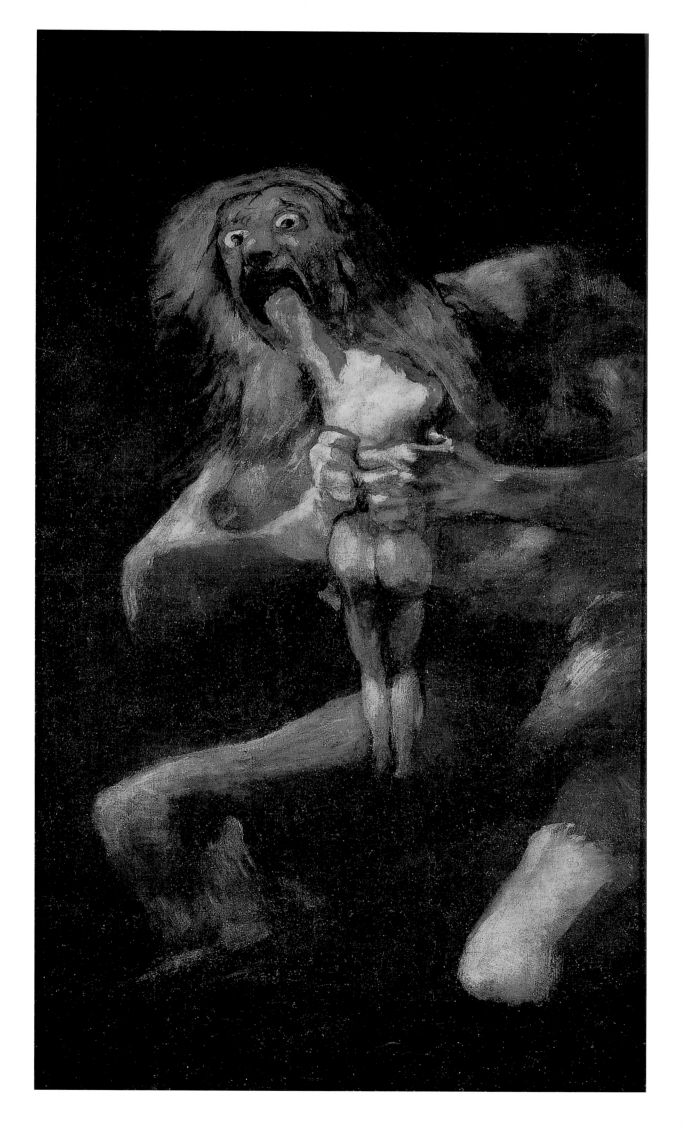

In the last years of the eighteenth century, Goya became interested in the subject of witchcraft at a time when enlightened men and women thought that believing in the occult was a sign of little intelligence. In a letter to his great friend, Martin Zapater, Goya wrote, "I'm not afraid of witches, hobgoblins, apparitions, boastful giants, knaves or varlets, etc., nor indeed any kind of beings except human beings." *The Witches' Sabbath* (p.131) is one of six paintings on the theme of witchcraft that hung in the boudoir of the Duchess of Osuna's country house, La Almeda. It is not known if they were specially commissioned by his liberal patroness or if she bought them after they were painted.

The Witches' Sabbath shows the devil disguised as a he-goat crowned with vine leaves, a reference to lustful Bacchus. He is surrounded by a group of poor, old and ugly women of the type who might be suspected of witchcraft. Witches reputedly sucked the blood of children and were blamed for infant mortality; here the women present the devil with various children. A healthy baby is held by the woman on the right, while another hides under the cloak of a woman reclining in the foreground. An emaciated child stretches out its arms to the devil and, on the left, an infant lies dead on the ground. Above him a woman holds a rod from which hang three unborn corpses, a reference to the practice of abortion, often carried out by such outcast women.

Two Foreigners, 1820-1823,
oil on plaster transferred onto
canvas, 125.1 x 261 cm,
Prado Museum, Madrid.

El Aquelarre (The Witches'
Sabbath), 1797-1798,
oil on canvas, 44 x 31 cm,
Museo Lazaro Galdiano, Madrid.

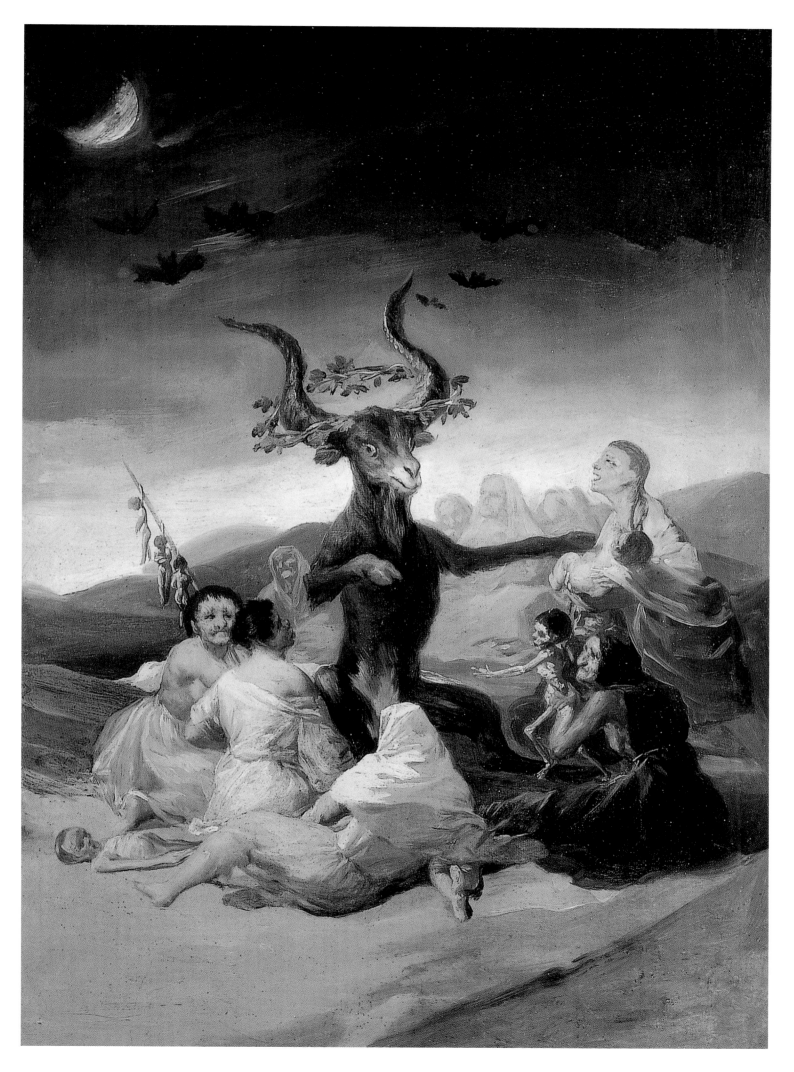

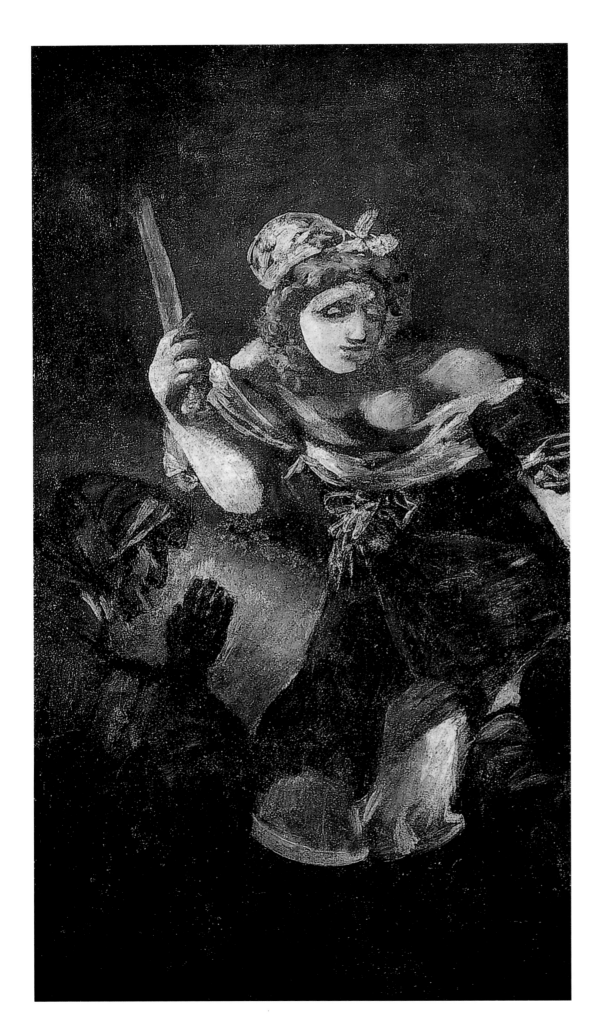

Judith, ca. 1821-1823,
oil on plaster transferred onto
canvas, 146 x 84 cm,
Prado Museum, Madrid.

Self-Portrait with Dr Arrieta, 1820,
oil on canvas, 117 x 79 cm,
Institute of Arts, Minneapolis.

Tu que no puedes
(Thou Who Canst Not),
1797-1798, from *Los Caprichos*,
pl. 42, etching with lavis,
21.7 x 15.1 cm.

Bruja poderosa que por ydropica...
(Mighty Witch Who because of Her
Dropsy Is Taken for an Outing by
the Best Fliers...), 1797-1798,
sepia wash, 24 x 16.8 cm,
Prado Museum, Madrid.

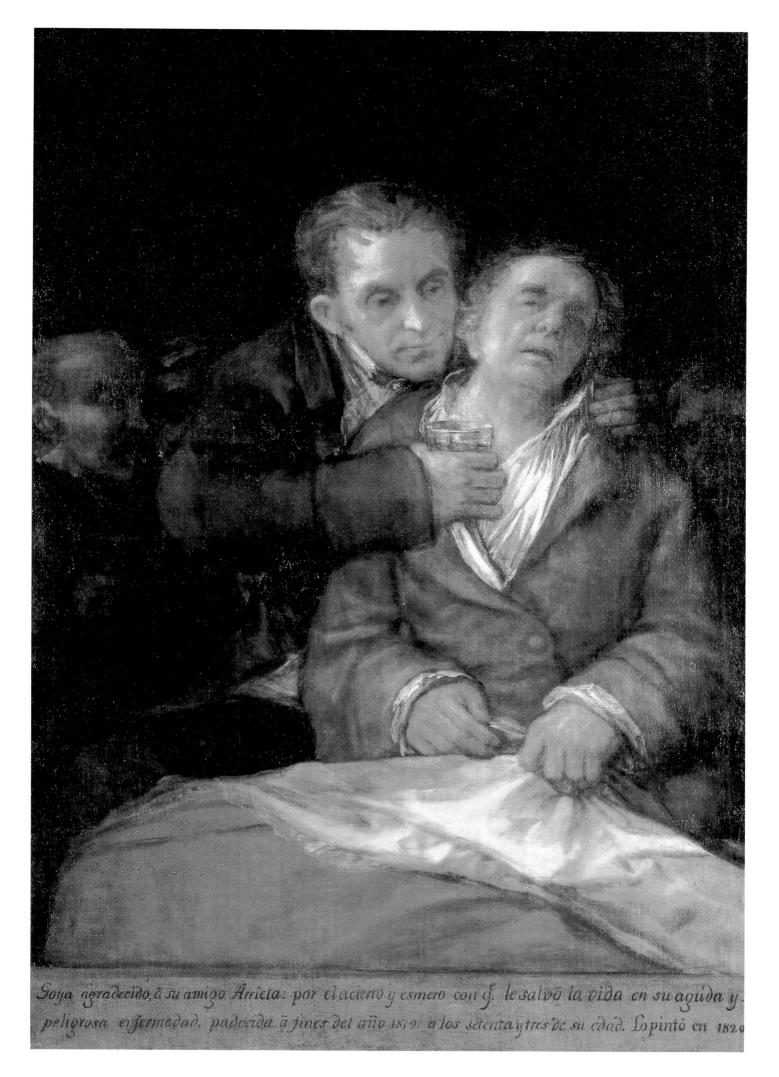

Goya agradecido, á su amigo Arrieta: por el acierto y esmero con q. le salvó la vida en su aguda y peligrosa enfermedad, padecida á fines del año 1819, á los setenta y tres de su edad. Lo pintó en 1820

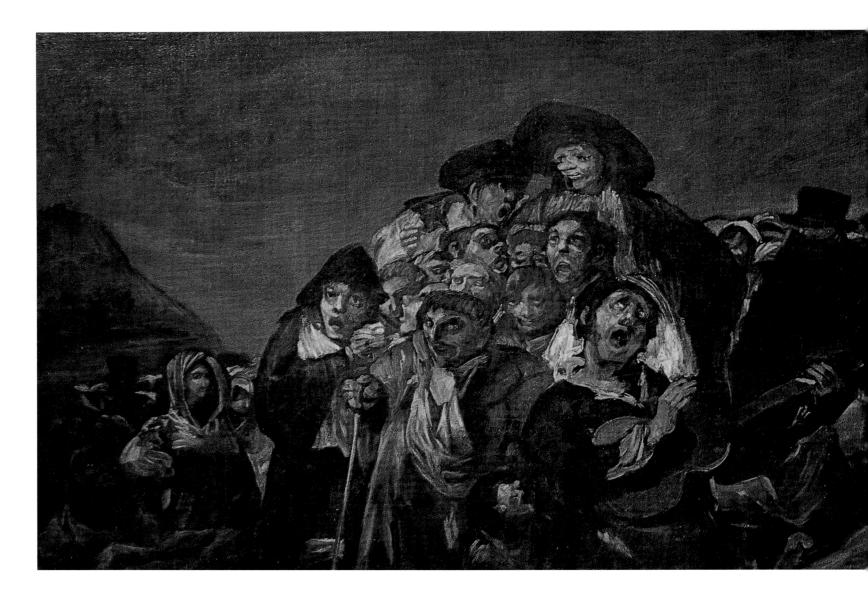

Los Caprichos

Goya fostered his interest in fantasy in a collection of pen-and-ink drawings, entitled *Sueños* (Dreams), begun in 1797. These he developed, engraved and produced as a series of eighty prints entitled *Los Caprichos* (The Caprices) which were advertised for sale on 6 February 1799. In this instance 'caprice' refers to those ideas that do not adhere to reason or any discernible rules and are led by fantasy – in effect to artistic freedom.

Los Caprichos can be seen as Goya's contribution to the campaign waged by Spanish intellectuals to bring the Enlightenment to Spain. Shot through with satire and caricature – the weapons of liberal intellectuals – the prints arouse extravagant emotions, among them fear and horror. Although in general they are critical, today the meaning of some of Goya's images are obscure. The plates are numbered and have explanatory inscriptions, but these may also be veiled because Goya used well-known proverbs, figures of speech, parts of sayings and double meanings.

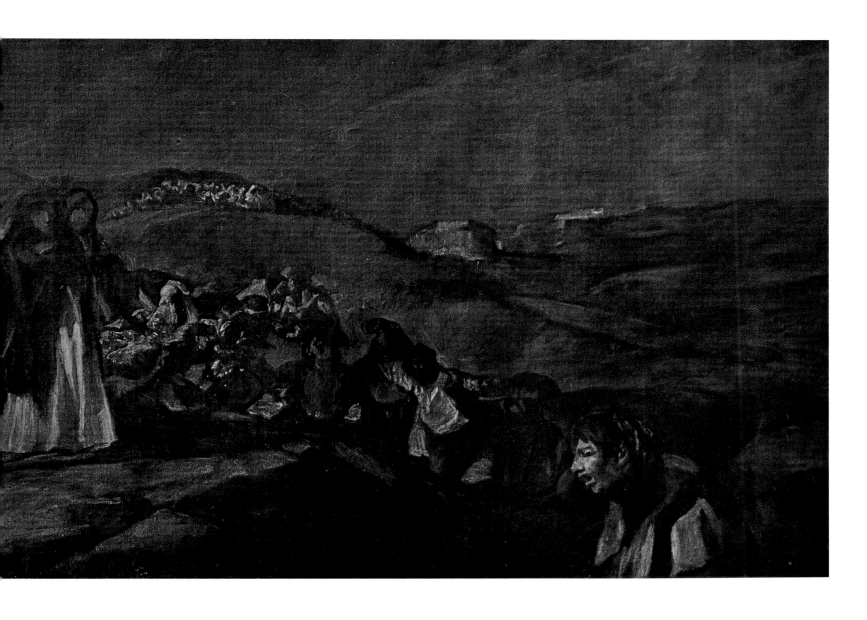

The first plates of *Los Caprichos* are concerned with aspects of human weakness and vice, in particular with immorality and corruption. There are images of marriages of convenience and of the games of deception men and women play, illustrated by masks in the drawing (p.148) which became plate number 27. There are scenes of children being abused and badly brought up and of the follies of the upper classes, the idle and greedy clergy, and of the persecutions of the Inquisition. Goya also depicts prostitutes; at first these are coquettish, but later we see them persecuted and finally in prison.

In the middle of the collection appear a series of asses, representing members of the upper classes. An ass plays the part of a teacher, a doctor, a music lover, a 'pure-bred' aristocrat and a person of importance having his portrait painted by a monkey. The last plate depicting asses, *Thou Who Canst Not* (p.134), illustrates an archetypal upside-down image, an irrational world where a man carries a beast of burden. The asses wear spurs, indicating their nobility, and scratch each other in a leisurely manner as they ride

Pilgrimage to San Isidro, 1820-1823, oil on plaster transferred onto canvas, 140 x 438 cm, Prado Museum, Madrid.

peasants wearing espadrilles and ungartered stockings. The men strain under the weight, unable to refuse, their closed eyes blind to the injustices done to them. Goya's intent is apparently to ridicule the existing social order wherein the oppressed labourer, barely able to survive on his paltry wages, supports an aristocrat, an unproductive member of society who considers it demeaning to do any useful work. The image is comic but moral overtones are strong.

The Sleep of Reason Produces Monsters (p.124) depicts an artist who, working through the night, has fallen asleep with his head on his arms, on a block covered with paper and pens. His creative work has been interrupted by sleep, and reason has given way to the imagination of his subconscious. The nightmare in his mind is described by the creatures that loom out of the darkness and circle round him, while a lynx lies watching and, in the centre, a black cat stares out with large, hostile eyes. The figure may be taken to be in despair, unable to continue, a traditional image of melancholia. *The Sleep of Reason* comes in the middle of the series, at the end of the satirical images of society and as an introduction to the theme of witchcraft, and from this it can be taken to suggest that the writer has abandoned his work because he suspects that truth may never be found through reason. At the same time the image shows how, when reason lies dormant, the imagination is liberated.

The bats, owls and animals that inhabit the night take us into Goya's world of fantasy. The plates that follow show hobgoblins, demons, phantoms and a host of witches. He illustrates the training of novice witches, their rituals and remarkable nocturnal habits. There are several scenes of witches in flight, such as the preparatory drawing for plate number 65, entitled *Mighty Witch who Because of her Dropsy is Taken for an Outing by the Best Fliers* (p.135). Goya uses witches for comic effects but also, and more importantly, as allegories of human behaviour. In so doing he suggests that the line between human actions and devilry is very fine.

By making prints of his designs for *Los Caprichos*, Goya hoped to make his work widely accessible. The series was advertised on 6 February 1799 in the Diario de Madrid. On the 19 February it was advertised again, but instead of being generally available from Madrid's bookshops as before, this time it could be bought only from a shop selling perfume and spirits in the building in which Goya lived. Two days later the prints were withdrawn from sale. Goya's change of mind presumably resulted from fear that wide distribution of his pitiless social satires, which touched on sordid intrigues at court, might have repercussions and that purchasers might be indicted. That caricature was a powerful political weapon was evident in Britain where, since the time of William Hogarth, nobody was immune from ridicule; such prints were not allowed in Spain.

Corral de Locos (Yard with Lunatics), 1793-1794, oil on canvas, 43.8 x 32.7 cm, Meadows Museum, Dallas, Texas.

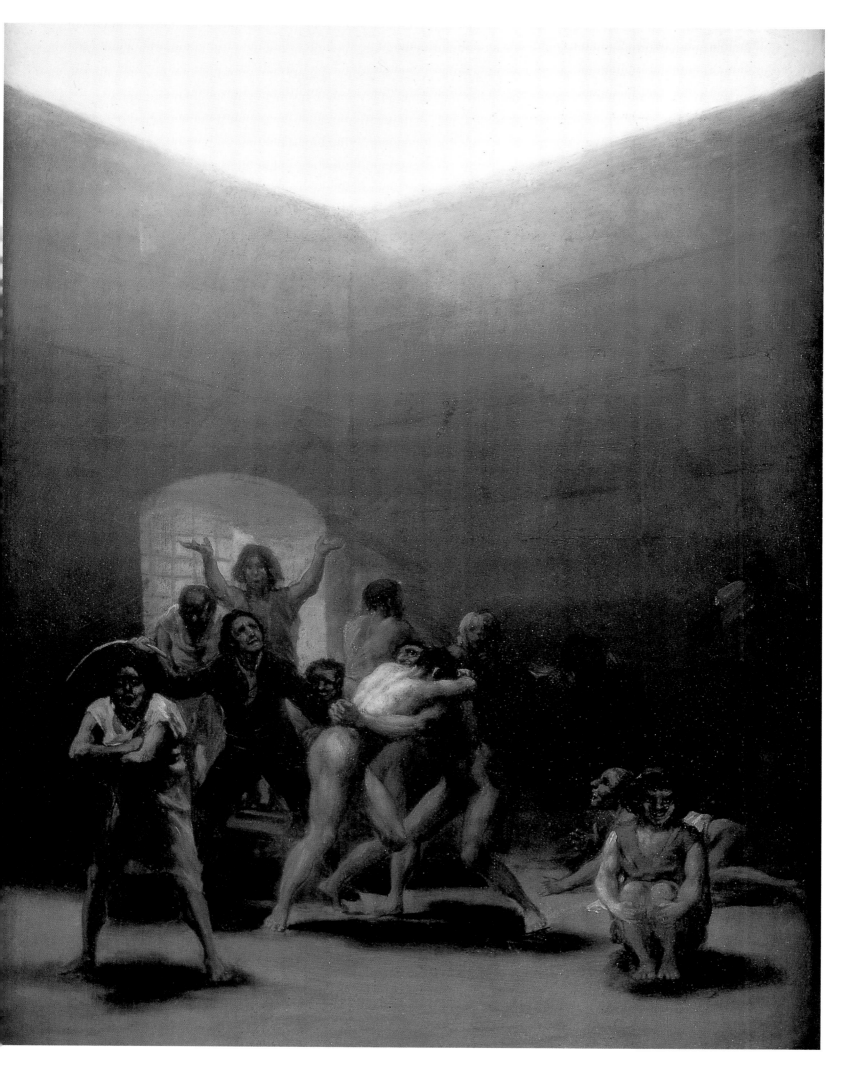

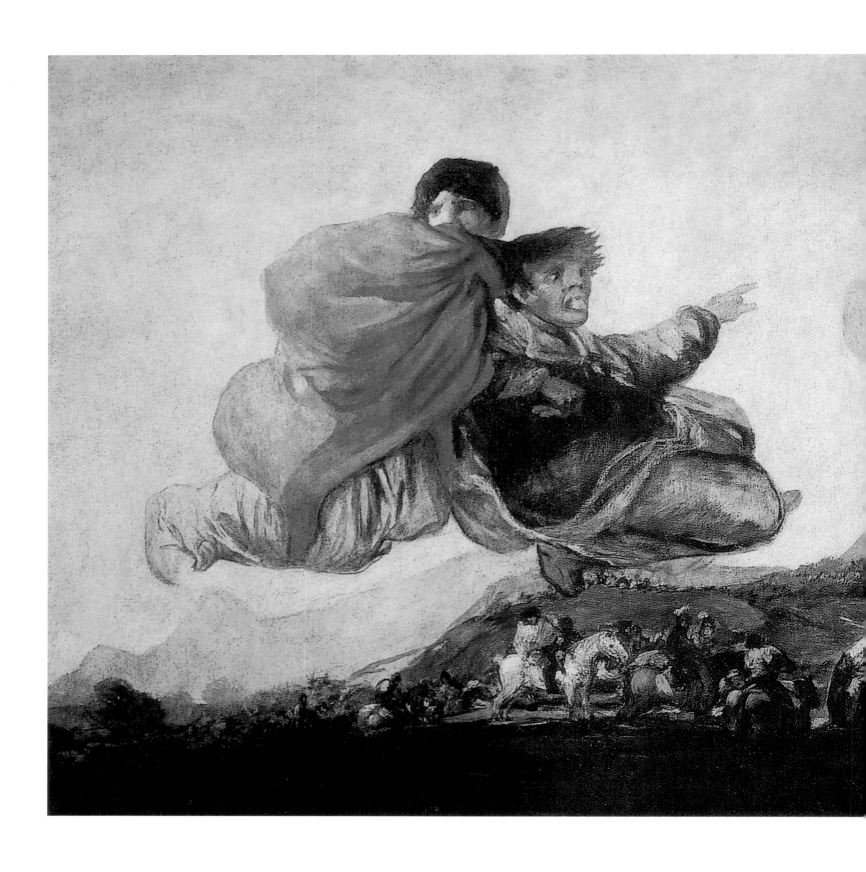

Fantastic Vision or *Asmodea*,
1820-1823, oil on plaster
transferred onto canvas,
127 x 263 cm, Prado Museum,
Madrid.

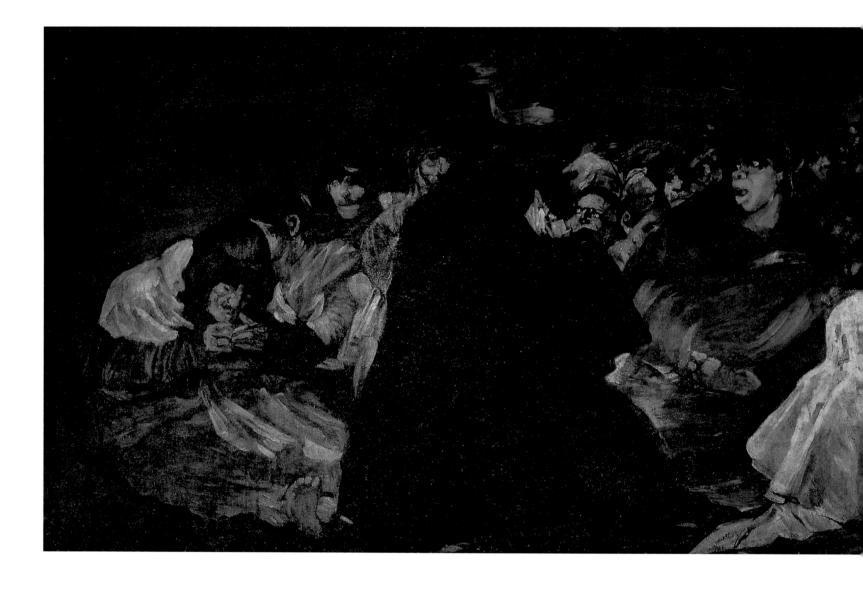

The Black Paintings

In February 1819 Goya bought a house in a quiet rural location near the hermitage of San Isidro and with a fine view of Madrid over the River Manzanares. Known already, coincidentally, as 'La Quinta del Sordo' ('the deaf man's house'), here Goya's friends would gather, according to the artist's early biographer, Laurent Mathéron, "so that all the arts conspired to delight the spirit and the senses." Following his near-fatal illness in the winter of 1819 Goya, aged seventy-three, began to decorate the house with a series known as The Black Paintings.

On the walls of two rooms of approximately the same large size (4.5 metres x 9 metres), one above the other, Goya painted large compositions in oil, in rapid brushstrokes, directly on to the plastered walls. These were transferred to canvas in 1873 and now hang in the Prado Museum. A reconstruction of their original arrangement depends on an unreliable inventory of 1820, when titles were given to the paintings. The paintings are populated with sinister figures and, because of their extraordinary visionary nature, the meaning of the works have been variously interpreted; traditionally the paintings have been seen as an investigation into the behaviour of mankind, in an attempt to understand the evil that had troubled his country.

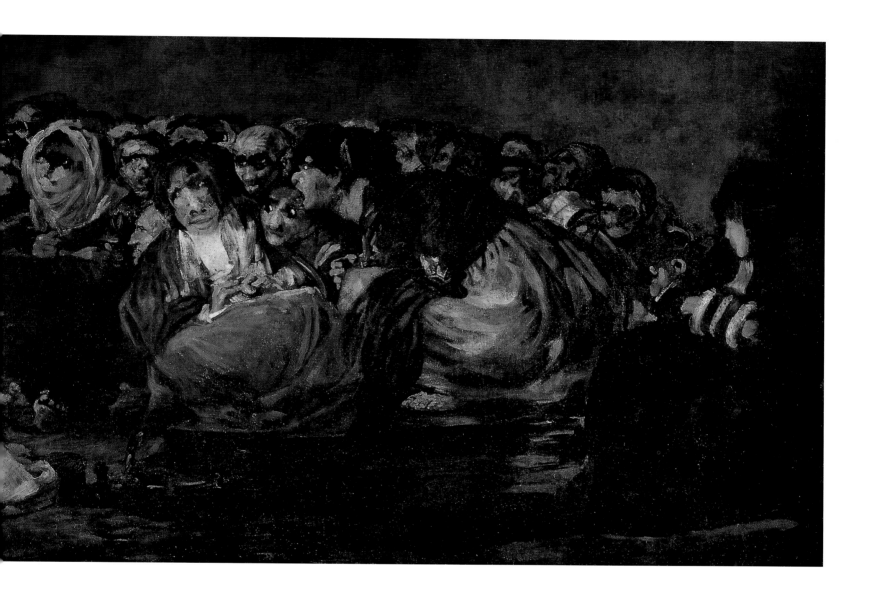

Alternatively, Goya's intentions in making these paintings may have been altogether less serious; they may have been simply a response to the new European fashion for violence, mystery and the supernatural. They were meant to be seen in near darkness, by the light of a candle, and guests may have been invited to be entertained by the artist's invention. This interpretation would accord with Mathéron's recollections of light-hearted social gatherings at Goya's home.

The paintings in the ground-floor room probably included *Saturn Devouring his Children*, *Judith*, *The Pilgrimage to St Isidro*, *The Witches' Sabbath*, *La Leocadia* and *Two Old Men*. *Saturn Devouring his Children* (p.129) shows Saturn off balance and with a crazed expression as he performs the monstrous act; according to legend, once the ancient god had been warned that he would be ousted from his kingdom by his son, he devoured his offspring as soon as they were born. Equally perverse, *Judith* (p.132), represents the Apocryphal saviour of the Israelites who slew Holofernes, the enemy of her people. She is not depicted as the beautiful widow of biblical account, but as a woman clearly capable of murder.

Witches' Sabbath, 1821-1823, oil on plaster transferred onto canvas, 140 x 438 cm, Prado Museum, Madrid.

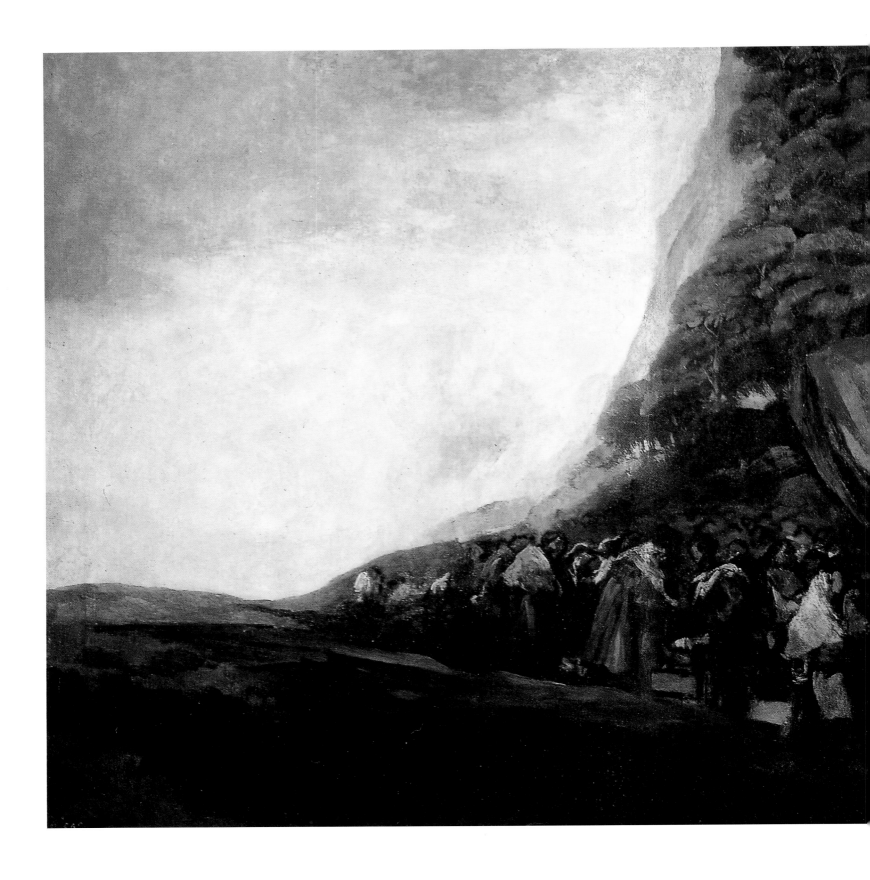

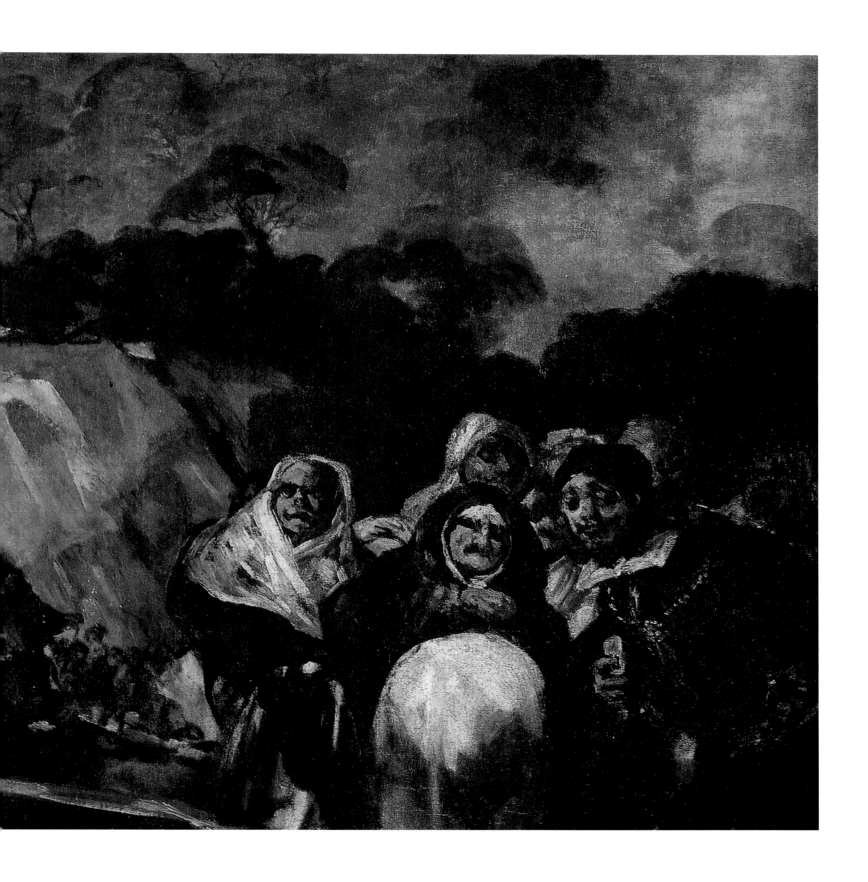

Promenade of the Holy Office,
1821-1823, oil on plaster
transferred onto canvas,
123 x 166 cm, Prado Museum,
Madrid.

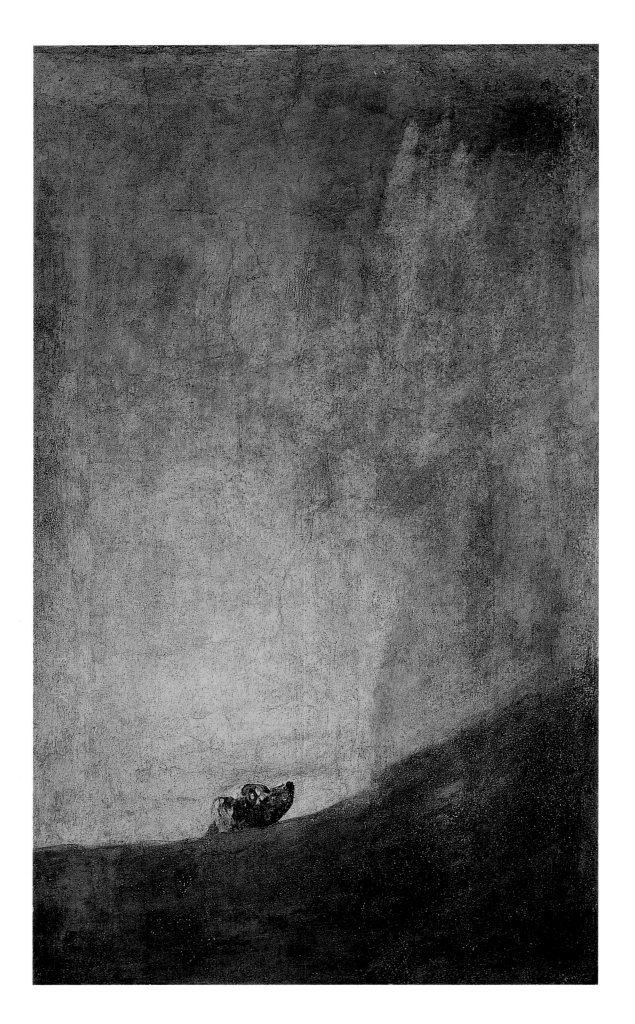

The Dog, 1820-1823,
oil on plaster transferred onto
canvas, 131.5 x 79.3 cm,
Prado Museum.

La Leocadia, 1820-1823,
oil on plaster transferred onto
canvas, 147 x 132 cm,
Prado Museum, Madrid.

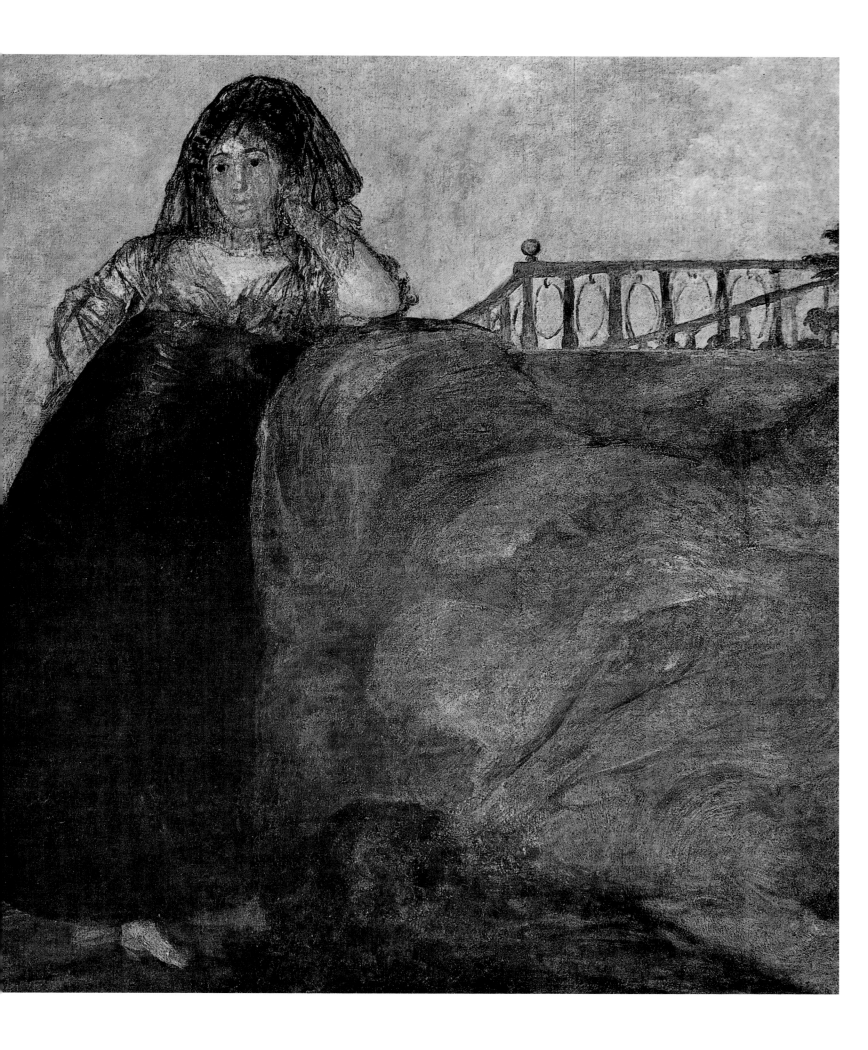

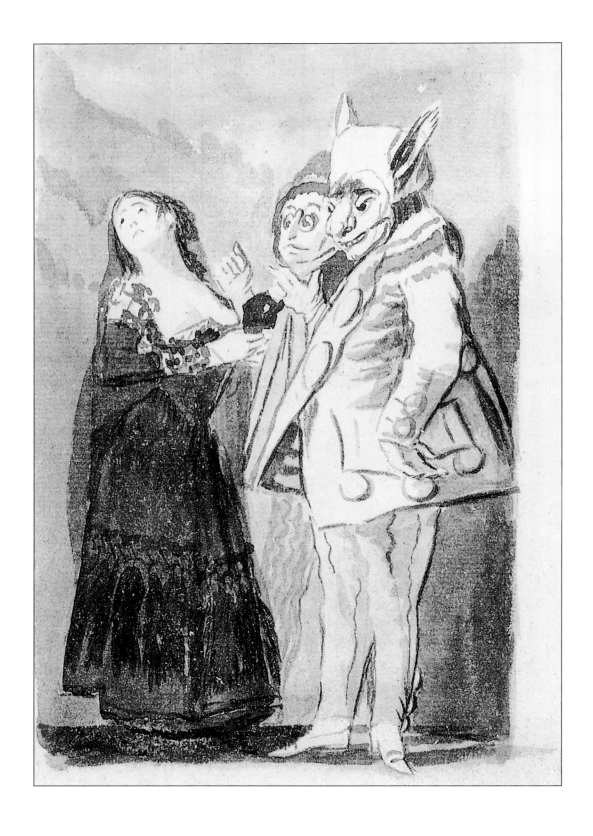

The Pilgrimage to St Isidro (pp.136-7) covered one wall of the room. Although it echoes Goya's earlier composition, *The Meadow of St Isidro* (pp.78-9), in this painting Goya makes a mockery of the happy occasion. From a long procession, a mass of figures emerges off centre out of a nocturnal landscape. Their distorted faces seem threatened by madness, and they huddle together as if frightened of some dark force. Facing The Pilgrimage, *The Witches' Sabbath* (pp.142-3) not to be confused with the earlier painting of the same title made for the Duchess of Osuna (p.131) reveals the exaggerated fear and awe on the faces of the participants in a demonic ritual.

Near the door of the room were probably *Two Old Men* (p.128) and *La Leocadia* (p.147). Leocadia Weiss was Goya's housekeeper and companion and was related to the Goicoechea family into which Goya's son Javier had married. She had two sons from her previous marriage and Goya may have been the father of her daughter, Maria del Rosario Weiss, born in 1814. Her tranquil pose may have been intended to contrast with the violent action of the *Judith*, which stood opposite.

The upper room probably housed *The Cudgel Fight, The Fantastic Vision, The Holy Office* and *The Dog* (p.146). In *The Cudgel Fight* figures come to blows with blunt-ended sticks. They sink up to their knees in the ground, in what may be an allusion to the futility of the Spanish civil war or the war with France.

It has been suggested that the huge rock featured in *The Fantastic Vision* (pp.140-1) refers to the Rock of Gibraltar, the refuge of Spanish liberals between 1815 and 1833. Goya presents dramatic contrasts of scale. Two giant figures hover over a tiny group of horsemen while, on the right, soldiers with rifles aim in their direction and create a feeling of panic and fear.

The eccentric group in *The Holy Office* (pp.144-5) expresses terrors shared by everyone. In spite of the distortions, the diabolical faces and the violence, Goya's figures are credible and are clearly human. Like Mary Shelley's Frankenstein, published a year earlier, in 1818, Goya shows how monsters are created by man.

Goya was worried that his paintings might incriminate him and, with the restoration of Ferdinand VII to absolute rule in 1823, Goya assigned the Quinta del Sordo to his grandson, Mariano. Early the following year Goya went into hiding and requested leave to go to France on the pretext of taking a cure. On 24 June he arrived at the house of his friend, the playwright Leandro Fernández de Moratin, in Bordeaux. Goya settled in Bordeaux, living in self-imposed exile among representatives of liberal Spain, until his death at the age of eighty-two.

Máscaras crueles (Cruel Masks), 1796-1797, Album B (called Madrid), pl. 55, Indian ink wash, 23.7 x 15 cm, National Gallery of Art, Washington.

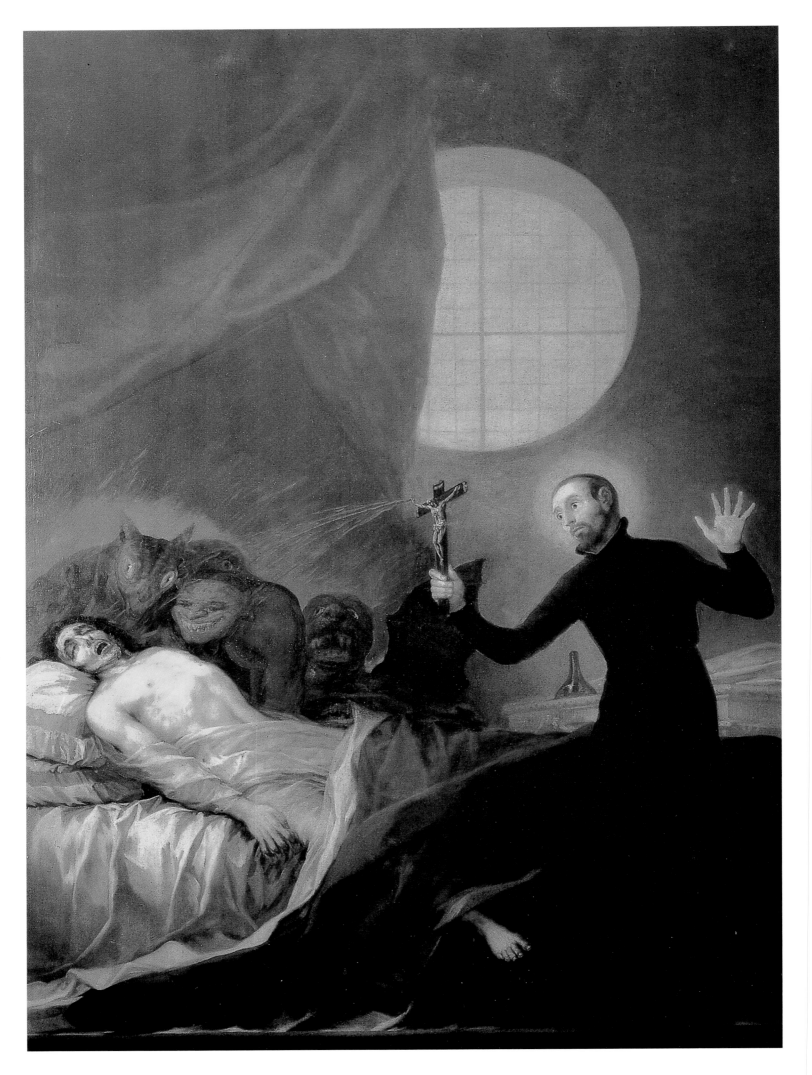

IV

Conclusion

A study of Francisco Goya's life and work appears to present many contradictions. For nearly forty years Goya was the principal painter at court and he recorded the glittering wealth of the Spanish nobility. At the same time, in one of the least enlightened countries in Europe, Goya was a liberal thinker. He was a tireless commentator on the social conditions of his age. He hated authority in any form, be it priest, soldier or official, and above all he hated those who exploited the helpless. He was concerned with the floating population, with criminals and prostitutes, and by the crippling poverty that resulted from the injustices of an uneven distribution of wealth. The court must have been ignorant of his criticism or blind to his cries of protest.

As painter to the court, Goya was entirely professional. During the 1870s and 1880s he was able to paint merry scenes of life in Madrid at a time when he himself must have been experiencing terrible grief; between 1774 to 1782 he wrote in his notebooks the full names and dates of birth of seven of his children, all of whom died in infancy. In his private work Goya expressed a universal suffering and made an extensive analysis of mankind. His devouring curiosity and restlessness of mind, even at the end of his life, is illustrated by the drawing of an old man, hesitantly leaning on crutches, inscribed "And I am still learning" (p.152).

Goya was a pragmatist and yet he was also preoccupied with disturbing fantasies and the supernatural. A macabre posthumous event adds even more interest to the life of this fascinating artist. When, in 1901, his body was exhumed from its resting place in Bordeaux for transportation to Madrid, it was found that his head had been mysteriously removed from the grave.

St Francis Borgia Exorcising, 1788, oil on canvas, 350 x 300 cm, Cathedral of Valencia.

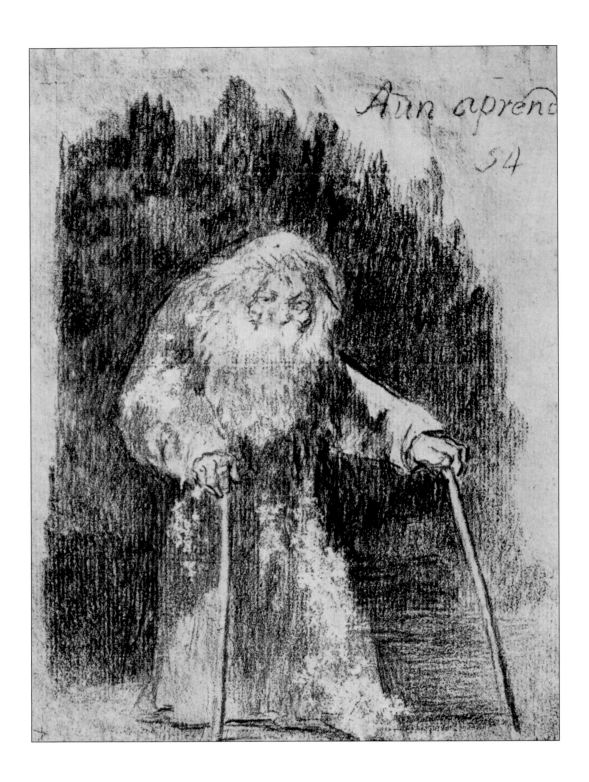

Following his death, Goya's work had little influence in Spain, because few of his works were on public view. When the Prado Museum in Madrid opened in 1819, only three of his paintings were placed on show, although there were many other Goya canvases in the museum's store. It was not until the end of the century that more were displayed, and Goya was not honoured with a major retrospective exhibition in Madrid until 1900.

Goya's reputation developed initially outside Spain, particularly in France where, in 1825, ten plates of *Los Caprichos* were published. Goya was a notable hoarder of his own work and during the nineteenth century his family periodically sold canvases, which were often bought by foreigners. From 1838 to 1848 the Spanish Gallery in the Louvre Museum in Paris showed some of Goya's everyday scenes, including *The Forge* (p.104).

Aun aprendo (I'm Still Learning), 1824-1828, Album G, pl 54, black stone, 19.5 x 15.6 cm, Prado Museum, Madrid.

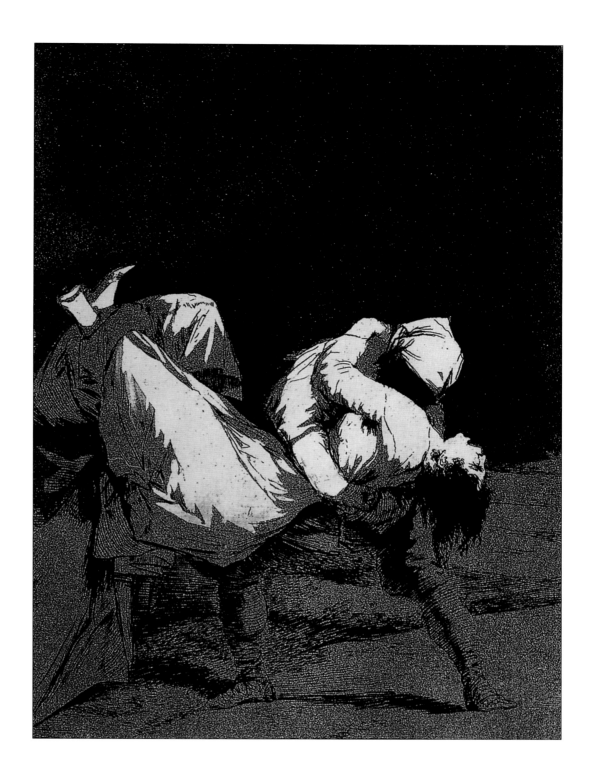

Goya's rejection of heroism and his refusal to glorify or idealize influenced strongly the French realist painters of the mid-nineteenth century. Inspired by Goya, Jean François Millet and Gustave Courbet painted the working classes and the harsh conditions in which they lived. Other great French painters, Eugène Delacroix and Honoré Daumier to name but two, owe a debt to Goya's work. Perhaps his greatest admirer was Edouard Manet, who based several of his principal canvases on masterpieces by Goya (pp.154; 155).

Goya's reputation only increased during the twentieth century. As recently as 1997, as a part of the notorious Sensation exhibition at London's Royal Academy, Jake and Dinos Chapman created *Great Deeds Against the Dead*, a more than life-sized, three-dimensional reconstruction of plate 39 of Goya's Disasters of War (p.116). In the modern world, at the end of probably the most violent century in history and despite the fact that we are exposed to a mass of uncompromising photographic journalism, Goya's images still have the power to shock.

Edouard Manet, *The Balcony*,
1868-1869, oil on canvas,
170 x 125 cm, Musée d'Osay, Paris.

Majas at Balcony, ca. 1808-1812,
oil on canvas, 162 x 107 cm,
Private Collection.

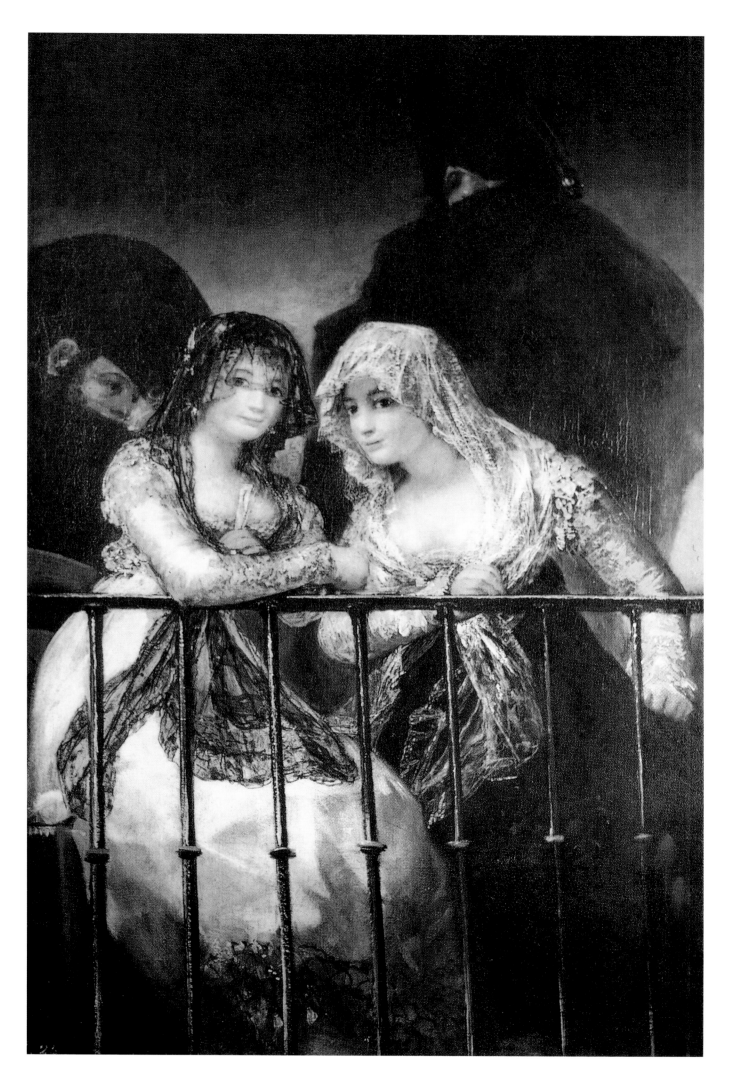

Biography

1746: Francisco Goya y Lucientes is born in Fuendetodos near Saragossa, Spain. His parents were members of the rural nobility and his father was a gilder. Except for a few isolated facts and dates, we know very little about Goya's childhood and adolescence.

1759: At the age of 13, Goya begins studying at local painter José Luzan's workshop where he will stay for four years.

1763: Goya leaves for Madrid where he is denied entry into The Royal Academy of San Fernando.

1766: At 20 years of age, he again attempts to enter The Royal Academy of San Fernando without much result.

1767-1771: Goya stays in Rome where he is influenced by Roman neoclassicism. He receives a special mention at a painting competition organized by the Academy of Parma.

1771: Goya receives his first commission: it is for a fresco for the vault at the Cathedral of El Pilar in Saragossa.

1773: Goya settles in Madrid where he marries Josefa Bayeu, whose three brothers are painters. It is here that Goya receives a commission for the Royal Factory of Santa Barbara. Within 18 years, Goya will produce three series of tapestries (1774-1780, 1786-1788, 1791-1792). At the same time he pursues a career as a portrait artist.

1774: The paintings of *Aula Dei*.

1778: He does engravings influenced by Velázquez.

1780: Goya is elected a member of The Royal Academy of San Fernando. He tries to introduce himself, little by little, into the complex university system. He makes a good impression on the royal family with his cartoons, which are destined for the Prado Palace. Goya's position appears to be improving, which helps to explain his growing rebellion against the artistic supervision of his brother-in-law, Francisco Bayeu.

1785: Goya is nominated several days before his fortieth birthday as the Deputy Director of Painting for The Royal Academy of San Fernando.

1786: Goya becomes one of the King's painters.

1789: Goya is promoted and becomes a painter for the King's Chamber.

1792: Goya becomes deaf after suffering from a serious illness for many years. He begins a series of etchings that permits him to satisfy his fantasy and imagination.

1795: Goya is nominated as the Director of Painting for the Royal Academy. The same year he paints the first portrait of the Duchess of Alba, with whom he falls in love.

1797: His illness prevents him from serving his function as Director and Goya is nominated as an honorary director.

1798: He undertakes the decoration of The Hermitage of San Antonio de la Florida in Madrid.

1799: Publication of the collection of eighty plates of his *Caprices*. Goya becomes the First Court Painter.

1805-1810: He paints several still lives and undertakes the eighty-two plates from the *Disasters of War* series, during the agitated political times marked by the war and the French occupation.

1812: His wife Josefa Bayeu dies.

1814: Goya paints *The Second of May, 1808* and *The Third of May, 1808*.

1816: Publication of *The Bullfight*.

1819: Goya buys a country house not far from Madrid, which will become "The House of the Deaf". There, in 1821-1822, Goya most likely realizes his so-called *Black Paintings*. He also does his first lithograph.

1824: He rejoins all of his friends in exile in France.

1825: Publication of the lithographs: *The Bulls of Bordeaux*.

1828: Goya dies in Bordeaux in April.

Bibliography

CASSIER P.
— The Drawings of Goya: The Complete Albums, New York, 1973.
— The Drawings of Goya: The Sketches, Studies and Individual Drawings, New York, 1975.
GASSIER P. AND WILSON J.,
Goya, His Life and Work, Paris, 1971.
GLENDINNING N.
— *"Goya and England in the Nineteenth Century"*, Burlington Magazine, CVI, 1964, pp. 1-14.
— *"Goya and His Critics"*, New Haven and London, 1977.
— *"Goya on Women in the Caprichos: The Case of Castillo's Wife"*, Apollo no. 107, 1978, pp. 236-247.
— *"Goya's Patrons"*, Apollo no. 114, 1981, pp. 236-247.
HARRIS T.
— Goya's Engravings and Lithographs, 2 vol., Oxford, 1964.
— Goya, London and New York, 1969.
HANSON ED. H.W.
Goya in Perspective, New Jersey, 1973.
LICHT F.
Goya and the Modern Temper in Art, New York, 1978.
LÓPEZ-REY J.
"Goya and the World around Him", Gazette des Beaux-Arts, XXCIII, 1945, pp. 129-150.
MALBERT R.
The Disparates, London, 1997.
NORDSTRÖM R.
Goya, Saturn and Melancholy, Stockholm, 1962.
PÉREZ SÁNCHEZ A. E. AND GALLEGO J., GOYA
The Complete Etchings and Lithographs, New York, 1995.
DE SALAS X.
Goya and the Black Paintings, London, 1964.
SÁNCHEZ CANTÓN F. J.
The Life and Works of Goya, Madrid, 1964.
SCHICKEL R.
The World of Goya 1746-1828, Time-Life Books, New York, 1968.
SYMMONS R.
Goya, London, 1998.
TOMLINSON J.
— Goya in the Twilight of Enlightenment, New Haven and London, 1992.
— Francisco Goya y Lucientes 1746-1828, London, 1994.

Exhibition Catalogues

Goya and His Times, Royal Academy of Arts, London, 1963-4.
The Changing Image: Prints by Francisco Goya, Museum of Fine Arts, Boston, 1974.
Goya and the Spirit of the Enlightenment, Museo del Prado, Madrid; Museum of Fine Arts, Boston; Metropolitan Museum of Art, New York, 1988-9.
Goya and the Satirical Print in England and on the Continent, 1830-50, Boston College Museum of Art, 1991.
Goya, Truth and Fantasy, the Small Paintings, Museo del Prado, Madrid; Royal Academy of Arts, London; The Art Institute of Chicago, 1993-4.
Spanish Still Life from Velázquez to Goya, National Gallery, London, 1995.
Painting in Spain in the Age of the Enlightenment: Goya and His Contemporaries, Spanish Institute, New York, Indianapolis Museum of Art, 1997.

Index